THE ART OF
WATERCOLOR

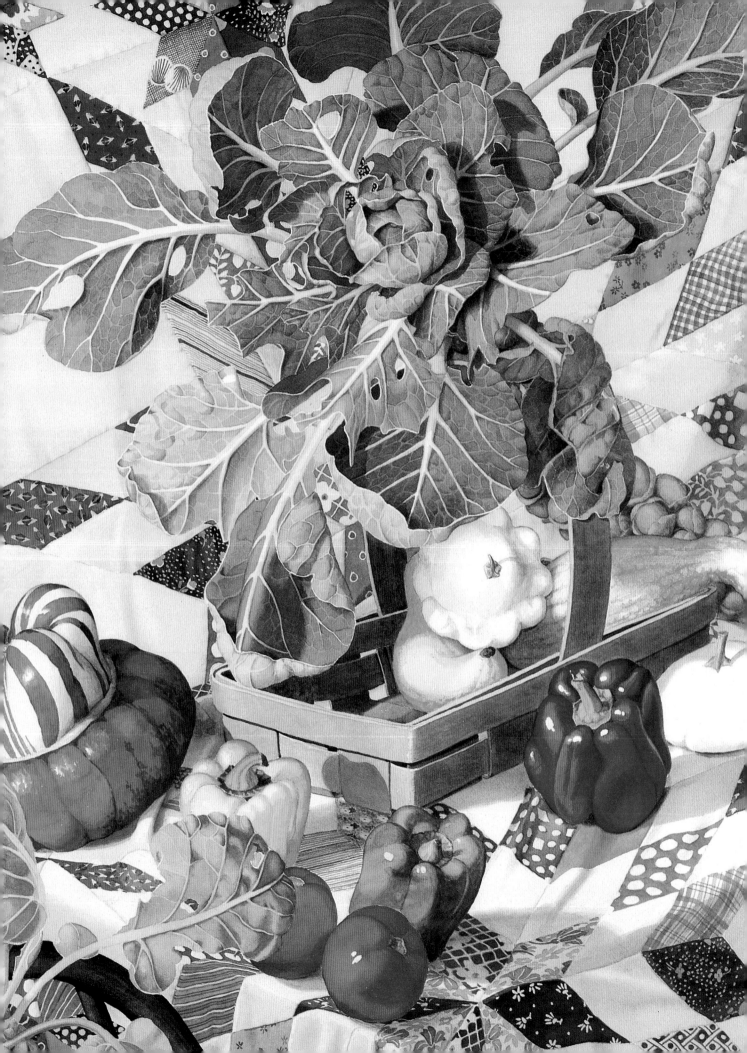

THE ART OF WATERCOLOR

REVISED EDITION

CHARLES LE CLAIR

TECHNICAL ILLUSTRATIONS BY THE AUTHOR

WATSON-GUPTILL PUBLICATIONS/NEW YORK

ACKNOWLEDGMENTS
I am deeply indebted to each of the artists, museums, galleries, and private collectors who have contributed visual material for this book. Special thanks also go to three people who have been especially helpful—Beatrice Epstein, photograph librarian at the Metropolitan Museum of Art; Tamantha Kuentz, director of rights and reproductions at the Philadelphia Museum of Art; and Sique Spence, assistant director of the Nancy Hoffman Gallery in New York City. Above all, I want to thank my editor, Dale Ramsey, whose expert hand has shaped this text, and Areta Buk, who is responsible for the book's handsome design.

Note: Unless otherwise indicated, it should be understood that the watercolors in this book are painted on paper over penciled contours and that the works are in private collections.

Title page image:
Sondra Freckelton, detail, *Still Life with Star Quilt* (page 54)

Picture credits
Geoffrey Clements (Burchfield, *Dandelion Seed Balls;* and Marin, *West Point);* Wayne Cozzolino (Le Clair watercolors, except in Chapters 7 and 11); D. James Dee (Mitchell, *Ferry to Staten Island);* eeva-inkeri (Wiley, *The Good and the Grubby);* G. R. Farley (Mitchell, *All the Way Across);* Joseph Painter (all paintings by Scott, Keyser, Hamburg, Pratt, and Lent, plus Le Clair's Roman watercolors in Chapters 7 and 11); Zindman/Fremont (Porter, *Maine Towards the Harbor* and *Door to the Woods).*

Library of Congress Cataloging-in-Publication Data
Le Clair, Charles
 The art of watercolor / Charles Le Clair; technical illustrations by the author. — Rev. ed.
 p. cm.
 Includes index.
 ISBN 0-8230-0291-8
 1. Watercolor painting—Technique. I. Title.
ND2420.L4 1994
751.42'2—dc20 93-38097
 CIP

Manufactured in Singapore

1 2 3 4 5 / 98 97 96 95 94

CONTENTS

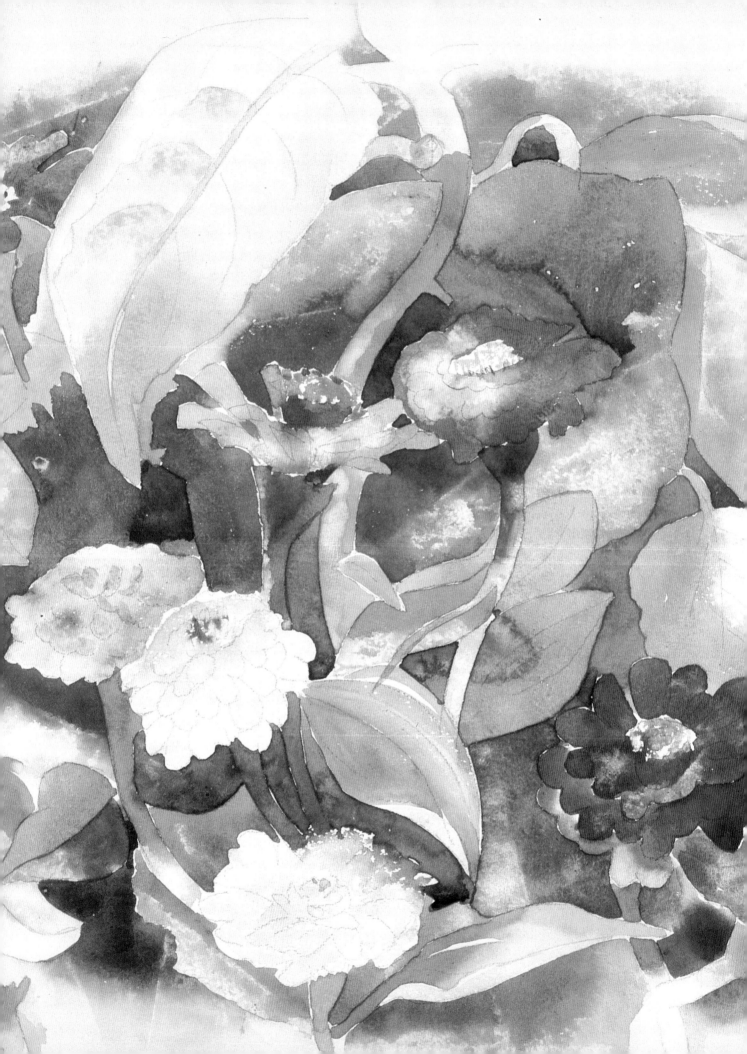

PREFACE TO THE REVISED EDITION

There are a good many books on watercolor available, but they are by no means alike—and, as the French say of the sexes: *vive la difference!* This book, for instance, differs markedly from other guides to the medium in at least four respects.

First, *it is the only handbook offering a comprehensive course of study* of the kind you would find in a university or professional art school. Instead of suggesting easy formulas for glamorous effects, it encourages the serious student—whether working at home or in a classroom situation—to explore basic and advanced techniques in projects that range from still lifes, figure studies, and landscapes to exciting abstract approaches.

Second, *it is unique in featuring the work of historic and contemporary masters of the medium.* You won't turn the pages of another book on watercolor technique and find Winslow Homer, John Singer Sargent, and Paul Cézanne next to such contemporary stars as Carolyn Brady, Sondra Freckelton, and Andrew Wyeth. In all, there are a hundred full-color illustrations of contemporary art, plus more than thirty masterworks from the Museum of Modern Art, the Metropolitan Museum of Art, and other major collections.

Third, *it offers how-to techniques, not as ends in themselves, but in the context of visual ideas.* In art, rather than a single "correct" approach, there are many ways to express oneself. Thus technical explanations are related here to the esthetic concepts they might serve. And arguments for and against a procedure are noted so that you can make a thinking person's choice.

Fourth, an important distinction is that *it combines studio information with art-historical comment.* Unusual in a handbook, this is nevertheless a logical approach to the subject and one that reflects the way painting is taught in our better art schools, where studio teachers correlate practical assignments with slide presentations and museum visits.

Beyond these specifics, my goal is to encourage the reader—as I do my students in studio classes—to enjoy working with watercolor by learning very quickly how to be good at it. Happily, since the first edition came out in 1985, *The Art of Watercolor* has proved to be the kind of book that inspires people who never thought they could paint to set to work at the kitchen table. It has also found favor as a textbook in colleges and art schools across the country. This revised edition, therefore, is designed to update a publication of proven effectiveness without changing its basic content. Various illustrations have been replaced by more recent examples and the work of interesting new artists has been added. Chapters on landscape, the figure, and developing a composition have been strengthened. And the most significant improvement, of course, is the shift from black and white to a vivid full-color format.

The wonderful thing about watercolor is that it offers a uniquely spontaneous painting experience, for in contrast to oils or acrylics that may take weeks to complete, a watercolor can be dashed off in an afternoon. This immediacy, however, is coupled with a wide range of technical possibilities, with the result that the medium appeals to people with various levels of training and experience. Those who haven't painted before find its modest scale and sketchiness congenial. Accomplished artists, who may take up watercolor after years of working with opaque media, find its potential for indirect and experimental techniques exhilarating. Teachers can adapt watercolor to precollege, undergraduate, graduate, or adult leisure-time programs. And anyone working at home in close quarters will find the medium's minimal equipment requirements attractive.

As you will see, this book addresses the practicing artist with plain talk in the manner of a studio encounter. It has evolved from a college course that I developed over the years, and its eleven chapters correspond roughly to the weeks in a semester of studio classes. Thus, by completing the suggested projects, you should come up with fifteen or twenty paintings—a substantial and quite varied portfolio.

I must emphasize, however, that *The Art of Watercolor* is designed as a guide, rather than as a schedule to be followed rigidly like a diet or exercise program. Each chapter presents alternative strategies, and one or another should appeal to you. If not, give the suggested exercise a quick try, and perhaps later you will come to see its value. Then, before moving on to the next chapter, do a painting entirely on your own.

Ultimately, watercolor depends, more than any other medium, upon the extremes of utter spontaneity and complete control—the seemingly accidental splash done with just the right timing. By following a fairly straightforward path of study, yet digressing from time to time when inspiration strikes, you will develop the sure hand and creative spirit of a successful watercolorist.

CHARLES DEMUTH
Detail, *Zinnias*
(page 50)

1 MATERIAL CONCERNS

You can't make a silk purse out of a sow's ear. Yet many art students (unless forcefully persuaded otherwise) try to paint with materials that cannot produce the desired results. *He* uses a palette so small that color mixtures run together in a mottled mess. *She* has a brush, bought at a saving of ten dollars, that bends left or right but will not spring back. *They* work on paper that will yellow within the year. My first purpose, therefore, is to assure you that the list of basic supplies at the end of this chapter is a minimum, rock-bottom requirement. To cheat on it is to cheat yourself, since "making do" with inadequate materials will lead to a discouraging experience and prevent you from realizing your potential.

As painting media go, watercolor is relatively inexpensive. Space and equipment needs are minimal: you can work on the kitchen table or in the backyard with a board on your lap. Pigments go a long way, brushes are slow to wear down, and even the most elegant paper is cheaper than canvas. Still, be prepared for a substantial initial outlay. Afterward, the fun begins, and you will want to protect your investment by learning how to use and take care of your materials.

Costs are particularly modest if, like most artists, you plan to work in a traditional small-scale format. A #6 sable brush costs 75 percent less than a #12, a lightweight paper sketch block eliminates the need for a heavy drawing board, and pigments go a long way in small areas. In recent years, however, many leading watercolorists have turned to new oversize papers, and perhaps—after you gain confidence with the medium—you will want to follow suit. In any case, when you work in a larger scale, costs escalate and so do the technical problems relating to stretching and flattening the paper that are discussed in these pages.

NATALIE BIESER
Detail, *Untitled #66*
(page 91)

WATERCOLOR PAPERS

A smart chef can substitute margarine for butter without ill effect, but as far as I am concerned the serious watercolorist must work with good paper. So-called *student-grade paper* is composed of wood pulp or other material that self-destructs like old newspaper. Furthermore, its absorbent surface responds to washes quite differently from the glazed finish of quality stock, and though easy to use, it encourages bad technical habits.

Artist-grade paper, on the other hand, is made of chemically neutral 100-percent rag fibers. It has a firm finish and permanent whiteness. Traditionally, it was laid by hand with a beautiful deckled edge now imitated by machine technology. (Although genuine handmade paper has all but disappeared from supply stores, several small firms make interestingly textured special-order papers for a price.) In any case, linen is the best rag stock, but nowadays less costly cotton is usually substituted. Quality papers also have embossed logos, like the emblems of Gucci or St. Laurent, and—although both sides are usable—the "right" side, with a slightly more subtle finish, is determined by holding the trademark up to the light. Nine out of ten painters interviewed for this book prefer Arches, the French paper, but there are equally fine American products as well as English Whatman and Italian Fabriano.

Manufacturers offer a choice of three standard finishes:

Hot Press. A smooth surface polished by a hot "iron." Designed for detailed rendering, this paper is inappropriate for the broad technique we will start with. It lacks the tooth needed to hold a wash, and the surface buckles and leaves rings when wet.

Rough. A heavily textured paper that also has somewhat specialized uses. It acts like pebble board in dry-brush work, commercial designers use it for stylized renderings, and occasionally a major artist like John Marin finds an exciting way to use it. In general, however, a rough finish tends to "take over," and you should have some experience before tackling it.

Cold Press. The all-purpose paper you will rely on at the outset. Its surface is pressed between cool rollers to a degree of smoothness, but with some texture remaining. The tooth is thus unaggressive, yet sufficient to hold wet passages attractively.

Watercolor paper comes in various weights (or thicknesses). These are determined by the weight of a 500-sheet ream in the standard size of 22 × 30 inches. Professionals generally prefer heavy 300-lb. stock because of its handsome physical presence and resistance to buckling. Yet all finishes are available in thinner 140-lb. and 90-lb. weights at half or one-third the cost. A medium-weight 140-lb. cold-press paper is recommended for the beginner. This is the thickness of most papers that come in a roll, incidentally, and is thus the choice of professionals whose work is very large. I have often used this weight, and Sondra Freckelton says she prefers it to heavier 300-lb. cold-press paper because the texture is less insistent.

Size is another consideration. If you are cost-conscious, the 22 × 30-inch standard (or Imperial) sheet is advantageous, since it is well proportioned when used whole or torn into 15 × 22-inch halves or 11 × 15-inch quarters. Instead of cutting corners with inexpensive substitutes, learn to get the most out of a piece of really good paper. The half-sheet, favored over the years by artists from Winslow Homer to Sidney Goodman, is an excellent shape for your first endeavors, and the quarter-sheet will do nicely for small studies. This last was Charles Demuth's preference, and neither he nor Cézanne were averse to making a second start on the back. You can do this, too, when a sketch fails to jell. One advantage of quality rag stock is that it can be used on both sides.

The watercolor block (or tablet) is a convenient alternative to separate sheets. This is a pack of paper secured in a gummed binding, so that you can paint on the top sheet and cut away afterwards to a fresh layer. Blocks come in several sizes and usually contain twenty-five 140-lb. sheets. The paper develops hills and valleys when wet, since it is not really stretched. However, it *is* held in place on a light cardboard backing that eliminates the need for tacks, tape, and drawing board.

If convenience is all-important for you, by all means buy a tablet. Like convenience foods, however, sketch blocks are not to everyone's personal taste. They lack the deckled trim of sheet paper, the raised edge of the block inhibits the sliding action of the painter's arm, and they tend to lock you into a conventional size and proportion.

Oversize paper is of growing interest to contemporary watercolorists. A 29 × 41-inch sheet, which Elizabeth Osborne uses, is better proportioned than the old, overly long paper (25 × 40 inches) known as Double Elephant. Philip Pearlstein and Carolyn Brady use 40 × 60-inch 300-lb. Arches as a standard format, and Joseph Raffael sometimes paints watercolors 6 or 8 feet long on paper that comes by the roll.

Large-scale watercolors aren't for everyone, but if you are interested, buying paper by the roll is probably your best bet. In contrast to the difficulty of obtaining separate oversize sheets, available only in a few metropolitan centers, a roll can easily be special-ordered by an art store. Arches 140-lb. cold-press paper comes in 10-yard rolls 44 or 50 inches wide. I always keep one on hand for the convenience of being able to cut a piece of any size or proportion. On a cost-per-square-inch basis, a roll is the best buy and is particularly recommended for an art class, where students and teacher can divide a roll and share costs.

TO STRETCH OR NOT TO STRETCH?

Before starting to paint, you face an immediate question: whether to stretch or not to stretch the paper. This is an important issue bearing on equipment, technique, and esthetics, and one on which artists have opposing views. After listening to the arguments, you may, like Hamlet, have difficulty making up your mind, because there are advantages either way.

Stretched paper is a nuisance to prepare, but it is a surface that—however much scrubbed, sponged, and pummeled—will spring back to drumhead tautness when dry. For a perfectly smooth finish, finely detailed lines, or wet-into-wet techniques, stretching is necessary and well worth the trouble. The tape or tacks used in stretching, however, destroy the original paper edge, and when the painting is finished, it must be matted. Presenting a watercolor in this way, with the picture running under and behind a framing window (sometimes with an indeterminate outer boundary that could be changed by a different mat), is a Renaissance device favored by conservative painters. Modernists, on the other hand, often prefer to exhibit a watercolor as an "object," like a tapestry or embossed print, complete with deckled edge and naturally rippled surface.

Unstretched paper, in contrast, requires no preparation and has a handsome physical presence undamaged by stapling or trimming. This is my own preference, and I exhibit watercolors mounted in front of a linen backing, or suspended within a mat rather than cut off by it. Not having to stretch makes for a more easygoing experience, in which you can walk into the studio and go to work without preliminaries. The one drawback is that unstretched paintings, even on heavy stock, sometimes become excessively warped. Now, with the discovery of devices for smoothing out wrinkles after your painting is finished, even that drawback can be eliminated.

METHODS OF STRETCHING PAPER

Here are three basic stretching techniques, each of which is designed for a particular situation. If you decide to stretch your paper, consider its size, weight, and what you will use it for, and then select the process which is most appropriate.

1. *Stretching with tape on plywood or a drawing board* is a neat, simply executed process for small papers in the 16 × 20-inch range. Although some artists, like Don Nice, use it for huge watercolors, this is tricky, and I do not recommend taping for large work. More often than not, shrinkage will be so great that the paper will pull loose before the gummed tape has had time to set.

 Proceed by penciling a 1-inch margin around the paper as a guide for the tape. Next, wet both sides of the sheet briefly with a sponge, faucet, or a dip in the tub. Then lay it on the board to expand for ten minutes, and remove excess surface water with a towel. As an added precaution, the 1-inch border may be further dried with a blotter. Now cut strips of 2-inch wrapping tape—the brown-paper kind with a water-soluble gum backing. Moisten each strip with one stroke of a sopping-wet sponge, so that the glue side is evenly wet and the back dry. Apply the tape half on the paper and half on the board. Press down firmly and rub repeatedly for several minutes. The paper must dry in a horizontal, not vertical, position. After the painting is completed, cut it from the board with a mat knife.

2. *Stretching over wooden canvas supports* is a rough-and-ready method with advantages for students in an art class. Open to the air on both sides, the paper dries in minutes. Very little work is involved, and the apparatus is inexpensive and lightweight. Standard 22 × 30-inch paper fits over a 20 × 28-inch canvas stretcher with a 1-inch border all around, and other dimensions with similar margins may be used.

 Since the paper will be stretched like a drum, a pencil point might puncture it, so complete your preliminary drawing first. Then soak the paper thoroughly in a tub for ten minutes, lay it down with the slightly smaller stretcher on top, and fold up the extended sides. Fasten one side at a time with thumbtacks at 2- or 3-inch intervals, and fold in the corners. Push in the tacks diagonally, with only one edge against the paper, for easy removal later. Once dry, the paper is a taut surface that will soften as washes are applied and then tighten up again.

3. *Stretching with a staple gun on plywood* is the most dependable method of stretching large watercolors. The paper will tighten up for fine details but take any amount of soaking, drying out, and rewetting during the painting process.

 Charles Schmidt suggests covering a piece of ³/₈-inch plywood with colorless polyethylene plastic folded around and stapled on the back. This keeps the paper's underside clean and prevents harmful substances from leaching out of the plywood. Next, soak the paper thoroughly in cold water, staple it to the plastic-covered plywood with tack points about 1¹/₂ inches apart and ¹/₄ inch from the edge. Dry the paper horizontally, to prevent tearing or wrinkling, and if there is some slight ripping away from the

staples, a few new ones can be driven in halfway between the others. When the picture is finished, do not cut it off with a mat knife, as you would if it were taped. Instead, remove all staples with a thin screwdriver and needle-nose pliers, so that the plastic sheeting will be intact for future use.

Joseph Raffael's technique is similar, but instead of using plastic sheeting, he coats the plywood with polyurethane varnish. And because he works with extra-large paper that becomes greatly expanded when wet, he removes excess moisture by pressing it between large white blotters. Before stapling, he applies brown gummed wrapping tape to carefully penciled borders. The gummed tape will not hold by itself, but it keeps the edges flat, and staples driven through the double layer of tape and paper hold more firmly than in paper alone.

Tips on Handling Paper

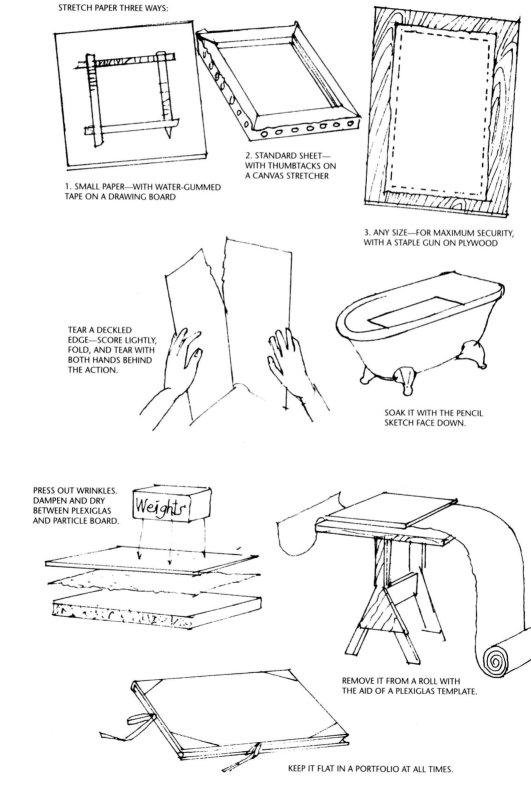

STRETCH PAPER THREE WAYS:

1. SMALL PAPER—WITH WATER-GUMMED TAPE ON A DRAWING BOARD

2. STANDARD SHEET— WITH THUMBTACKS ON A CANVAS STRETCHER

3. ANY SIZE—FOR MAXIMUM SECURITY, WITH A STAPLE GUN ON PLYWOOD

TEAR A DECKLED EDGE—SCORE LIGHTLY, FOLD, AND TEAR WITH BOTH HANDS BEHIND THE ACTION.

SOAK IT WITH THE PENCIL SKETCH FACE DOWN.

PRESS OUT WRINKLES. DAMPEN AND DRY BETWEEN PLEXIGLAS AND PARTICLE BOARD.

Weights

REMOVE IT FROM A ROLL WITH THE AID OF A PLEXIGLAS TEMPLATE.

KEEP IT FLAT IN A PORTFOLIO AT ALL TIMES.

HOW TO FLATTEN A WATERCOLOR

Flattening a watercolor, in order to remove wrinkles and buckling, is a simple process few artists know about. This is unfortunate, because watercolor paper expands unevenly as one area becomes wetter than another, and painters often exhibit lumpy work without realizing how much it might be improved by a few days under weights.

To restore its original flatness, the whole sheet must be dampened, allowed to expand, and permitted to shrink back slowly and evenly under pressure. There are various ways to do this. Elizabeth Osborne uses a system she learned from museum conservators, involving masonite sheets, blotters, and felt pads. The method I have invented is simpler and equally dependable.

Obtain a sheet of 1/8-inch Plexiglas and a piece of 3/4-inch particle (or flake) board, with both cut to a size that leaves at least a 3-inch margin around your paper. (I put 22 × 30-inch student paintings in a 28 × 36-inch flattener, for example, and I have a larger one at home for my

own work). Lay the particle board on the floor, where it will serve as the bed of the "press," and place the Plexiglas on a table with your finished watercolor face down on it. While holding the paper firmly, moisten the back for a good ten minutes with repeated applications of a square-cut synthetic sponge. When strokes are kept 1/4 inch from the paper's edge, the sponge won't wet the Plexiglas, but if a little moisture creeps around to the front of the picture it will evaporate later without damage. Next, lay the picture dry side up on the particle board and blot any visible moisture lightly with facial tissue. Then cover the painting with the Plexiglas, add evenly spaced piles of books or other weights, and let it stand for several days. The porous particle board absorbs water slowly from the back without noticeable dampness penetrating to the floor. Weather and furnace heat determine drying time, and sometimes one removes the painting too soon, before it is bone dry. If rippling recurs, just repeat the process.

TEARING, DECKLING, AND SOAKING PAPER

Tearing watercolor paper, instead of cutting it, produces a soft, natural edge that is compatible with its linen-like texture. This is important for the artist who paints out to the edge instead of using a mat. It is particularly helpful when a paper must be split into half-sheets; the torn edge will then be compatible with the other deckled sides.

The following procedure is recommended: Draw a lightly ruled pencil line on the reverse of your paper, score along the line with a mat knife, barely cutting into the surface, and then fold along this line, sharpening the ridge with a thumbnail or ruler. At this point, the heaviest paper can be torn with confidence, provided that you know the trick of moving both hands back as you go, so they are always between you and the point of the tear. In taking paper from a roll, a large rectangle of Plexiglas is most helpful: when laid on the stiffly curved paper, it flattens it onto the table, provides a template for ruling dimensions with an assured right angle, and serves as a firm support against which to tear off the piece you want.

Making an artificially deckled edge may be preferable to tearing one if you are painting a large watercolor on heavily deckled stock. I often change the proportion of a 40 × 60-inch sheet by trimming one edge and deckling it to match the others. Carolyn Brady sends her oversize watercolors to a framer who deckles all four sides along a penciled line she determines after the picture is finished.

My own procedure is as follows: First, draw the desired edges with a lightly ruled pencil line (to be erased later). Then draw a 3/8-inch border with a second line and trim the paper to this outer shape with a mat knife.

Next, lay the paper face up on a drafting table with the *inner* line lined up along one edge of the table. Now, with an ordinary pair of pliers, begin to take nips out of the 3/8-inch overhanging paper, aiming each time not for the penciled line but a spot about 1/8 inch outside it. You will find this easy to do and not at all risky, because the nose of the pliers hits the drafting table and can't go any farther. With an easy tearing rhythm, make many small, closely spaced nips to avoid a coarse-looking deckle.

Soaking the paper is required if it is to be stretched or painted in wet-into-wet technique. A home bathtub accommodates standard flat sheets or oversize paper rotated in a loop. In a school situation, a plastic photographic or printmaking tray large enough to hold 22 × 30-inch paper is needed.

The process is simple, yet there are a few refinements. Your pencil drawing, for instance, should be done in advance and placed in the water face down so that it cannot have any of the less saturated spots that might develop on the floating top side. Though the rule is to use cold water, you can safely speed things up with a lukewarm temperature. When paper is wet through and through, rather than merely on the surface, it appears translucent. This takes time, and I advise ten minutes in the tub for average paper and an hour for a 300-lb. sheet. The exact time doesn't matter so much if you plan to stretch paper, but for wet-into-wet painting, it is good to play it safe with a two-hour or even an overnight soaking. The longer paper sits in water beforehand, the longer it will stay wet while you work on it.

Watercolor Brushes

Nowadays grocers display caviar in a padlocked case, and my art supplier keeps Winsor & Newton's finest Series #7 red sable brushes—the type that sell for several hundred dollars in the larger sizes—in his safe. These are what professionals use, and a few years ago I would have advised you, too, to buy only top-quality brushes—the kind traditionally made by hand from Siberian kolinsky sables, with the natural curve of each hair turned toward the point rather than pressed into position.

But times change, and inflation has put both Russian caviar and kolinsky sable brushes "out of sight" for most of us. Fortunately, manufacturers have come up with serviceable alternatives. These include *inexpensive sables* made from less than top-grade fur; *sabelines* that mix in other kinds of animal hair; *synthetic* fibers, like Robert Simmons's White Sables; and *sable and synthetic blends*, as in the Winsor & Newton Sceptre line.

My recommendation is a sabeline or genuine sable in the smaller, less expensive sizes and a Winsor & Newton Sceptre brush—which I have had very good luck with—in the largest (#14) size. But whatever your choice, remember that it is better to buy one good brush than several that won't do the job. A bargain brush—the kind, for instance, that is included free in a set of colors—invariably loses its shape and turns to mush the moment you dip it in water.

You need three basic painting instruments: A large #12 or #14 round brush; a medium-size #6 or #8 round brush; and a broad, flat wash brush. There is no harm in trying some of the specialized brushes shown in art store displays—Oriental bamboo-handled styles, round-ended "mops," or squared-off lettering brushes. In practice, however, you will do 90 percent of your work with a good-quality, large round brush that comes to a point, holds a generous amount of fluid, and springs back into shape after each stroke. This is an all-purpose tool that produces fine lines as well as juicy strokes. Occasionally you will need the smaller round brush for details. And open spaces like a sky or a wall are best laid in quickly and smoothly with a wide, square-ended wash brush. This brush is also used at the start of a picture to establish general tones that will be painted over later. Expensive wash brushes are available, but an ordinary 1-inch housepainter's brush from the hardware store will do just as well.

Good brushes thrive on tender loving care. Some of mine are ten years old and still going strong. There are only a few care guidelines, but as in caring for teeth, they must be followed regularly:

1. Wash your brush in warm water and Ivory soap after each use. Then shape the point with suds to hold the hairs in position when dry.

2. Avoid using it for acrylics, ink, or any other medium.

3. Don't let it stand in water, because the wooden handle will swell and the point may be blunted. Instead, lay your brush on the table when not in use or put it in a jar bristle-end up.

4. When carrying brushes in a case, attach them with a rubber band to a slightly longer stick to prevent the tips from hitting the box.

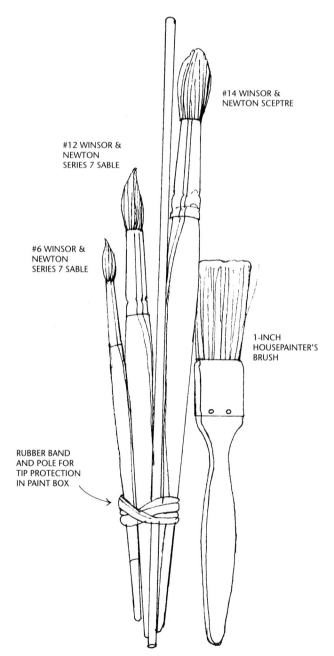

#14 WINSOR & NEWTON SCEPTRE

#12 WINSOR & NEWTON SERIES 7 SABLE

#6 WINSOR & NEWTON SERIES 7 SABLE

1-INCH HOUSEPAINTER'S BRUSH

RUBBER BAND AND POLE FOR TIP PROTECTION IN PAINT BOX

The brushes I use, shown at roughly half of actual size.

Watercolor and Gouache

Transparent watercolors are made of finely ground pigment mixed with gum arabic, one of those natural products—like maple syrup, which also comes from a tree—that science has yet to improve on. A secretion of the acacia, gum arabic not only binds pigment to the paper when dry, but encourages color particles to float evenly suspended in water. A distinctive feature is that, unlike most mediums, gum arabic remains forever soluble. Thus you can soften and reuse dried paint on your palette, or wash down a picture with a sponge and start over again. (I often sponge out a small area or object I don't like, let it dry, and then repaint it). It is also a considerable advantage that the paint on your brushes remains soluble. If cleaning is delayed, they won't be ruined, as would be the case with acrylics, India ink, or gouache.

Watercolors are available in two forms: moist tube colors and solid cakes (or pans). The latter are conveniently packed in a neat tin case you can tuck in your vacation suitcase, but cakes dissolve more slowly and tend to produce paler washes than pigments squeezed from a tube. Most professional artists prefer tube colors, although there are exceptions. Philip Pearlstein, for instance, likes to work with one cake color at a time in a neat little pan. In any case, dry colors invariably inhibit the beginner, and I urge you to start with moist tube paints. Mastering watercolor is like surfing—a matter of developing ease and expansiveness.

For this reason, I favor generous brushes and paint squeezed out "at the ready" in a creamy mix.

Gouache is widely misunderstood as simply an "opaque" version of the watercolor medium. Actually, modern gouache (also called designer's color) doesn't have the same gum arabic base. Instead, it is a versatile medium that, like acrylic, can be used either opaquely or in thin, transparent washes. Transparent painting is possible as long as you avoid colors mixed with white. When a selection of gouaches is matched color for color with your watercolor palette, washes in the two mediums are of equal transparency. In my classes, when students put up work in both mediums for a critique, no one can distinguish between them.

If the effect is so similar, why use gouache instead of watercolor? One reason is that it has a binder that sets when dry. Afterward, you can wipe off spills and splatters with a damp sponge, and whereas a watercolor would dissolve, the picture can even be remoistened in a tub without disturbing the image. Gouache also has advantages for designers and illustrators: Gradations are more mechanically perfect, the process of layering overlaid washes won't dissolve what is underneath, and tiny strokes maintain their sharpness. But while gouache is an occasionally useful alternative, it lacks the puddly, drippy, sensuous quality of true watercolor. So by all means see what you can do with the classic medium of Homer and Cézanne before considering other options.

Your Palette—A Word with Double Meaning

The word *palette* has two basic meanings: It is the board or slab on which artists lay out their colors, and it is also the selection of pigments that one might prefer.

In either sense of the word, a choice of palette is significant. Some artists need a spacious work surface, while others work neatly within the dimensions of a shoe box. One painter achieves profundity with a few tones; another, excitement with every color in the spectrum. My advice for the beginner is to be generous on both counts: get yourself a big palette, and play with lots of colors. You can always cut back after you have explored the full range of possibilities.

For a palette to mix paints on, a 12 × 16-inch cookie sheet is an excellent choice. This comes in white Teflon or plain metal with a little turned-up rim. As permanent studio equipment, I prefer a 24 × 30-inch sheet of plate

glass, but portability is important in many situations, and you can tuck a cookie sheet under your arm or toss it in the car with the greatest of ease. An advantage in either case is that colors are squeezed onto a flat surface, rather than into little pockets that collect water. There is also ample mixing space that can be sponged or rinsed off, when you clean up, without disturbing the reusable colors along the top and the side.

Art-store palettes, in contrast, are elaborate, heavily molded with indentations like a TV-dinner tray, and usually too small. If you want to splurge, get a professional palette, but look for something generously proportioned like Martha Mayer Erlebacher's plastic tray. And note how the artist has simplified the central space, which originally had four compartments, by inserting a single piece of glass that can be removed for washing.

Recommended Colors

In a perfect world, you would need only three tubes of paint—red, yellow, and blue—because theoretically everything else is a mixture of these primary colors. Unfortunately, however, combining pigments diminishes their brilliance, and the orange you mix with red and yellow is less intense than one squeezed from a tube marked "Orange." Fine-arts pigments have little to do with perfection, in any case. They are oddly assorted substances—made from metals, synthetic compounds, and natural earths from historic places like Umbria and Siena—that artists value for their permanence and distinctive character.

Thus an artist's palette of colors isn't an evenly calibrated affair like the rainbow hues in a set of poster paints. Instead, it is a highly personal collection of warm and cool or bright and dull pigments that reflects the artist's taste. And like other collectors, painters tend to fall into three groups: minimalists, those with a taste for abundance, and those who prefer a workable but not overly extensive selection.

"Less is more" is a famous art axiom, and its followers use what is known as a *limited palette*. Neil Welliver, for instance, limits his palette to seven or eight colors, and Charles Schmidt creates subtle effects with only three or four. One typical Schmidt scheme consists of cadmium red light, Indian red, ivory black, and Payne's gray; another is of ultramarine, burnt umber, and raw umber. Martha Mayer Erlebacher's palette of forty-six pigments is the opposite extreme. While Schmidt paints subtly-toned weatherbeaten surfaces, Erlebacher's interest in painting vivid still life objects accurately requires as many as six or seven versions of each hue. Not surprisingly, most watercolorists prefer something in between—a palette that is neither comprehensive nor minimal. Don Nice's, for example, includes eleven colors; Philip Pearlstein's, seventeen.

This is an appropriate range for the beginner, who should start with a dozen or so tube watercolors and consider impulse-shopping later on. Certainly you will need this broad a selection if you are to include neutral earth colors, gray, and more than one version of some spectrum hues. Since there is no one "true" red, the painter must have both a purplish alizarin and an orangey cadmium red, and the same principle applies to greens and blues. Here, then, are my recommendations for your initial palette:

- 1 GRAY (optional): *Payne's gray, Davy's gray, or neutral tint.* The inclusion of gray is a matter of personal taste. My neutrals are a mix of blues and burnt sienna. Payne's is a cool gray used by many artists, Davy's is a warm slate gray, and neutral tint is a balanced tone.
- 1 VIOLET: *Pthalo violet or cobalt violet.* Phthalocyanine colors are may be labelled either phtalo, Thalo (the Grumbacher spelling), or by a brand name like Winsor. They are very intense, and cobalt violet is a milder alternative.
- 2 BLUES: *Cerulean, plus permanent blue or ultramarine light.* Cerulean is sky blue; the others are inkier.

The ultramarines— brilliant, French, light, and deep— are modern imitations of the original lapis lazuli that is still available for a price as ultramarine genuine.

- 2 GREENS: *Viridian or pthalo (Winsor) green, plus sap green, Hooker's green light, or Winsor emerald.* The first two are dark bluish greens; the second group are lighter and warmer. For an additional dull green, you might try chromium oxide or terre verte.
- 1 YELLOW: *Cadmium yellow medium.* One medium yellow will suffice, but if you can afford it, a pairing of cadmium pale and cadmium deep—one with a twist of lemon, the other with a hint of orange—is better.
- 1 ORANGE: *Cadmium orange.*
- 2 REDS: *Alizarin crimson or cadmium red deep plus cadmium red medium or cadmium red light.* The first group are purplish reds, but the second red must be a bright geranium hue that is hard to find. Study the manufacturer's charts and see if a salesperson will remove the cap to show what you are buying.
- 2 EARTH COLORS: *Burnt sienna and raw sienna.* Reddish burnt sienna and leather-tan raw sienna are the most transparent earth colors, although Venetian red and yellow ochre are also useful.
- NOT RECOMMENDED: *Chinese white and ivory black.* To master transparent watercolor, you must give up opaque white. And though you may want to add black later, it is best to learn how to mix optical blacks with other colors at the outset.
- TOTAL: *A palette of eleven or twelve colors.*

When you are ready to paint, it is important to squeeze your pigments onto the palette in a logical, rather than a random, order. After a work session, leftover paint remains in place for future use. Since the arrangement of pigments becomes fairly permanent, it should be a sensible one, so that you can reach for a particular color with an assured, automatic gesture. The above listing of pigments—a sequence from gray and cool spectrum colors to warm hues and earth browns—suggests the kind of order you might use.

Meanwhile, the mixing area on your palette has to be cleaned regularly. With a small palette like Erlebacher's, this is done with a sponge or tissues. A large glass palette or cookie sheet, however, should be laid out with colors only along the top and one side, so that it can be rinsed under a faucet. In either case, the leftover colors remain undisturbed and become dried-out cakes between sessions. A helpful before-breakfast ritual is to soften yesterday's paint by moistening it with an atomizer or laundry spritzer. Later, add dabs of fresh paint where needed, and you are ready to go to work.

Finally, two small warnings: *Tube colors must be rolled up from the bottom* or paint will squirt out the back seam. To avoid a sudden spurt, this must be done after each use rather than just before removing the cap. Also remember that, to avoid tearing the tube, *a cap that is stuck should be expanded by heat instead of forcibly twisted.* Apply hot water or match flame until it turns easily.

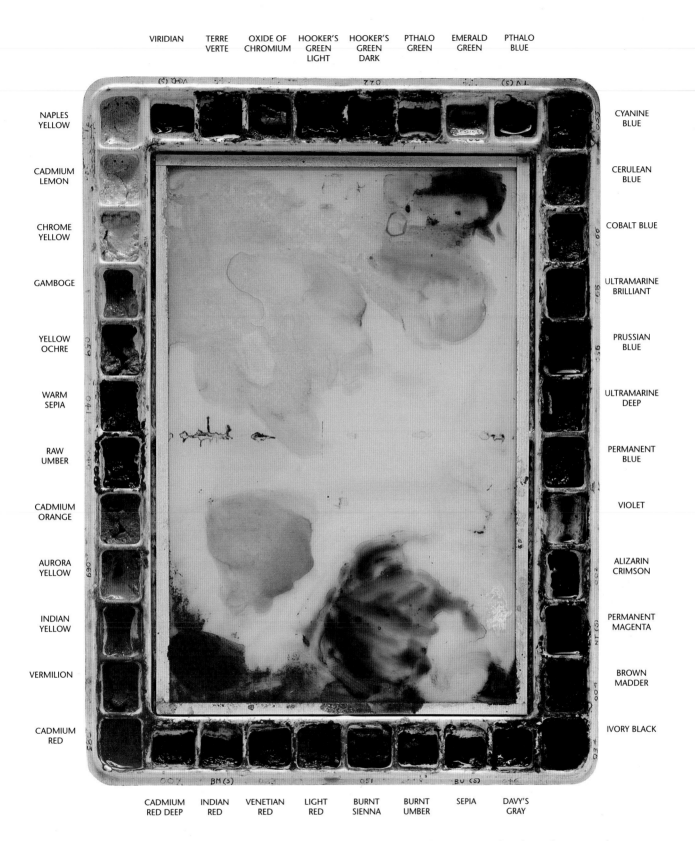

VIRIDIAN TERRE OXIDE OF HOOKER'S HOOKER'S PTHALO EMERALD PTHALO
 VERTE CHROMIUM GREEN GREEN GREEN GREEN BLUE
 LIGHT DARK

NAPLES YELLOW — CADMIUM LEMON — CHROME YELLOW — GAMBOGE — YELLOW OCHRE — WARM SEPIA — RAW UMBER — CADMIUM ORANGE — AURORA YELLOW — INDIAN YELLOW — VERMILION — CADMIUM RED

CYANINE BLUE — CERULEAN BLUE — COBALT BLUE — ULTRAMARINE BRILLIANT — PRUSSIAN BLUE — ULTRAMARINE DEEP — PERMANENT BLUE — VIOLET — ALIZARIN CRIMSON — PERMANENT MAGENTA — BROWN MADDER — IVORY BLACK

CADMIUM INDIAN VENETIAN LIGHT BURNT BURNT SEPIA DAVY'S
RED DEEP RED RED RED SIENNA UMBER GRAY

Martha Mayer Erlebacher's "maximum" palette. You will want to start with a dozen or so colors from this comprehensive list and explore others as your work progresses.

OTHER EQUIPMENT

Like a chef in a well-stocked kitchen, the watercolorist relies on various incidental supplies and equipment. Some standard items are noted without description in the shopping list at the end of this chapter. Others need explanation:

Pencils are crucial, and they must be just right—neither so soft as to dirty the paper, nor so hard as to dig into it. A 2B is suggested, but the standard is variable in different brands, and touches vary. So discover what is best for you, keep it at hand, and always sharpen the unmarked end.

The water jar must be capacious, and some artists use two—one for rinsing the brush and one for clear washes. A wide-mouthed quart pickle jar is an excellent choice.

A *portfolio* is essential, because both your paintings and paper supply should be kept flat at all times to prevent buckling. For carrying work about town, a professional portfolio complete with waterproof cover, handles, and zipper is recommended. For home or studio use, you can assemble a do-it-yourself foamcore folder in minutes for a song. Foamcore is a rigid styrofoam stiffener that comes in 4 × 8-foot sheets. Simply cut two pieces to the size you want with a mat knife, lay them side by side, make a hinge of Mystic cloth tape (applied above and below the seam), and—presto!—a portfolio. I keep several on hand, for large and small papers, and use metal spring clips as a closing device.

A *Turkish towel* can be surprisingly helpful. Keep one on your lap so that, after laying a wash and allowing fluid to settle, you can squeeze the bristles dry on the terry cloth and then use your brush to suck up the excess liquid on your paper.

A *supply kit* won't improve your work, but it is a great convenience. Professional kits are equipped with snap-locks, handles, and suspended trays for paints and brushes, but a standard fishing-tackle box offers the same features at less cost. Whatever your choice, be sure it will hold everything except your water jar and sketch block (or paper tacked to a drawing board). On a sketching trip, you should have no more than three things to carry.

Sponges are needed for both palette clean-up and paper dampening. Square-cut synthetic sponges are best, and you need two—one to be kept clean and one for dirty work. Some artists also use a small natural sponge as a painting instrument, either for putting on soft washes or for premoistening areas to be filled in later with a brush.

Transfer paper with a graphite coating is recommended for anyone who works from a drawing. It is often best to work out a difficult composition in pencil on tracing paper and then transfer it lightly to your watercolor paper so that your painting surface will be undamaged by smudges or pencil-point indentations.

Finally, a *drawing board* or other support for your painting must be obtained. A drafting table at school or a rigid sketch block, if you work at home, may be sufficient at the outset. Eventually, however, you will want to work larger or with wet paper that requires a firm backing board. This must be big enough to accommodate standard 22 × 30-inch paper with margins all around. Unfortunately, the drawing boards sold in art stores are often small and unsubstantial. Thus you may have to devise something for yourself. These are the main alternatives:

1. *Plywood* of a 3/8-inch thickness, cut to order at a lumberyard and then coated with synthetic waterproof varnish. Paper is attached with thumbtacks or masking tape.

2. *Fiber board,* such as Homosote, also cut to order at a lumberyard, takes tacks but is too soft for tape, and it has the disadvantages of heaviness and a rough outer edge. Nancy Hagin minimizes the weight problem by making a handle near one edge with a jigsaw cut-out that she can put her fingers through. Sondra Freckelton treats the edges in an elaborate but interesting way. She frames Homosote panels (in various sizes to fit different paintings) with 1 × 2-inch wood stripping, and she hangs them on the wall from time to time in order to study work in progress.

3. *Plexiglas,* or transparent acrylic sheeting, of 1/8-inch thickness. This is commonly carried and cut to order by lumberyards, glass suppliers, and hardware stores—otherwise, check "Plastics" in the Yellow Pages. Attach paper with spring clips or lay it down loose, as I do, on a drafting table tilted so that it won't quite slide off. I also sandwich paintings between two Plexiglas sheets after each work session. This inhibits buckling and permits the watercolor to be studied "under glass" as it will appear later when framed. Furthermore, acrylic sheeting is rigid enough to provide support beyond the edges of your usual work surface. Thus it is ideal for large work. On a 30-inch table, for instance, you can use a Plexiglas sheet cut to fit 40-inch watercolor paper with 10 inches extending over the sides.

4. *Foamcore,* purchased at an art store, can be cut to the desired shape with a mat knife. This might seem an overly fragile possibility, but Philip Pearlstein uses it for 40 × 60-inch watercolors, which he paints at an easel in an almost vertical position. It is even more feasible for small-scale work. Simply cut the foamcore to the exact size of your paper and attach the latter with spring clips. Keep several boards on hand, discarding them when bent.

YOUR SHOPPING LIST

Everyone has something old, borrowed, or blue to add to watercolor gear, whether it be leftover colors, a baking pan that might do for a palette, or merely pencils and erasers. So check your holdings against the list of basic supplies listed below:

ESSENTIALS

- **Paper** — Artist-grade cold-press 140-lb. 22 × 30-inch watercolor paper or an 18 × 24-inch block of similar quality.
- **Brushes** — One #12 or #14 round Winsor & Newton Sceptre watercolor brush; one #6 or #8 round Sceptre or sabeline watercolor brush, and one 1-inch flat housepainter's brush
- **Palette** — A 12 × 16-inch cookie sheet or a large professional palette
- **Pigments** — Eleven or twelve tubes of moist watercolors
- **Water jar** — Quart-size glass or plastic container
- **Pencils** — Venus 2B or equivalent
- **Eraser** — Nonstaining white vinyl or Art Gum
- **Sharpener** — A small hand unit is satisfactory
- **Masking tape** — Use ¹/₂-inch width only

- **Sponges** — Two square-cut cellulose sponges
- **Thumbtacks**
- **Ruler**
- **Ivory soap**
- **Facial tissues**
- **Turkish towel**

USEFUL EXTRAS

- **Atomizer**
- **Drawing board**
- **Gummed tape** — 2-inch brown paper wrapping tape
- **Mat knife**
- **Paper flattener** — Matching sheets of Plexiglas and particle board
- **Portfolio** — Professional or handmade foamcore folder
- **Spotlights** — Two clamp-on spots with 150-watt reflector floodlights
- **Spring clips** — Two of 3-inch width
- **Staple gun**
- **Supply kit** — Fishing-tackle box or artists' supply kit
- **Transfer paper** — Graphite-coated only

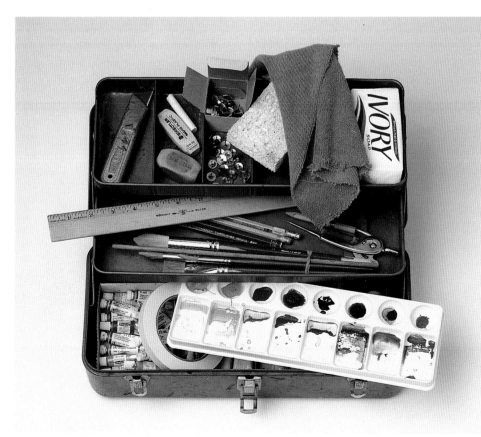

My "compleat" paint kit: A fishing-tackle box that holds everything except sketch block and water jar.

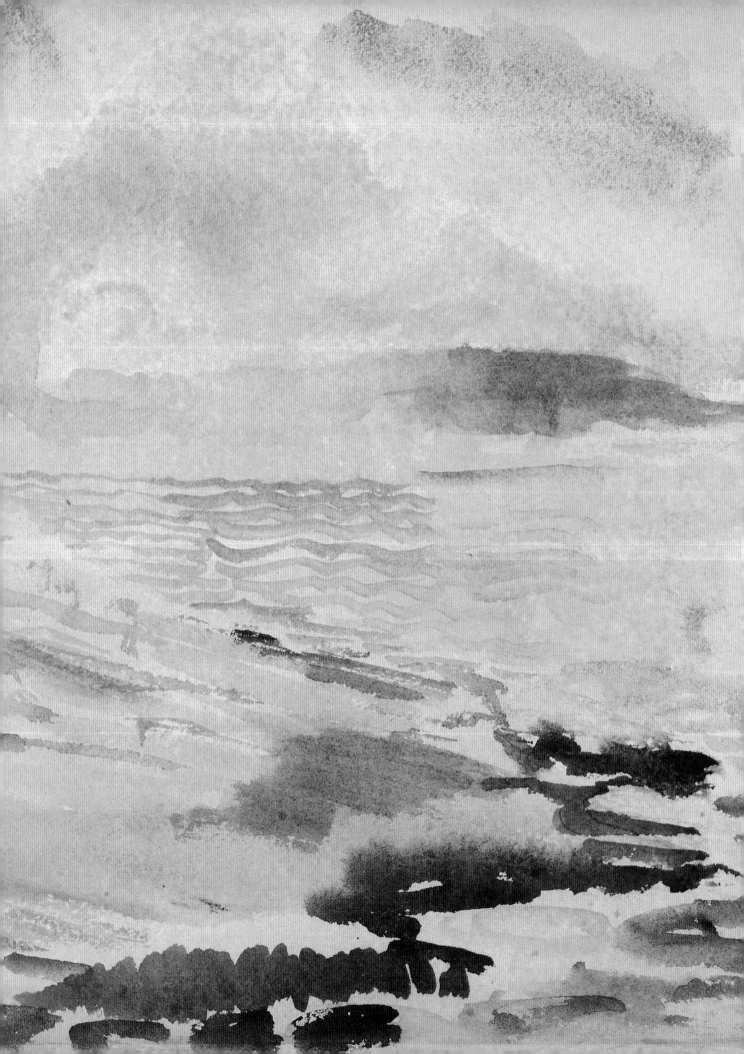

MAY 1994

AMERICAN ARTIST®

BOOK CLUB

ADVERTISING SUPPLEMENT TO AMERICAN ARTIST

INSIDE:

The Art of
Watercolor

Revised Edition
Charles Le Clair

**AND THE LATEST
ON COLOR FROM
HILARY PAGE**

THE LAYERED IMAGE

In these paintings, Dewey builds images with flat washes painted across the page in layers—as if each new color were on a separate plastic film laid over the others. Note the variety of effects that can be achieved with the same strategy. You can stop early on, as in the watercolor at right, or continue with more and more washes, as in the painting at far right.

David Dewey, *The Tower,* 1982. Watercolor, 60 × 40" (152.4 × 101.6 cm). Courtesy Tatistcheff Gallery, New York.

David Dewey, *Light Brown Victorian,* 1982. Watercolor, 42 × 30" (106.7 × 76.2 cm). Courtesy Tatistcheff Gallery, New York.

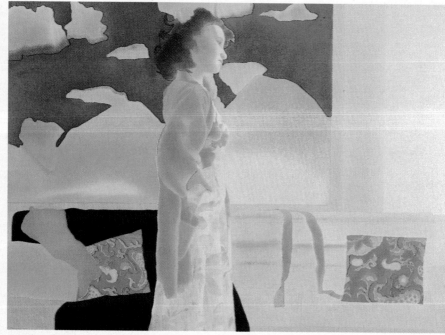

Elizabeth Osborne, *Nava in Blue Robe,* 1982. Watercolor, 30 × 40" (76.2 × 101.6 cm). Courtesy Marian Locks Gallery, Philadelphia.

PAINTING INTO PREMOISTENED AREAS

In the painting above, Elizabeth Osborne sharply defines the areas she works with. All visual elements—sofa cushions, dress patterns, the model's face and hair, and the sunlit clouds of a background landscape—are reduced to flat shapes bounded by immaculate pencil lines. Osborne carefully paints clear water up to her pencil lines and then floods color into the area, which will be contained until dry by capillary action.

LIGHTING THE SUBJECT

Shadow patterns can shape a colorful subject. The painting at right is cleverly pulled together by shadows and shiny white highlights that move through the composition, shaping the subject matter and creating shadows as intense as the subject itself.

HOW TO ORDER: *Mail the order form or call toll free 1-800-ART-TIPS*

Learn how to paint by studying the techniques of master watercolorists

THE ART OF WATERCOLOR

Revised Edition
Charles Le Clair

Now available in a new, full-color edition, this classic text covers every aspect of painting in watercolor. It begins with lessons on such basics as how to lay flat and graded washes on wet or dry paper; how to master value and color; how to set up a still life and develop a composition, and how to paint wet-into-wet. Then it covers special effects and advanced techniques using drybrush, salting, lifting, scraping, masking, spattering, and collage.

But what sets *The Art of Watercolor* apart from other watercolor instruction books is its interweaving of studio lessons with art history. You'll discover how a master watercolorist—John Singer Sargent, Paul Cézanne, Charles Demuth, Wassily Kandinsky— applied a particular method in an illustrated work. You'll also learn how the different styles of watercolor painting developed as these and other masters invented specific techniques to meet their artistic goals. Contemporary applications of these techniques are also illustrated in exciting works by such artists as Andrew Wyeth, Janet Fish, Philip Pearlstein, and Neal Welliver.

In addition, *The Art of Watercolor* explores the three main areas of still life, landscape, and figure painting, making it a complete watercolor resource that you will refer to again and again. Whether you are a professional artist, teacher, or hobbyist, you will find that it is the most informative and enjoyable book of its kind.

#002918. Cloth. 144 pages. 130 full-color illustrations. 10 b&w illus. Publisher's Price $29.95. **Club Price $23.95. SPECIAL PRICE $20.95!**

Special price is good for a limited time only—we must receive your order by May 31, 1994.

ABOUT THE AUTHOR

Charles Le Clair *is a nationally known painter and teacher who was dean of the Tyler School of Art in Philadelphia from 1960 to 1974. He is also the author of* Color in Contemporary Painting *(listed below).*

SAVE 30%!

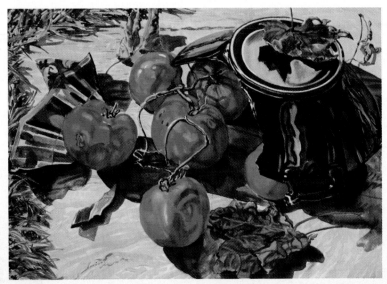

Janet Fish, *Bowl of Tomatoes—Broken,* 1988. Watercolor, 22³/₄ × 30" (105.4 × 76.2 cm). Courtesy Robert Miller Gallery, New York.

Cover: Charles Le Clair, detail, *Painting Flowers,* 1988. Watercolor, 46¹/₂ × 34¹/₂" (118.1 × 87.7 cm).

THE BOOK OF CROSS-STITCH
Gail Lawther

GOUACHE FOR ILLUSTRATION
Rob Howard

Whether you want to add opaque effects to your watercolors or use gouache as a primary medium, you'll find the help you need in this book, which presents all the basic techniques for handling the medium. Of special value is a mini "consumer's guide" comparing different brands of gouache, as well as a series of tests you can use to evaluate paints and brushes. **#021653.** Paper. 144 pp. 150 full-color illus. 24 b&w illus. Publisher's Price $24.95. **Club Price $19.95.**

HOLBEIN GOUACHE
12-Color Set

Here's a chance to try the gouache that Rob Howard (author of *Gouache for Illustration*) ranks as the best on the market. In this set, you get 12 tubes (5 ml) of colors: carmine, flame red, permanent yellow, lemon yellow, yellow ochre, permanent green deep, emerald green, ultramarine deep, Prussian blue, burnt sienna, ivory black, and permanent white. **#096297.** Manufacturer's Price $29.00. **Club Price $23.20.**

THE PASTEL BOOK
Bill Creevy

In the most thorough, innovative book yet written about the medium, Bill Creevy covers not only traditional soft and hard pastels but also oil pastels and oil sticks. Artists who prefer soft and hard pastels will find expert instruction on all the basic techniques and many advanced ones. Those who enjoy experimenting with mixed media will find unusual ideas and media combinations to try. **#039021.** Cloth. 176 pp. 450 full-color illus. Publisher's Price $32.50. **Club Price $26.00.**

SENNELIER EXTRA SOFT PASTELS "À L'ÉCU"
12-Color Set

To introduce you to the luminous and velvety pastels in its top-of-the-line product, Sennelier has put together a special package featuring the most popular colors: white, yellow ochre, lemon yellow, cadmium yellow orange, helios red, carmine, black brown, viridian, leaf green, cerulean blue, sapphire blue, and ivory black. **#09698X.** 12-color set. Manufacturer's Price $49.95. **Club Price $39.95.**

With so many delightful cross-stitch projects to choose from, you're sure to find the perfect gift for every occasion in this book. More than 30 traditional and contemporary designs appear in color photographs that show how the projects look when finished. For special occasions you can make a cross-stitched birthday card, wedding photo frame, anniversary sampler, or baby blanket. Holiday projects include an Easter egg cozy and Christmas wreath. Plus, a full alphabet enables you to personalize your gifts. Each project is rated for "easiness" and "time to complete," and all the patterns are shown full size and in color. A final section presents patterns for borders and all-over designs that you can add to the projects in the book or use to create your own designs.
#005178. Paper. 128 pages. 60 full-color illustrations. 25 b&w illus. Publisher's Price $22.50. **Club Price $18.00.**

2 BASIC WASH TECHNIQUES

There is no more exhilarating sight than athletes cavorting in a pool, divers bouncing off the springboard, swimmers snorting bubbles in the crawl. Motions are rhythmic and effortless because marathon hours have been spent practicing efficient "form." So it is with watercolor. Anyone can splash around, but it's more fun when you learn some strokes. Therefore, we will begin by exploring basic strategies through a series of warm-up exercises.

The ways of applying watercolor to paper are as clearly different as the swimmer's backstroke and Australian crawl. And though several approaches may be combined in one painting, they are usually done as separately timed actions that require specific conditions: damp or dry paper, under- or overpainting, and so on. Fortunately, these techniques aren't too complicated and can be mastered, one by one, in a few practice sessions. What *is* difficult is learning to use them with clear intent in a painting. When you confront a nude, a tree at sunset, or an arrangement of Chianti bottles, there is so much to consider that it is often difficult to decide what to do. That's why it is good to have practiced basic wash techniques in advance, so that you will be able to determine the most effective strategy for the subject at hand.

Watercolor may be applied either to dry or to moistened paper. The two techniques—*wet-on-dry* and *wet-into-wet* painting—are quite different in effect and call for opposite ways of working. The dry method is bright and crisp, the wet soft and atmospheric.

JOHN MARIN
Detail, *Seascape, Maine*
(page 22)

Dry vs. Wet Paper Techniques

Just as there is no such thing as a "little" pregnancy, there is no "slightly dry" paper for the watercolorist. The surface is either damp or it isn't. Thus one method involves waiting patiently until the area you want to paint is dry (or using a hair dryer to speed things along), while the other calls for preserving wetness by working quickly and remoistening with an atomizer.

A comparison of Winslow Homer's *Natural Bridge, Bermuda* and John Marin's *Seascape, Maine* makes the distinction abundantly clear. The paintings are opposites in technique, yet otherwise they are quite similar. Both depict sea and sky against a foreground shore developed with light/dark contrasts and striated brushmarks. The 19th-century master Homer, however, captures the harsh glare of tropical sunshine with a realist's eye for crisp detail and clean-cut washes, whereas the modernist Marin gives us a more abstract interpretation of a misty New England morning with strokes that blot and blur on dampened paper.

In studying watercolor, one of these approaches must come first. Here, I am a firm believer in starting with the basic technique of working with a wet brush on dry paper, outlined in the next few pages. Watercolor requires equal measures of control and spontaneity. After developing confidence and a working rhythm, you will be ready to expand your range with wet-into-wet painting and the experimental processes described in later chapters. Those with a casual or recreational interest may want to plunge immediately into the adventure of soaking paper and watching colors run. For anyone willing to engage in sustained study, however, disciplined practice should come first, because—as in ballet, theater, or any of the arts—it provides the assurance needed for genuine freedom.

To begin, then, we will explore the basic grammar of watercolor. Your brushmarks will be distinct and measurable, in the sense that you will be able to attain a desired darkness, shape, or coloration. You will learn to build volumes, preserve lights, deepen washes in even gradations like stair steps and lay transparent colors over one another in effective combinations. These are the methods of artists as diverse as Sargent and Klee, and later you will find that many of these principles apply to wet-into-wet painting as well.

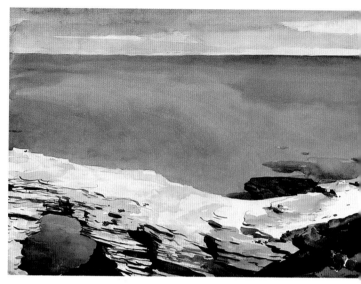

WINSLOW HOMER (American, 1836–1901)
Natural Bridge, Bermuda, ca. 1898
Watercolor, 14 × 21" (35.6 × 53.3 cm)
Metropolitan Museum of Art, Lazarus Fund

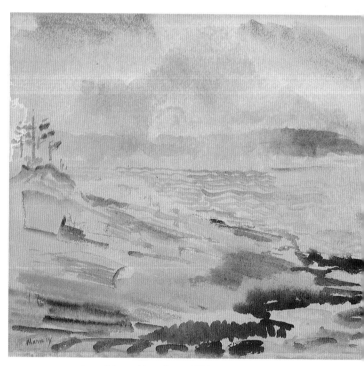

JOHN MARIN (American, 1870–1953)
Seascape, Maine, 1914
Watercolor, 14 1/8 × 16 5/8" (35.9 × 42.2 cm)
Philadelphia Museum of Art. Samuel S. White III
and Vera White Collection

THE FLAT WASH

Some handbooks distinguish between *washing* (on wet paper) and *glazing* (when the surface is dry). However, few watercolorists make this distinction when discussing their work, and the term *glaze* is more generally reserved for the kind of glossy overlayer found in resin-oil painting or ceramics. Therefore, we will simplify matters by talking only of washes here.

Learning to "lay a wash"—to paint a clean, smooth, flat, and evenly liquid tone—is one of the first skills you must acquire. Fortunately, it's as easy as neatly cracking an egg—a trick that long eluded me until I saw Audrey Hepburn do it in the movie *Sabrina*. She used a brisk down-and-up snap of the wrist, and all was made clear! So it is with laying a smooth watercolor wash—there's an easy trick to it. Follow a few simple principles (see illustration), and success is assured:

1. Work on an inclined surface. Tilt the drafting table slightly, or if you have a drawing board or sketch block, prop it on books. Remember that watercolors run downward, and there must be drainage in one direction if an even tone, without back-up puddles, is to be achieved.

2. Use the biggest brush you can handle. Fewer strokes mean fewer "seams" between strokes; and since a good round watercolor brush comes to a fine point, a surprisingly large one can be used in close quarters. For wide open spaces, use a flat wash brush or house-painter's brush.

3. Keep a juicy mixture of pigment and water ready. Some artists fill mixing cups in advance so they can flood the paper and thus prevent spottiness and irregular drying. The solution must also be strongly pigmented, for it is easier to dilute a strong wash than to beef up a weak one after you have started.

4. Begin at the top, work within marked boundaries, and let each stroke settle before continuing. Outline the wash area in pencil so that you will know where you are going. Make a broad, slowly brushed stroke at the top of the paper. After the fluid has settled, make a second and then a third horizontal mark, each time blending in the surplus from above. An irregular zigzag twist to the strokes makes transitions smoother and avoids a striped effect.

5. When the whole area has settled, remove excess fluid at the lower edge with the tip of a dry brush. You will discover that this acts like a miniature suction pump. I keep a towel in my lap, and the process of painting juicily, squeezing the brush dry on the towel and then using it to suck up excess fluid is a basic watercolor rhythm.

These are simple procedures, but they do run counter to one's instincts. The natural tendency is to work quickly, yet swiftly executed strokes leave bare spots or taper off to thin, fast-drying edges. The trick is to use *lots* of fluid and to work *very* slowly, remembering that the edges of your brushmarks won't dry as long as they are brimming with water.

Capillary action gives a fully loaded wash a certain stand-up thickness, like syrup. Thus, with enough fluid, there is plenty of time to reload the brush, decide how to enlarge the wash, and to shape it as you wish. If each stroke is slow and fully pressed down, the color will have time to flow into the paper's hills and valleys. Otherwise it will dry with bubbles of white and you will be tempted to go back and touch things up. Retouching almost inevitably makes matters worse. So learn to start at the top of a slanted board, pull the wash downward with successive horizontal strokes, and maintain a standing puddle that will be sucked up only at the last minute.

Laying a Flat Wash
OUTLINE THE AREA IN PENCIL.
USE LOTS OF FLUID AND LOTS OF PIGMENT.
MAKE HORIZONTAL, SLIGHTLY ZIGZAG STROKES.
LEAVE A STANDING PUDDLE AT ALL TIMES.
SUCK UP EXCESS WITH DRY BRUSH.

GRADED WASHES

In dancing, you learn a basic step and then begin to relax and "swing" with it. For the watercolorist, flat washes are like that—a basic vocabulary for creating an image with clear-cut planes. Yet in practice, variations are usually called for. Skies lose their depth, and shadows in a still life turn to cardboard if they are painted too mechanically. Thus the artist "swings" a little by using a *gradation* instead of a flat tone.

To illustrate, let's look again at Homer's *Natural Bridge, Bermuda* (p. 22), one of several watercolors that depict Bermuda's bizarre coastal formations, with the figure of a British soldier added to suggest their enormous scale. The master of a broad style, Homer creates the scene with a few distinctive shapes—a band of grayish sky, an undulating sweep of inky water, a sun-bleached ledge with a hole worn through by the waves, and a triangle of brown cliff. The basic scheme looks as flat as a poster, yet spatial depth is achieved by variations in each area. The eroded cliff is described in a linear style of separately drawn marks, but Homer treats the other areas as fluidly brushed washes. Each area is boldly shaped, yet subtly modeled. Look closely at how the sky is darkened at the top and streaked to suggest clouds, while the sea shades from rich ultramarine at the horizon to a lighter cobalt and then to a deep, smoky blue as it reappears under the stone bridge. Similar nuances animate the shoreline on the lower right, where the soldier's red coat adds a touch of color.

For a traditional painter like Homer, such modulations serve primarily as an enriching device, a means of heightening the illusion in a quickly executed sketch. On the other hand, in large-scale watercolors by such contemporaries as Joseph Raffael and Carolyn Brady, gradations are used for much more powerful effects. In Brady's *Emerald Light (Black Desk for Zola),* for example, dramatic shading is the dominant element in a composition that is essentially abstract, despite its surface realism. Ostensibly, the subject is an Eastlake desk, whose cluttered top and Japanese ornament are reminiscent of Emile Zola's desk in Manet's famous portrait of the French novelist. In a deeper sense, however, this is a painting about light itself—the poetry of reflections and shadows shifting from brilliance to blackness in passages created by virtuoso wash technique.

We see here that washes may be graded either from darker to lighter shades of the same color (as in the emerald lampshade), or from one hue to another (as in the shift from yellow to orange on papers scattered over the desk). Brady also combines these possibilities at the top of her painting, where black shadows mingle with amber lamplight and greenish echoes of the tinted lampshade. For the beginner, however, it is best to think of dark/light gradation and color modulation as distinctive techniques to be practiced separately.

Grading from dark to light is actually easier than making a perfectly even wash. In a large area, start with full color at the top and add more and more water to the strokes as you move down the page. If you want the bottom edge to dissolve into nothingness, make a stroke of clear water at the end and blot with tissue or suck it up with a dry brush.

Brady works this way, and unlike many artists who rely on slowly built up layers of washes, her transitions from virginal white paper to darkest dark are achieved, like an unbroken film shot, in a "single take." Typically, she starts with a fully saturated mixture of the deepest color and fades toward the lightest tone in a continuous passage that needs no retouching. Her watercolors are extremely large, however, and this technique requires a certain amount of space, since strong colors above must have room to drain into lighter areas below. Therefore, for abrupt transitions in tight spots, you may want to reverse the process. Start with a light stroke, add intense color beneath it, and water from above will run down

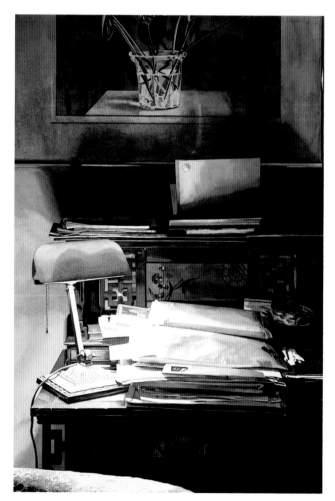

CAROLYN BRADY
Emerald Light (Black Desk for Zola), 1984
Watercolor, 60 × 40" (152.4 × 101.6 cm)
Courtesy Nancy Hoffman Gallery, New York

into a smooth middle-value blend. Finally, as you decide upon the shading you want, remember this: It is entirely kosher to turn the paper right side up, upside down, or sideways in order to get the desired effect.

Grading from one color to another is easy after you have learned to shade from dark to light. Simply add more and more of a new color instead of diluting the wash with water. Begin by mixing two distinct pigment solutions. Then make a broad stroke with one, follow with a blend of the two colors, and finish with a brush dipped only in the second hue.

In general, these shifts should be from a bright to a muted tone, to suggest sunlight and shade, or from one intense hue to another to achieve a radiant effect. *Analogous* colors—hues next to each other on the color wheel—make particularly luminous gradations. A tangerine, for example, is more vivid when blended with yellow and red-orange than when painted from a single tube. In nature, the redness of an apple ranges from warm vermilion to cool russet, and what we think of as sky blue is actually a chameleon tone that shifts from violet- to greenish blue.

Claude Monet discovered all this more than a century ago, and it is interesting that, among today's watercolorists, it is the more abstract painters who are interested in spectrum colors. Realists like Sondra Freckelton, Philip Pearlstein, and Janet Fish tend to emphasize the essential, or local, colors of objects. Fred Mitchell uses a neon-bright, kaleidoscopic palette in his abstraction *All the Way Across* (p. 84), and Joseph Raffael paints the white rose in *Summer Memory in Winter* in rainbow hues. This image of a giant blossom nearly 4 feet wide is a marvelous example of the iridescence that can be achieved with color gradations. We find the full spectrum here, but we also see that Raffael's color choices are controlled by a logical visual scheme—golden reflections from underneath the blossom, rose-violet light hitting the edges of the petals from above, and bluish shadows on their undersides.

Your questions about color gradation, then, will have less to do with the technique, which is simple, than with how many jazzy effects to get into. My advice is to try everything—experiment with all sorts of combinations and pull back to a more sober palette later if you wish. Remember that watercolor has a special affinity for luminous color because it is a transparent medium, and transparent things—flashing water, the glitter of glass—are perceived in terms of changeable hues.

GRADING FROM
DARK TO LIGHT

1. ADD MORE WATER TO EACH SUCCESSIVE STROKE.

2. LET SURPLUS SETTLE BEFORE CONTINUING.

GRADING FROM ONE
COLOR TO ANOTHER

1. PUT STRONGEST COLOR ON TOP—EVEN IF PAPER IS UPSIDE DOWN.

2. ADD MORE NEW COLOR TO EACH SUCCESSIVE STROKE.

3. FINISH WITH SECOND COLOR.

Graded Washes

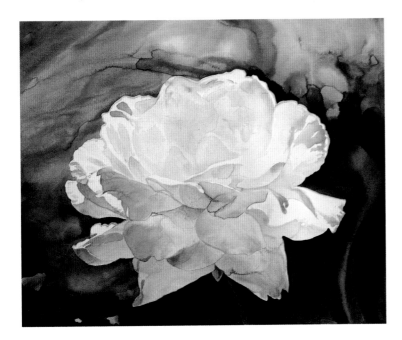

Joseph Raffael
Summer Memory in Winter, 1982
Watercolor, 44¹/₂ × 53"
(113 × 134.6 cm)
Courtesy Nancy Hoffman Gallery,
New York

Edge Shading

Dealing with edges is a key issue in watercolor. There is constant tension between the initial pencil lines and the more exuberant marks added by the brush. Neil Welliver calls it the "name of the game"—playing with a line, using it here, destroying it there. For an inexperienced person, however, reconciling lines and washes may seem a precarious balancing act, because one soon learns that too much fussing with edges dampens spontaneity, while painting without "guide" lines can lead to incoherence.

Basically, there are two ways of tackling the problem: by painting flat washes up to your penciled contours, or by using graded washes that fade away from these edges. The first strategy is illustrated by Mark Adams's *On East Brother,* the second by Charles Demuth's *A Red-Roofed House.*

In Adams's view of an idyllic island in San Francisco Bay, he charms us with simple blocks of solid color: tan buildings with brown and orange roofs, moss-green trees, violet sky. Demuth, on the other hand, avoids solid colors in favor of dramatically shaded planes that carve out lights and shadows in an atmospheric space.

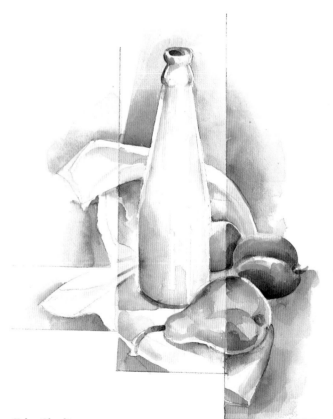

Edge Shading
1. BRUSH FIRM COLOR AGAINST PENCIL LINE.
2. ADD CLEAR WATER ON THE OTHER SIDE.
3. FOR MORE CONTROL, BLOT WITH TISSUE.
4. DEVELOP EDGE PATTERNS WITH DARK-LIGHT REVERSALS.
5. LEAVE A WHITE STRIP BETWEEN TWO DARKS.
6. BROADEN AND DEEPEN TONES WITH ADDED LAYERS.

You will find that the latter technique, called *edge shading,* is easily mastered. It involves no more than brushing a stroke of rich color against a pencil line, then dissolving the other side with a stroke of clear water that is sucked up by a brush or blotted into vagueness with tissue. This is essentially a graded wash done in a compressed space. But sudden transitions add drama, and Charles Demuth, the artist most closely associated with this technique, uses it with a number of creative refinements. In a typical work like *A Red-Roofed House,* for example, he achieves subtly varied, bubbly textures by sprinkling salt on washes while they are still damp (see Chapter 11). The artist also modifies certain areas by partially erasing or shaping them with a blotter. On the central red roof, for instance, the flat side of a small blotter has been used to lift off paint and lighten part of the area, while the blotter's thin straight-cut edge has been used to introduce a crisscross tile motif.

Reverse edge shading is an important corollary of this technique. Since the wash's function is to push one side of the pencil line back and the other forward, you must make a conscious choice between shading to the right or to the left of any given contour. Yet, as you proceed, there is usually a point at which you must change sides, or "reverse" the shading, in order to keep foreground and background elements in balance. Follow the outline of the gray rooftop on the upper left of Demuth's watercolor, and you will find several such transition points—places where the artist's attention has shifted from the positive plane of the rooftop to the negative background of trees and sky behind it. For the most part, his edges appear as crisp darks against blank paper—an effect enhanced by white separation strips like those around two yellow facades. For variety, sometimes Demuth paints washes on both sides of a contour, but always with one side strongly emphasized, as in the section where a foreground shed cuts in at the lower left. Here the gray roof of the house, the top of the shed, and a small, dark window are developed as a sequence of overlapping edges, each darker than the last.

A leading American modernist, Demuth (1883–1935) was strongly influenced by French Cubism, and his watercolors—sensitive, yet boldly conceived—are a superb demonstration of what can be done in an abstract vein. Here decisions about edge shading or dark/light patterns are arrived at quite arbitrarily, in the interest of visual excitement rather than representational accuracy. For anyone exploring the medium, this is an approach that promises both fun in the doing and a successful outcome. Fun, because you have total freedom in the choice of colors and shapes, and successful, because the discipline of painting on one side of a line and then reversing the shading will give your work both technical polish and a sense of design.

MARK ADAMS
On East Brother, 1985
Watercolor, 22 × 28"
(55.9 × 71.1 cm)
Courtesy John Berggruen
Gallery, San Francisco

CHARLES DEMUTH (American, 1883–1935)
A Red-Roofed House, ca. 1917
Watercolor, 10 × 14" (25.4 × 30.8 cm)
Philadelphia Museum of Art, Samuel S. White III and Vera White Collection

BERNARD CHAET
Green Peppers, 1983
Watercolor, 22 × 30" (55.9 × 76.2 cm)
Courtesy Marilyn Pearl Gallery, New York

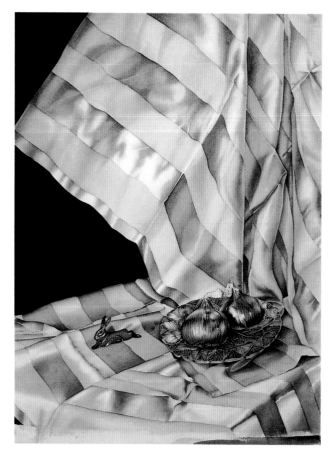

P.S. GORDON
Hare Apparent, 1981
Watercolor, 30 × 22" (76.2 cm × 55.9 cm)
Courtesy Fischbach Gallery, New York

Edge-shading techniques are equally useful in realistic work. Bernard Chaet, for instance, has developed an interesting still life strategy. He paints seemingly unarranged arrangements of fruits or vegetables scattered on a sheet of white paper, which, except for small pockets of shadow, is represented as just that—untouched paper. Thus, as in Demuth's work, Chaet's washes tend to shade from a dark edge into white, but they are painted more freely, with emphasis on organic shapes rather than on geometric planes. And whether he is dealing with six green peppers or sixty strawberries (see p. 109), his strategy is to unify the disparate elements of an "accidental" set-up by a rhythmic handling of shaded contours. The rhythms of *Green Peppers* are typical. Here, the eye is led in a continuing movement from shell-like, convoluted shapes on the lower left to ascending tubular forms in the center and—after various twists and turns—up to the top left corner.

Despite the spin Chaet puts on it, this is a bare-bones scheme whose simplicity has advantages for the watercolor student. It is a still life format without elaborate set-ups. An exercise in shading the kinds of rounded or tubular forms you will encounter in most painting genres. And, above all, a strategy that encourages freshness, for there is no background to be filled in, and positive images are set down with a few bright brushstrokes on a field of white.

P.S. Gordon's *Hare Apparent* is another kettle of fish entirely (to use an image as playful as the artist's punning title). Like many current realists, P.S. Gordon sees watercolor not as a medium only for light sketches, but as comparable in solidity to oil painting. This translates into painting to the edges of the paper as one would do on canvas. I show you *Hare Apparent* here as an example of edge shading that has been done on a colored underpainting, rather than on white paper. Lustrous drapery folds are the vehicle for a show-stopping display of modeling technique. As a preliminary step, the artist establishes the local color of each area with a flat wash— jet-black for the background, pale cerulean for the matte stripes, and a warm off-white foundation for the shiny satin stripes, which are to have dramatic dark/light shading. Only the areas of the ceramic rabbit and red onions are spared the underpainting, since they will be painted later with white highlights. At this point—after the paper has been covered with generalized tones—the shading of intricate folds and edge patterns is begun.

If this two-tiered procedure seems complicated, be assured that it works very well for both inexperienced and experienced painters. It can be used for simple set-ups of apples and oranges or boxes and bottles; it is also appropriate for more complex subjects involving twisted forms or weathered surfaces. In any case, there are two things to keep in mind: First, the shading should be done in a distinctive tonality: brownish, rusty, greenish, or—as in *Hare Apparent*—a bluish Payne's gray. Second, don't forget at least a few areas of reverse shading—as in the shadows cast by Chaet's peppers and the changeable contours of Gordon's satin stripes.

THE BOTTOM LINE: SHAPING GEOMETRIC VOLUMES

Mastering the washes outlined in this chapter will give you a simple, direct technique for representing most of the things you want to paint—or at least for establishing their basic shapes in line with Cézanne's dictum that all of nature can be reduced to the cube, cone, and cylinder. In summary, these are the three kinds of washes we have discussed and what they can do:

1. *Flat washes* provide a vocabulary for boxes, books, tables, church steeples, factories, and all things architectural.
2. *Graded washes* can evoke the arch of a western sky, the sunlit wall behind a figure, or almost any large area that needs dramatic shading.
3. *Edge shading* can be used to create either geometric planes or spherical and cylindrical volumes like fruits, vegetables, bottles, tree trunks, and even the human form.

In watercolor, the bottom line is being able to use these washes to capture the essential volumes of objects. And note that this must be done before fussing with details. In other words, you paint a wall before putting cracks in it, or a green sphere before making it look like an avocado. The reason is that watercolors are built in layers, like a pyramid, with the biggest layers underneath. Since specifics are usually described by small, rather dark strokes, they inevitably come last and on top.

To see these principles in action, consider how Mark Adams uses them in *On East Brother.* Here the local colors of sky, pavement, and buildings are established by *flat washes,* while *edge shading* is used to round out the bulbous tree forms. As a further refinement, two key shapes are sharpened by *graded washes*—a strip of water on the left, which shades from light violet (against dark trees) to deep blue (against a pale dockside), and the dock itself, which is graded from a dark tan on the right into paleness on the other side. Finally, spatial depth is encouraged by dramatic shadows, several of which are painted as overlaid washes that modify the original colors. On the distant light station, for instance, a purplish shadow turns white windows to lavender and orangish sunlit walls to dusky tan.

Adams has a gift for pared-down shapes and distilled imagery. He stops where another artist might go forward, and a work like *On East Brother* should be seen as a kind of visual outline that could be fleshed out in any number of ways. A realist might add windowpanes and clapboard siding; an impressionist, scattered clouds and sun-dappled leaves. And you will have your own way of doing things. Whatever your personal approach to watercolor, the basic techniques remain the same.

WARM-UP EXERCISES

At this point, you may be inclined to read ahead, perhaps with the thought of trying out wash techniques as they are called for in an actual painting. However, you will get farther and avoid discouragement by giving serious attention to these exercises. Use a quarter-sheet of cold-press paper.

For clarity, the problems are stated rather literally, but they are meant to stimulate your imagination. After grasping the strategy of an exercise, feel free to transform it in ways that will make it your own.

EXERCISE 1: HOUSES IN FLAT WASHES
With a ruler and a 2B pencil, make a fanciful drawing of cube-like houses—simple boxes without windows and doors or precise perspective. After drawing a horizon line, paint sky and land with flat washes in firm, but not too deep, tones. Then fill in the remaining rectangular shapes, letting one section dry while you work elsewhere, until the compositional mosaic is complete. As you proceed, assume light from one side and shadow on the other, toning each house as a dimensional block.

EXERCISE 2: GRADED BANDS
Divide the page with a horizontal ruled pencil line. In the upper section, press down five or six vertical strips of half-inch masking tape in a pipe-organ pattern. Fill in the columns with playful combinations of intense graded colors. When dry, pull up the tape slowly and carefully. Then paint similar bands in the lower area, but this time use a single rich color in each stripe, shading it from dark to light by adding water rather than other colors.

EXERCISE 3: EDGE-SHADED STILL LIFE
Draw four or five pieces of fruit of contrasting shapes and colors, a plate, a cigar box, and a wine bottle. Be sure objects overlap and that a tabletop is indicated. Then paint the areas of the table and the wall with edge-graded washes in neutral gray or brown, and go on to create the cylindrical bottle and spherical fruits in spectrum hues.

To create a cylinder, use edge gradation from either side fading to a central white strip (outlined beforehand in pencil so that you will remember to "save" it). *For spherical shapes,* paint a ring of color around the outer contour while saving a central highlight (also outlined in advance). Add water toward the center of the form and then blot with tissue so that the middle of the fruit is lightened and the edges are left firm. After drying, the process may be repeated several times, with the same or slightly different colors, for greater definition.

3 LAYERED TRANSPARENCIES

In watercolor, as in daily life, it is important to have sound "values." The function of tonal values in art is much like that of ethical values, providing an orderly principle, or scale, against which to measure ongoing actions.

For an artist, *value* is the lightness or darkness of a color, and we speak of tones as "high-keyed," "deep," or of "middle value." This is an element to be consciously studied, and the way to visualize values is to imagine your watercolor as a black-and-white photograph. In looking through a pile of sketches, you will see that some are pallid, while others are gloomy. Undoubtedly, the best of the lot will have clear lights and snappy darks. These are the pictures that not only photograph well but also "carry" when you look at them from a distance in an art gallery.

Now that you have practiced basic washes, you must figure out how to combine them into a coherent image. Here the systematic use of values can be a great help. Start by reducing your picture to areas of wash, each of which is a single tone on an evenly stair-stepped value scale—making it not just any color, but a distinct light, medium, or dark tone. Once you have learned to simplify in this way, you will be able to group washes of various sizes and weights so that they suggest objects in space.

As an illustration of this principle, note how much the Colorado artist Rita Derjue accomplishes with minimal means in *Dallas Divide* (p. 33). In a tiny space, hardly bigger than a postcard, she conjures up a massive mountain range. And she is able to do so with just a few bold strokes because her concept of the values to be used is strong and clear: craggy mountains shaped by white, medium, and dark tones, set against a pale blue sky that is at once darker than the white of the paper and lighter than the mountain shadows.

NEIL WELLIVER
Detail, *Study for "Trout and Reflections" #2*
(page 32)

31

COMPOSING WITH FOUR VALUES

Watercolor can be many things, and as we shall see in later chapters, some painters use elaborate processes and dozens of washes. Yet there is a classic approach to watercolor that views it as a shorthand medium. This is where you should begin, both because the technique is easy to grasp and because it will provide a solid foundation for future experiments.

Homer, Marin, Cézanne, Klee, and many other masters work in a classic watercolor style. By this I mean that—despite otherwise divergent attitudes—they base their techniques on evenly stepped light-to-dark tones that create an image with utmost economy. There is always some question, of course, as to how many layers to use. Cézanne watercolors usually have two or three layers of pale tones supported by a pencil drawing, and Klee's often feature six or seven elaborately calibrated gradations. The most common "classic" technique, however, calls for four values: *light, medium-light, medium-dark, and dark*. This is far and away the most practical number, since three values are limiting, while more than four can't be easily kept in mind and need to be rather mechanically figured out.

The contemporary realist Neil Welliver holds quite strictly to four values, and two watercolors of brook trout give us a fascinating glimpse of his working methods. In general, after penciling in the subject, he paints an initial layer of *light* washes throughout the composition; this is followed by *medium-light* tones overlaid in each area, then *medium-dark* strokes, and, finally, some *very dark* accents. The local colors of watery sky reflections,

NEIL WELLIVER
Study for "Trout" #2, 1980
Watercolor and pencil, 22⁵/₈ × 8³/₄" (29.5 × 22.2 cm)
Courtesy Marlborough Gallery, New York

NEIL WELLIVER
Study for "Trout and Reflections" #2, 1982
Watercolor and pencil, 22³/₈ × 30¹/₈" (56.8 × 76.5 cm)
Courtesy Marlborough Gallery, New York

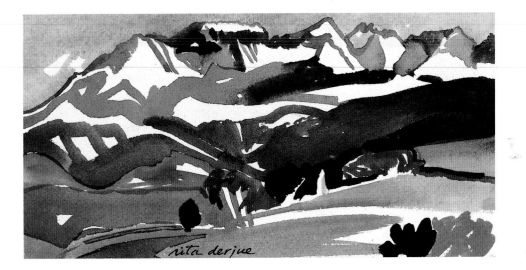

RITA DERJUE
Dallas Divide, 1992
Watercolor 4¹/₂ × 9"

FAIRFIELD PORTER
(American, 1907–1975)
*Untitled (Christmas
Morning),* 1972
Watercolor, 20 × 26"
Courtesy Hirschl & Adler
Modern, New York

sand, rocks, and fish are indicated, and within each color
zone there are clearly stepped values—usually four, but
sometimes just two or three. In *Study for "Trout" #2,* for
instance, darks are omitted from the upper sky-blue areas,
so that those pale areas will contrast with the sandy depths
below, while in *Study for "Trout and Reflections" #2,*
the trout's speckled scales are emphasized by black dots
sprinkled over light golden tones, without an intervening
middle value. In this purposely "unfinished" study, also
observe the interaction of Welliver's brushmarks and his
incredibly detailed pencil drawing. As you can see, every
rock on the sandy bottom is separately outlined, with
shadows indicated by crosshatching.

This is a highly formalized four-value system, in
which Welliver's stylized brushstrokes provide an abstract
underpinning for his distinctive brand of "new realism."
As such, it is very much in line with the recent enthusiasm
for "deconstruction"—the idea of taking the elements of
an image apart so that they can be creatively rearranged
in various ways. Thus, Welliver typically explores a
particular theme, such as this one of trout, in numerous
watercolor studies and eventual print editions, and the
four-value painting system is easily translated into
multiple-layer print processes like color etching, serigraphy,
or woodcut. This approach also has an important
practical advantage, since washes scattered across the
page have time to dry between layers, instead of running
together in a crowded space.

Although Welliver's analytical approach is instructive,
most watercolorists are interested in more spontaneous,
unstudied effects. But in even the most freely handled
work, as we have seen in Rita Derjue's *Dallas Divide,* a
four-value treatment is almost a necessity, in the interest
of clarity. Fairfield Porter's *Untitled (Christmas Morning)*
is a case in point. Here the artist gives us both a story—
presumably, gifts under the tree and on a temporary table
have been opened and carted away—and a description of
three different architectural spaces. Clearly, a shorthand
system is needed for digesting all this information, and
though Porter's style is more casual than Welliver's, he

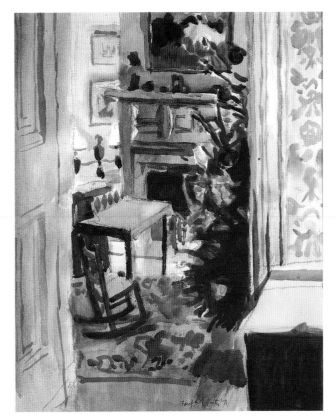

uses a similar four-value approach to both the details and
overall design of his Christmas watercolor. Blur your eyes,
and you will see that the picture has a dark center, light
side panels, and one brown-black square on the lower
right—perhaps a box left in the hall—that gives the rather
conventional image a little abstract punch. Within this
general scheme, wallpaper and moldings on the side
panels are rendered in pale tones, while the central scene
is described with a full range of values. The small table is
a brightly lighted cube with dark shadows; the fireplace is
shaped with black, white, and two shades of gray; and
even the picture over the mantel is sketched with four
distinct values.

STEPPING UP AND DOWN THE VALUE SCALE

Welliver and Porter show us how to create an image with a few well-placed tones. There is another lesson in the work of the Swiss modernist, Paul Klee—the use of washes, not as individual shapes, but in clusters that we perceive as visual chords, like arpeggios plucked on a harp.

Klee's *Goldfish Wife,* for instance, is a wide-eyed creature with a valentine heart and a pearl necklace, who swims, like Welliver's trout, in an undulating pool. Here, however, watery ripples are created with a different technique. Instead of the gestural brushmarks Welliver favors, Klee uses washes that overlap in sequential clusters like layers of colored tissue paper. I count five layers of progressively darker tones in the brownish waters around the lady's hairdo and six between her fantail legs.

If you have attended art school, you will recognize this device as the *value* scale—a sequence of tones progressing evenly from white to black—that every first-year student learns to paint. Such evenly stepped tones are difficult to render in oils, because each color must be separately mixed, tested, and fussed over until a crisp edge is achieved. In watercolor, on the other hand, this is a natural idiom, since colors show through one another, and you can make use of overlapping marks. Two applications of a light wash produce a middle value, and a third or fourth layer over that adds up to a fairly deep tone.

To appreciate how this works, consider the plaid tablecloth in my painting *Checks and Balances.* The horizontal stripes were laid in first, followed by vertical bands of the same light pink. Where they cross there is a double pigment layer that forms squares of deeper red, just as the intersection of up-and-down threads does in a woven cloth. Thus the checked pattern was established by simple overlays, rather than by applying paint for each separate square. Later, shadows were brushed in with a single bluish wash that transformed the color of individual squares in various ways. The principle is like dyeing different fabrics in the same solution. In this case, white squares turned blue, pink checks became violet, and the red ones deepened to a shade of rust.

Playing with transparent overlays is fun and a bit like solving a puzzle. The title *Checks and Balances,* incidentally, suggests the picture's game-like strategy and—like Whistler's portrait of his mother, which the artist exhibited as *Arrangement in Black and Gray*—my kitchen still life should be seen as an essentially abstract composition of stripes, circles, and squares.

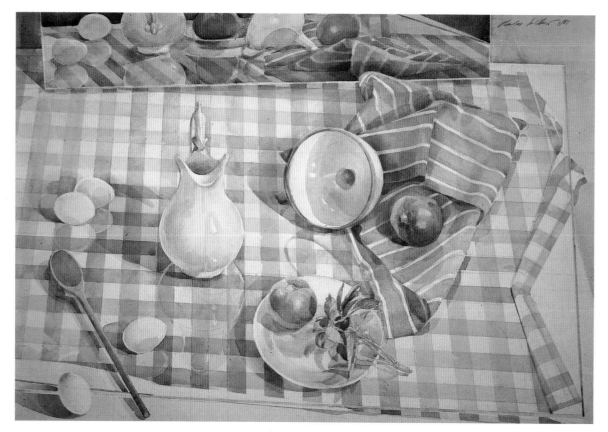

CHARLES LE CLAIR
Checks and Balances, 1981
Watercolor, 29 × 41" (74.7 × 104.1 cm)

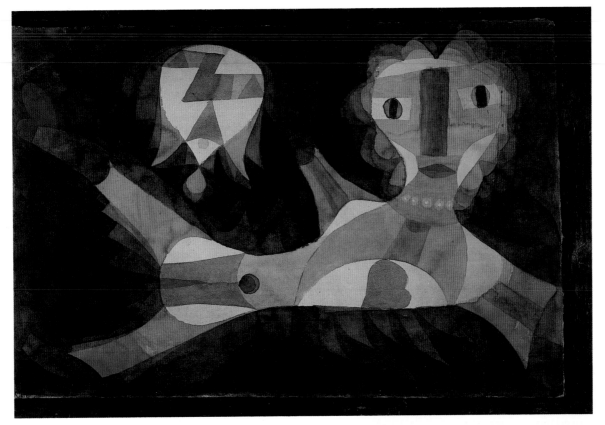

PAUL KLEE (Swiss, 1879–1940)
Goldfish Wife, 1922
Watercolor, 24 × 20½"
Philadelphia Museum of Art,
Louise and Walter Arensberg Collection

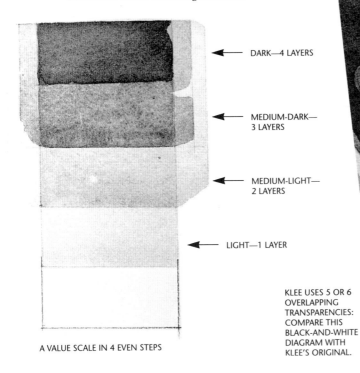

← DARK—4 LAYERS

← MEDIUM-DARK—
3 LAYERS

← MEDIUM-LIGHT—
2 LAYERS

← LIGHT—1 LAYER

A VALUE SCALE IN 4 EVEN STEPS

Using a Value Scale in Layering Technique

KLEE USES 5 OR 6
OVERLAPPING
TRANSPARENCIES:
COMPARE THIS
BLACK-AND-WHITE
DIAGRAM WITH
KLEE'S ORIGINAL.

Color Is a Many-Layered Thing

The layered look is a familiar fashion idiom, and theatrical designers often use layers of colorful materials you can see through. An emerald gown overlaid with lavender tulle appears iridescent, whereas an onstage forest's changing seasons are evoked by transparent scrims that materialize and dissolve as lights play upon them. Layers of transparent watercolor act in much the same way.

Some watercolorists build forms with repeated applications of a color. This is Elizabeth Osborne's strategy in *Nava in Blue Robe* (p. 85). The artist shows us how to mold the folds of a garment or give weight to areas of intense color by going over them again and again—sometimes with a subtle variant, but more often with the essential hue—until they take on an enamel-like luster.

Layering variegated color combinations is another possibility that Joseph Raffael explores in enormous watercolors like *Peony.* Here a giant blossom is painted with maroon washes over underlayers of violet and vermilion, while the foliage is sparked by flashes of green over lemon yellow and brown over orange.

Jean Hamburg's *Configurations* is another exciting example of what can be done with multicolored layers—this time with free-flowing washes in an abstract mode. After isolating white shapes with masking tape, the artist brushes in broad, brightly colored washes with the wet-into-wet technique we shall consider in Chapter 7. Later, more specific, hard-edged shapes are overlaid in a clean, flat wash style. In the center, pinks and oranges show through these dark overlays. As a final touch, Hamburg adds smaller leaf shapes and linear tendrils. There is even a suggestion of positive plant forms and negative cast shadows at the bottom.

This is an approach that deserves your full attention, because the process of working with multicolored washes, laid over one another like sheets of stained glass, is a distinctive feature of the watercolor medium. It also provides a unique opportunity to study the interaction of pigments and to apply principles of color theory in a creative situation. So let's pause a moment to review some basic terms.

Joseph Raffael
Peony, 1988
Watercolor, 44 1/2 × 68" (113 × 172.7 cm)
Courtesy Nancy Hoffman Gallery, New York

JEAN K. HAMBURG
Configurations, 1990
Watercolor, 30 × 22" (76.2 × 55.9 cm)

THE PROPERTIES OF COLOR

Color has three essential properties: hue, value, and intensity. *Hue* is simply the color's identity on a spectrum or color wheel. The six main hues are red, orange, yellow, green, blue, and violet. Hues in between are described as yellow-green, red-orange, and so on.

Value, as we saw earlier, refers to the lightness or darkness of a color. In technical language, pale colors like pink or aqua are identified as a red and a blue of very light value; maroon and navy are a red and a blue of very dark value.

Finally, *intensity* describes a color's brightness or dullness. Of the three terms, this is the most difficult to grasp, since words like "light" and "bright" or "dark" and "dull" sound so much alike. The trick is to remember that the extremes of the *value* scale are black and white,

whereas the *intensity* scale moves from vivid hues to neutral brownish tones. Thus an orange that loses intensity becomes terra-cotta, yellow dims down to mustard, and blue fades to slate.

These are simplified definitions, but it is important to understand color principles in such a way that they can be helpful in your work. It is just here that the process of layering becomes invaluable, for one wash can establish an object's basic *hue,* or local color, while a subsequent shadow tone can deepen the *value* (or make it darker), and a third layer can modify the *intensity* (or kill some of the brightness). Thought of in this way, transparent wash technique is an admirable vehicle for exploring the components of color and putting them together in exciting combinations.

Applying Color Principles

The interaction of colors is most easily observed in an abstract painting like Wassily Kandinsky's *Landscape,* where each wash is independent rather than attached to a solid form. Like Welliver, Kandinsky has a four-value technique, and his manipulation of floating color planes is a model of clarity. He starts with light washes that are followed by smaller and progressively darker ones. What is most significant, however, is that each new layer is painted over both white paper and a previously established tone or group of tones. In this way, colors are made visible in both their original state and in see-through combinations. Near the top left corner, for instance, a small dark square with an X-shaped center neatly overlaps three other colors and thus creates four new ones. Although this is a cluster of muted browns and gray, you will find the same principle at work in a brighter passage on the lower left, where dark blue shapes are floated over oranges and rusty reds.

The beauty of this system is that it produces color mixtures effortlessly and with such visual logic. The artist is assured of an integrated "chord," rather than separate, ill-matched colors. To show how this works, I have diagrammed the color chord one might use in painting a simple object like an apple. The apple's local color, red, is represented by warm and cool variants—here, orange-red vs. violet-red. In the same spirit, I have added warm gray and cool gray shadows. As you see, layering four such basic colors produces numerous secondary mixtures that will work together harmoniously in either an abstract or figurative context.

As you explore color in your own work, it is a good idea to experiment freely with every combination you can think of. At the same time, keep a few guidelines in mind:

1. *Learn to move sideways on the color wheel.* For maximum brilliance, each wash should be not only a step darker than the previous one but also a slightly different hue. Accordingly, my red apple fluctuates between vermilion and crimson, a green leaf might be developed with lime and emerald, and a blue sky might be shaded from ultramarine to cerulean.

2. *Keep the "sun colors"—yellow, orange, and lime—underneath.* A glance at your palette will show that yellows and oranges are light in value, whereas other pigments are comparatively dark. This means that these "sunlight" hues make effective underlayers in a watercolor, but when painted over other colors, they can be as opaque as Chinese white. In any case, the illusion of warmth in a transparent painting must come from below—yellow shining through green, orange from under red, even red from beneath purple or brown. In accordance with this principle, watercolorists often use an underpainting of yellow, sienna, or ochre for landscape subjects or still lifes with brightly colored objects.

3. *Use warm and cool "space colors" to create depth.* If you look at a white wall, you will observe subtle shifts from *warm* (or sunny) to *cool* (or silvery) tones. Thus when you represent that wall in a painting, your white paper must be covered with washes that are distinctly not white but which nevertheless create the illusion of an illuminated white space. This is done with vaguely warm, vaguely cool washes of indeterminate hue that I call "space colors." The same principle of using changeable, atmospheric tones applies when the background space you are representing is dark or colorful instead of being white.

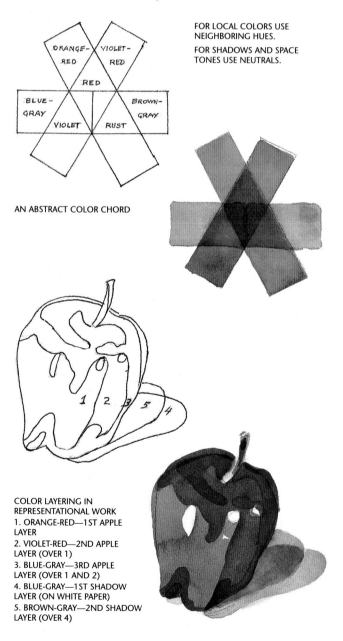

FOR LOCAL COLORS USE NEIGHBORING HUES.

FOR SHADOWS AND SPACE TONES USE NEUTRALS.

AN ABSTRACT COLOR CHORD

COLOR LAYERING IN REPRESENTATIONAL WORK
1. ORANGE-RED—1ST APPLE LAYER
2. VIOLET-RED—2ND APPLE LAYER (OVER 1)
3. BLUE-GRAY—3RD APPLE LAYER (OVER 1 AND 2)
4. BLUE-GRAY—1ST SHADOW LAYER (ON WHITE PAPER)
5. BROWN-GRAY—2ND SHADOW LAYER (OVER 4)

Creating a Color Chord with Layering

WASSILY KANDINSKY
(Russian, 1866–1944)
Landscape, 1924
Watercolor and ink, 18⁷/₈ × 23¹/₄"
(47.9 × 59 cm)
Philadelphia Museum of Art,
Louise and Walter Arensberg Collection

LAYERING EXERCISE

There are a few artists, like Carolyn Brady, who achieve their effects in a single "go" without needing to retouch. The classic approach, however, is to develop forms more gradually. For most watercolorists each section of a painting requires two or three rounds of washes—to establish local color, deepen it in places, and put in shadows. Getting the tones in the right order is very important, and this exercise shows you precisely how the technique of layered transparencies works.

TRANSPARENT COLOR SAMPLER

Draw an abstract grid with pencil and ruler on a half-sheet of paper (15 × 22 inches). Any formation of small areas—triangles, hexagons, checkerboard, brick pattern, spider web—will do, but it must be a network of small areas. Within this labyrinth, you will work like a quiltmaker,

developing abstract shapes—some covering several units of the grid, others just one or two. Start with an initial layer of washes putting each of the basic hues—red, orange, yellow, green, blue, and violet—in a different area of the composition, but be sure to leave one or two white shapes in each color zone. Next, paint a second layer of smaller and darker washes. These washes must move the color sideways—lime overlapping yellow, for example, or turquoise overlapping green. Finally, paint a third layer of deep neutral washes in brownish or grayish tones that suggest shadows.

Hues, values, and intensities have been established, and now you are on your own. Many new washes can be added if they will make the picture work. What you are painting now is an abstraction à la Klee or Kandinsky and, in the process, developing a color vocabulary.

4 From Concept to Finished Painting

Now that you have had some practice in working with transparent washes, you will want to use the technique in an actual painting. This chapter is offered as a guide to the various steps involved in creating a watercolor—arranging a set-up, lighting it, visualizing the composition, making the preliminary drawing, and then developing the painting in color. Along the way, we'll also consider watercolor's unique character and the distinctive attitudes a painter must bring to the medium.

Indeed, watercolor is so often taught as an incidental subject that one forgets how fundamental it is—fundamental in the sense of representing one of the three painting systems artists need to know. These are: opaque painting, glazing over an opaque underpainting, and working transparently on a white ground. Each of these processes is distinctive, yet art schools generally emphasize work in oils and acrylics while giving little attention to the special qualities of transparent painting.

To appreciate the difference, compare a canvas by someone like Rembrandt with a typical watercolor. Rembrandt worked on a brownish ground, pulling gleaming lights out of the gloom with touches of thick oil paint. This method is called *chiaroscuro*, a term that means "light out of darkness." For a watercolorist, on the other hand, the ground is untouched white paper. Lights aren't brushed in but are left blank or faintly tinted. There is the same concern for brightness and shadow, but instead of bringing out light areas *directly* with brushmarks, the artist must do so *indirectly* by surrounding each light zone with shading. In short, watercolor and oil painting involve quite opposite working methods.

PHYLLIS SLOANE
Detail, *P.S. 5 Lb.*
(page 44)

THINKING WHITE

People who take up watercolor after working with oil or acrylic find that they must acquire a new way of looking at things—a mind-set I call "thinking white." This comes from a gradual understanding that blank paper is a precious commodity to be savored until the last minute, rather than lost forever as the result of a too-hasty brushmark.

In a particularly vivid expression of this attitude, Carolyn Brady, in *Dark Ground*, depicts an intricate web of blossoms and stems by painting, not the bouquet itself, but the space behind it. In other words, she started by putting in the "dark ground" of the title, thus, establishing the entire foreground image as a white space in which each colorful tulip and carnation could be developed later with delicate shading and highlights.

The only trouble with "thinking white" is that like so many things in art—dancing on points, for instance, or singing high C—it isn't doing what comes naturally.

Everyone knows the natural way to paint: simply choose a subject, get the colors right, and then fill in the background. In theoretical language, this is called working with *positive* images rather than *negative* space. In practical terms, it means painting something that, however colorful, will end up darker than the background. Compare Brady's watercolor with Harry Soviak's treatment of a similar subject, *Daffodils and Peach Blossoms*. Where Brady paints the space around and behind her bouquet in an elaborate indirect technique, Soviak tackles his subject directly, with a simple brush drawing of peach-tree branches, yellow blobs for daffodils, and the silhouette of a blue vase splashed with pink and green ornament. This is a vibrant image set against the palest of backgrounds—an icy off-white wall and a pink-beige tabletop. In contrast to Brady's depth illusion, Soviak's work has the elegant flatness of a Japanese print.

CAROLYN BRADY
Dark Ground, 1987
Watercolor, 44 1/2 × 31" (113 × 78.7 cm)
Courtesy Nancy Hoffman Gallery, New York

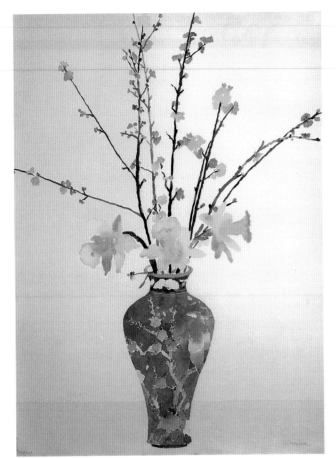

Clearly, both ways of seeing are valid. However, if Soviak's "natural" approach has the virtue of simplicity, it has the limitation of being effective primarily in simple formats like this floral arrangement, isolated from its surroundings. For a fully dimensional image, the artist must develop a more complex technique. This calls for Brady's strategy of painting the space *behind* before tackling things *up front*. This is a bit like eating smorgasbord and saving the best until last. In watercolor the thing saved, of course, isn't a herring or deviled egg, but the all-important light areas of the composition.

I can think of no better role model for anyone who wants to master this approach than Cleveland artist Phyllis Sloane. Her watercolors are done without technical flourishes in a clean-cut style that incorporates all the basic techniques we have covered—flat washes, graded washes, edge shading, and even overlaid transparencies. She also thinks in terms of clearly defined problems, and as you can see in her paintings *Still Life with Dragon* and *P. S. 5 Lb.*, "thinking white" is one of her major concerns. Indeed, these two still lifes tackle subjects I would recommend as exercises for any beginning watercolorist—first, the classic "white-on-white" set-up, and second, the study of white objects in a colorful environment.

Watercolorists are often drawn to subjects like eggs or onions on a white cloth, because they provide opportunities for delicately nuanced shading and preserving areas of snowy, untouched paper. In *Still Life with Dragon*, however, Sloane puts a contemporary spin on this familiar format by combining white-on-white passages with touches of intense color in a cleverly

worked out, rather abstract, design. Open spaces are developed with white objects—a cardboard box, a book, and a paper napkin—that disappear against a matching white background and are made visible only by painted shadows. Next, she adds a sprinkling of sharp accents in black, brown, and primary colors. Finally, the more distinctive objects: a rampant dragon on a cocktail napkin, a piece of decorative Indian pottery, and, as an amusing touch, several red-and-white striped peppermints.

Despite the elegance of Sloane's rendering, her strategy is a simple one that would make an ideal project for home or classroom. The set-up involves materials that are modest in scale, easy to find, and interestingly varied in character. White-on-white backgrounds are a cinch, and the featured objects could be anything in the house— feathers, ink bottles, paperweights, dog biscuits—you name it! More important, however, are the lessons to be learned. Look at *Still Life with Dragon* and you can count them: (1) creating box-like volumes with simple shadow planes; (2) shaping spherical volumes like Sloane's blue- and green-enameled balls (or grapes, marbles, or chocolates in your own set-up); (3) using graded washes (as in the knife blade) or reverse edge shading (as in the seashell rendering); (4) and above all, learning to work in and around areas of "saved" paper.

To understand the "thinking white" principle, it is good to start with this kind of extreme project, leaving most of the paper bare. Sloane's *P. S. 5 Lb.*, however, represents a more generally useful situation in which a few white objects are featured in an otherwise colorful setting.

Here we are dealing with three-dimensional, interactive volumes in a shadowbox space, rather than separate objects laid out on a flat surface. Furthermore, the objects are chosen not for their distinctive character, as in *Still Life with Dragon,* but to be rather neutral units in an overall design. Taking her cue from a quilted tablecover, Sloane selects only geometrical shapes in a matching color chord: blue, white, and caramel-colored cylindrical bottles; a white-on-white bowl of eggs that echoes the shapes of the bottles and the hexagonal quilt patches, and tan and white cubic boxes—with the 5-lb. bag of the title suggesting a crumpled cube.

In developing this kind of image, the main thing to remember is that, since light objects can't be fussed over the way dark backgrounds can, decisions about their treatment should be postponed until other elements are in place. With this in mind, one can easily reconstruct Sloane's painting plan: First, establish the background wall; next, lay in the tablecover patterns with clean, flat strokes; then create cast shadows with transparent overlaid washes that permit the quilt designs to show through. At this point, with most of the paper covered, a fair judgment can be made about handling the saved areas. As things worked out for Sloane, faint tones sufficed for the white box, whereas heavy blue-gray shadows were needed to bring the bowl of eggs into harmony with its forceful surroundings. Finally, like a modern Dürer or Van Eyck, Sloane signs her painting not just with her initials, the P. S. of the title, but—get out your magnifying glass!— with a tiny self-portrait reflected in the carafe.

PHYLLIS SLOANE
P. S. 5 Lb., 1986
Watercolor, 37¹/₂ × 43¹/₂"
(25.3 × 110.5 cm)
Collection of Mr. and Mrs.
John Schulze, Cleveland, Ohio

ARRANGING THE SET-UP

Before tackling your first painting, you must come up with a subject that is interesting and that you can handle. Proceed thoughtfully, even if you are in a hurry to get going, because in watercolor choosing what to paint is half the battle. An arrangement of fruit or flowers encourages a colorful painting, bottles in a row suggest structural shapes, and house plants on patterned fabric translate into a decorative composition. Thus, before lifting a brush, you must make crucial decisions that will determine the character of your watercolor.

There are good reasons for starting with still life. The human figure presents anatomical problems best postponed for a while, and in landscape you must *find* a proper subject; you cannot arrange it yourself. Still life, on the other hand, involves you in composing—changing the background, moving a bottle, or using a different tablecloth. It has the further advantage of offering a limited tabletop space instead of complex perspectives. For a watercolorist with a dripping brush, there is comfort in dealing with just a few simple objects that fill the page.

It is best to begin with an uncluttered set-up in which the clear-cut values we have discussed are evident and where light objects are incorporated to make you "think white." While Sloane's *P. S. 5 Lb.* shows you one way to go, Elizabeth Osborne's *Pennsylvania Still Life* demonstrates an equally effective but simpler arrangement. Here, vases and jugs are lined up at or near eye-level, so that each can be drawn in straight-topped profile rather than with open-mouth, elliptical rims in the usual view from above. This sort of "mantelpiece strategy" minimizes drawing problems and reduces objects to simplified shapes that can be moved about and played with like chess pieces. Osborne creates visual interest by overlapping objects and showing them against a varicolored background. The upended table runner is a particularly effective device, since its striped panels are a clear statement of both the picture's fuchsia/pink/green color chord and of the light/medium/dark value scale we considered in Chapter 3.

I recommend this approach for anyone working at home. In a classroom, however, such a neat arrangement

ELIZABETH OSBORNE
Pennsylvania Still Life, 1982
Watercolor, 29¹/₂ × 41" (74.9 × 104 cm)
Courtesy Locks Gallery, Philadelphia

can be limiting, and art schools typically prefer more elaborate set-ups with a wealth of material to suggest various compositional possibilities. The teacher collects white things, colored things, found objects, junk jewelry, wax fruit, and assorted drapes so that each still life can be given a "new look." The student is then invited to find one small section of the arrangement that will make an exciting picture. So, in the end, there are as many compositions as there are painters.

Sondra Freckelton's *Spring Still Life* suggests what such a massive set-up might look like. Her painting is, of course, a tour de force by a master watercolorist who has made an arrangement as complicated as a Bach fugue and then painted the whole blessed thing on a monumental scale. At first glance it would seem remote from a student's concerns. Yet any of the smaller sections—three apples on a quilt, lemons and grapes in a bowl, or a budding plant—are subjects a beginner might want to tackle.

There is also a contemporary sensibility here that is worth studying. Freckelton respects the traditional unities of theme and design, yet her arrangement is crowded with unconventional incident. Fruit, flowers, and quilts clearly go together in a country kitchen, and the rounded contours of chairs and tables harmonize with the plant forms; still, the picture's fascination lies in unexpected and even awkward relationships—the way that plates tip forward, grapes spill from their containers, and tablecloth corners are pulled downward as if tacked to the frame.

Modernists like extremes, and today's still life painters tend to prefer either an "unarranged" arrangement—jeans and T-shirts on a closet floor, for instance—or one that is arbitrarily designed with objects placed symmetrically or in rows. Freckelton's real-life clutter and Osborne's more formal scheme illustrate these contrasting attitudes. Even in your first paintings, you should opt for one or the other strategy. There's nothing complicated about it. Simply decide whether to arrange things as if on a chessboard or to scatter them about. Either way, you will give your watercolor a sense of direction.

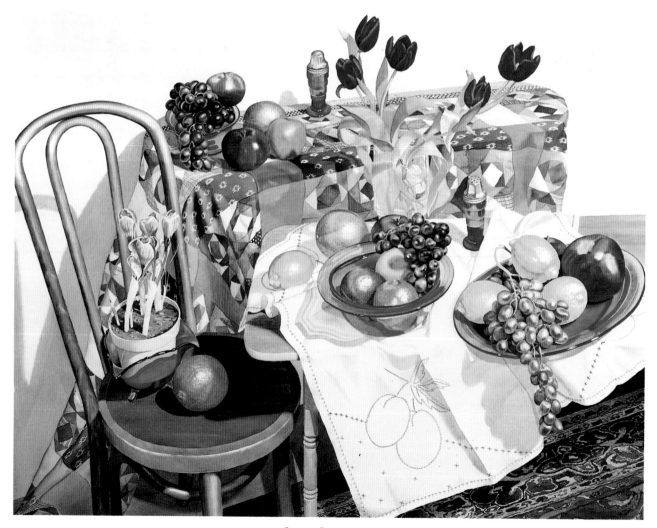

SONDRA FRECKELTON
Spring Still Life, 1980
Watercolor, 44 1/2 × 54 3/4" (113 × 139.1 cm)
Courtesy Maxwell Davidson Gallery, New York

Composing with a Viewfinder

Arranging the set-up is like designing a movie set—important, yet only a preliminary. The picture starts only when the director likes what he sees in the camera viewfinder. He may choose a long shot, a close-up, a high-angle shot, or an expressionistic, tilted angle. As you set out to paint, you will face similar decisions: whether to crop a figure or show the whole pose, put the horizon high or low, or place a bouquet on one side or at dead center.

The best way to anticipate these problems—rather than starting to draw and then having to erase—is to use a simple framing device, or viewfinder. Just cut a rectangular hole about 1½ inches long in a file card by folding it over, snipping a squarish tab out of the seam, and then unfolding it again. Through this opening you can survey the subject from different angles, finding your view as a photographer does. Since the cutout should match the watercolor paper in proportion, make several viewfinders, some elongated, others more nearly square, so you can reach for the right one.

Start with only a few objects. In a classroom situation with a wealth of material, the viewfinder will help you select a close-up. Imagine, for instance, that you are faced with a set-up like Freckelton's. Too much to handle as a whole, of course, but I have made a diagram of three small studies that might be feasible. Each includes a few rounded objects that fill the frame with enough indication of a chair or table to make the space dimensional. Two are horizontal arrangements of fruit, while the third frames a plant in an upward gesture, calling for a vertical format. Don't forget that turning the paper upright or sideways is your first crucial decision. Sometimes even experienced artists are so eager to start painting that they don't take time to make a considered choice between a vertical and a horizontal format.

A viewfinder has many advantages. It eliminates the need for preliminary studies, since alternatives can be visualized in minutes. It is a marvelous help on sketching trips. And if you put center lines on the viewfinder, you can visualize the composition in four quarters divided by imaginary horizontal and vertical axes. As you see in the diagram, this is the key to drawing objects in correct proportional relationship to each other and to a given space.

Composing with a viewfinder: A paper frame isolates three small compositions within a complex set-up of the kind used in today's art schools.

Drawing with a viewfinder as a guide to placement and proportion

LIGHTING THE SUBJECT

Lighting is serious business for the watercolorist. One reason is that bright lighting, by erasing details, encourages a simplified broad wash style. Another is that watercolor, as a transparent medium, is a "natural" for painting shadows. Shadows cast by a strong light source are perceived as shapes, but we also see through them. While water, glass, or mirrors may be sometimes used for transparent effects, shadow patterns are appropriate for almost any subject. Outdoors, you must do some inventing, since the sun isn't always cooperative, but in the studio all you need are two 150-watt reflector floodlights. These can be found in a hardware store along with domed metal bulb holders that will clamp onto a chair or table edge. Plug in your lights, move them about, and adjust the shadow angles until the effect is exciting.

Leigh Behnke's *Study for "Time Sequence: Value, Temperature, and Light Variations"* is a lesson in what can be done to alter a subject with lighting. Working with still life and architectural themes, Behnke is involved with combined images like a Renaissance altarpiece. Typically, these paintings reveal the same subject in different lights, as in this portrayal of an all-white table setting at the bright luncheon hour, on the left, and in evening shadows at dinnertime, on the right. Since there are no local colors except for some brownish background furniture, Behnke's watercolor diptych is primarily a study in contrasting silver-gray value patterns. In essence, the artist uses light and shade to create abstract shapes that either absorb or erase all fussy details. The back wall, bright in the left-hand scene, is gloomy on the right, and there are amazing transformations, particularly in the evening version,

where shadow engulfs dinner plates and light erases the bread-and-butter plate behind the upper waterglass.

The shadow drama Behnke achieves by observing natural light at different times of the day can be easily approximated with movable studio lights. Somewhere along the line, you should try a white still life like this, although it might be wise to avoid so many hard-to-draw geometric shapes. One machine-made plate or bottle would be sufficient, perhaps combined with lumpier things like cauliflower, onions, or turnips. The point is that, early on, you must learn to paint objects, not by themselves, but in the lights and shadows of the space they occupy—a principle that is most easily grasped with a white or neutral-toned set-up.

Shadow patterns can also shape a colorful subject, as Janet Fish shows us in a dashing watercolor of a broken bowl of tomatoes. In this situation, Behnke's subtle grays won't work, and the trick is to make the shadows as intense as the subject itself. In Fish's *Wild Grapes and Flowers* (see p. 76), orange and yellow blossoms are matched by vividly chromatic violet-blue shadows, while in her still life of tomatoes, a black bowl casts almost equally black shadows. A leading American realist, Fish is famous for combining energetically interactive, but unlikely, elements. Here, the conventional subject of a bowl of fruit or vegetables is—both literally and figuratively—turned upside down, smashed, and thrown on the sand in a tangle of beach grass and dead leaves. The resultant "mess" is then cleverly reorganized and pulled together by shadows and shiny white highlights that move, like electric current, through the composition.

LEIGH BEHNKE
Study for "Time Sequence: Value, Temperature, and Light Variations," 1982
Watercolor diptych, 21 × 30"
(53.3 × 76.2 cm)
Courtesy Fischbach Gallery, New York

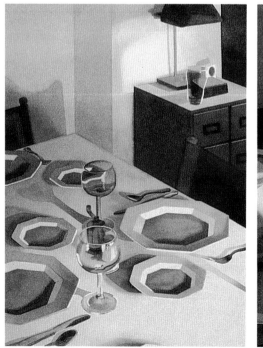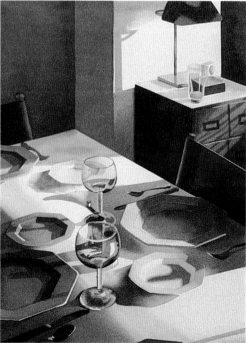

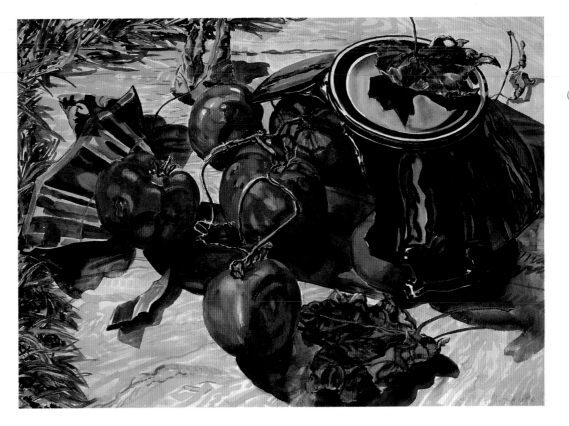

JANET FISH
Bowl of Tomatoes— Broken, 1988
Watercolor, 22³/₄ × 30"
(105.4 × 76.2 cm)
Courtesy Robert Miller Gallery, New York

THE PRELIMINARY DRAWING

Although we speak of "painting" a watercolor, the experience is closer to drawing than working with oil or acrylic. Instead of being covered, the paper surface shines through. And, as with a drawing, you may stop at any time—immediately, if the effect of a few marks is right, or after fully developing the image. This is because informal jottings have been the province of small-scale works on paper since the time of Leonardo, and because untouched paper doesn't have the aura of incompleteness conveyed by naked canvas. Then, too, a watercolor starts with an outline, usually in pencil, that is a far cry from the sketch one roughs in on canvas with the thought of painting over it later. In watercolor, the initial drawing is for keeps—a decisive road map for what is to follow. As washes are added, a dialogue ensues between these structural lines and the fluid washes that run under and around them like water lapping at the piles of a wharf.

There are many ways to draw—a watercolor contour (à la Raoul Dufy), brush and ink, charcoal, conté crayon, pen and ink, or even with a china marker for a white-line effect. But nine out of ten watercolors in museums and galleries are painted over a clean-cut pencil line, and this is undoubtedly how you should start. Charles Demuth—whose *A Red-Roofed House* we saw earlier—is an especially good guide because,

unlike many painters today, he didn't have a compulsion to "finish" everything and cover all the lines with paint. Typically, as in his wonderfully rhythmic *Zinnias,* he leaves some areas vague and unpainted, while others are fully defined. This conveys a sense of the painting's gradual development and encourages us to observe lines and washes as separate, yet interactive, elements.

In the drawing for a watercolor, cleanliness is next to godliness, because graphite smudges can soil the paper, a pencil point can leave grooves, and heavy erasure removes the paper's glaze finish. It is also important that contours be continuous rather than broken or sketchy. As Carolyn Brady says, "There has to be a line there, so I can think about the paint and not where I am going to put it." Such neatness is foreign to most people who take up watercolor after working in other media; they are used to arriving at an image with a flurry of exploratory marks that are only gradually firmed up. Unfortunately, this won't do. So I offer a few helpful hints:

1. *Use the right pencil*—neither so soft that it smudges, nor so hard that it digs in. A 2B is suggested, but touches vary, so discover what works for you. Keep it handy, and don't reach for the pencil used for grocery lists.

CHARLES DEMUTH (American, 1883–1935)
Zinnias, 1921
Watercolor, 11⁷/₈ × 18" (30.2 × 45.7 cm)
Philadelphia Museum of Art,
Samuel S. White III
and Vera White Collection

Tips on Drawing

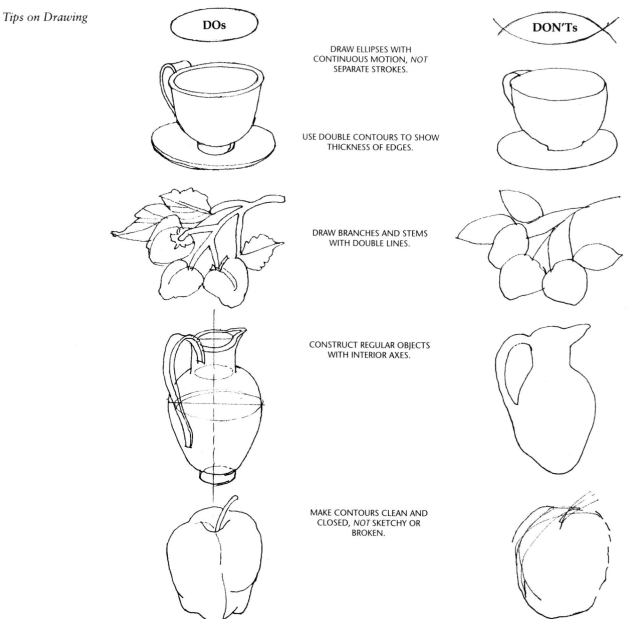

DOs

DON'Ts

DRAW ELLIPSES WITH
CONTINUOUS MOTION, *NOT*
SEPARATE STROKES.

USE DOUBLE CONTOURS TO SHOW
THICKNESS OF EDGES.

DRAW BRANCHES AND STEMS
WITH DOUBLE LINES.

CONSTRUCT REGULAR OBJECTS
WITH INTERIOR AXES.

MAKE CONTOURS CLEAN AND
CLOSED, *NOT* SKETCHY OR
BROKEN.

2. *Establish the overall composition before drawing specific objects.* If you start with a single object, it may turn out to be in the wrong place, or too large or too small. Instead, use the halfway marks on your paper viewfinder as a guide, and draw one horizontal element, like a tabletop, that you can locate in relation to an imaginary center line. Next, draw a vertical object, such as a bottle, checking the viewfinder again to see if it is right or left of the midpoint. These two steps divide the paper into four quarters in which subordinate elements can be easily located and sketched in lightly. Only then should you turn to particular objects and finish them off one by one (see diagram, p. 47).

3. *Don't be afraid to use a ruler.* Despite the old saw about amateurs not being able to draw a straight line, even experts rely on a straightedge. Some artists avoid using one for esthetic reasons, but watercolor softens edges anyway, and you should welcome mechanical aids that can be helpful. Look again at Demuth's *A Red-Roofed House* (p. 27) to see how a drawing made with a schoolboy's ruler can yield a most sensitive watercolor.

4. *Construct symmetrical objects around a center line.* Make this line of the object's axis pale and erase it before you start to paint. Regularly shaped forms like vases and coffee cups cannot be constructed by starting on the outside. The center line must be established first. Ellipses (the round opening of a cup or jar, when seen in perspective, is an oval, or ellipse) for the top, bottom, and middle are located next. Outer edges can then be drawn with assurance.

5. *Shape ellipses with a continuous motion,* like that of a racing car speeding along and then slowing for curves.

If you draw the top and bottom lines separately, the corners will be pointy and cigar-shaped. Instead, try for an easy, swinging motion.

6. *Indicate all thicknesses with two lines.* I have a lot of "how to get to our house" maps. Some show roads as a single line and others as two, with the space in between representing a highway. The latter format is the watercolor way. In oils, the rim of a wineglass is drawn with a single line and then highlighted later. In watercolor, it requires both an inner and an outer contour to indicate thickness. The same applies to plant forms, as we see in Demuth's *Zinnias*, where all the stems are drawn with two marks.

7. *Draw drapery three-dimensionally with overlapping contours.* In representing drapery, the trick is to draw it, not as a general mass, but one fold at a time and with great firmness. Follow a long fold that moves dimensionally into the interior. Then draw other contours, showing how they overlap or tuck into the first, and continue in this way until a solid structure is achieved.

8. *Transfer the drawing from a preliminary worksheet* if you tend to make a lot of corrections. It is easy and more satisfactory than trying to clean a messy page with an eraser. In working from the model, I always draw on tracing paper, making improvements on several overlays, and this can be done with a still life or landscape as well. The final drawing is then traced cleanly onto Arches paper with a few pencil touch-ups. I have used black carbon paper without ill effect, but transfer paper is preferable. It comes in sheets or rolls in various colors, and one called "graphite" has a beautiful silverpoint quality.

DEVELOPING THE COMPOSITION

It is easy to give advice about beginning a watercolor—easy because such preliminaries as choosing a subject, lighting it, and doing the working drawing involve fairly standard procedures. On the other hand, it is difficult to say just how to develop and finish a picture successfully, since each new project you undertake is unique and may very well present unexpected challenges.

Still, some guidelines are in order. The most important is that—in contrast to most mediums—watercolor requires a clear painting strategy. You can mess around with oils, pastels, or mixed media, get lost, start over again, and still end up with a magnificent achievement. Sometimes the sense of struggle even adds to the final effect. In watercolor, though, nothing is covered up. Thus the medium's transparency must be matched by an assured, straightforward technique.

Another thing to remember is that—just as novels are said to have just ten basic plots—there are only a few

basic ways to develop a watercolor. So let's look now at three time-honored ways of working with the wet-on-dry technique we have been studying, each of which reflects a different situation and time frame.

THE QUICK SKETCH

One option, which we might call the *shorthand strategy,* is designed for the small-scale watercolor that is to be completed in a single sitting. Here charm and freshness, rather than finish, are important, and a bold style, with emphasis on getting colors right the first time, is most effective. The small watercolor study is also treated more like a drawing than a painting on canvas, in the sense that it need not be painted "out." Often a few vigorous marks and washes will suffice on a predominantly white page. This is the idiom of Boudin, Sargent, Marin, and other masters of what has been traditionally considered a

"light" medium best suited for sketches and informal impressions. It is also the starting point for most beginners and art students, who see watercolor as a fun experience where pictures can take only a day to paint, rather than weeks or months, as an oil painting may require.

No one makes the shorthand strategy look easier than Rita Derjue, a Colorado artist who travels far and wide—from south of the border to Wyoming, Cape Cod, and Scotland—in search of exciting subjects, often with students from her watercolor workshops in tow. And I suppose quick sketches *are* easier than more detailed projects, if only because you can do so many and afford to discard those that don't work. Like Chanel's little black dress, however, Derjue's little landscapes aren't as effortless as they seem. A masterfully reductive touch is evident, for instance, in her view of Mexico's Caletta Bay. Here, a complex image of mountains, trees, waves, and seaside apartments is rendered in a convincing yet thoroughly relaxed and joyous style. To try something like this yourself, study Derjue's watercolor carefully, and check it against the following important DO's and DON'Ts.

- DO decide upon one or more objects that will be left white or very lightly tinted, and push them forward immediately by painting dark touches around them. As you see, Derjue does this with white buildings and pale tree trunks.
- DON'T paint in one place or with overly broad washes. Instead, build the image with small touches that suggest the whole space and that dry out quickly, so that you can return to the area.
- DO describe each subject with two or more color mixtures. In her tiny *Dallas Divide,* Derjue indicates sky, mountains, and mesa with single hues. But for a painting of normal size, form and texture should be suggested with multiple colors. In *Caletta* there are three blues, several greens, and various in-between mixtures.
- Above all, DON'T completely cover the paper in any area! The minute you do, your sketch will harden like a dried-out soufflé. In Derjue's panoramic landscape, white spaces are scattered throughout to suggest sunlight. In a still life or figure study, however, objects are usually painted more solidly, with whites placed toward the center of each form to suggest highlights. For an illustration, see Cézanne's *Oranges on a Plate* (p. 118), and Sargent's *Arab Woman* (p. 97).

THE LAYERED IMAGE

A second approach, which you might think of as a *printmaker's strategy,* is to conceive a watercolor in terms of multilevel colors, rather than the side-by-side marks and washes of the quick sketch. In a serigraph or woodcut, for example, the final image is developed through several printing stages, each adding a distinctive color or design element. The sequence of colors usually progresses from light to dark, so that bright hues, printed with transparent inks, will show through from underneath. And typically, there is a key screen or block that carries a detailed drawing of the subject.

As David Dewey shows us, much the same approach will work very well for a watercolorist with a feeling for structural design. A realist in the tradition of Sheeler and Hopper, Dewey brings a contemporary sensibility to paintings of somber Victorian mansions. His subjects are drawn with attention to both dynamic shapes and intriguing architectural details. And in paintings like

RITA DERJUE
Caletta, 1990
Watercolor,
15 × 22"
(38.1 × 55.9 cm)

The Tower and *Light Brown Victorian,* you can see how he builds images with flat washes painted across the page in layers—as if each new color were on a separate sheet of plastic film laid over the others. *The Tower,* for instance, was developed in three stages: (1) A pale ochre underlayer with hints of green and rose, (2) a mid-layer of intense violet that carries the key drawing of shadows, clapboards, and molding, and (3), a top layer of very dark accents—small squares, half-circles, awning stripes, and window frames.

As you see, *Light Brown Victorian* is conceived in much the same way, albeit with crisper washes and with darker architectural motifs painted on top, rather than as a middle layer. The main thing to note in these examples is the variety of effects one can achieve with the same strategy. You can stop early on, as in the first watercolor, or continue with more and more washes, as in the second. The clapboard facade of *The Tower,* for instance, could easily be developed further by giving it a specific color, say yellow or tan with white trim.

Another important option is to build toward climactic darks, as in *The Tower,* or dramatic lights, as in *Light Brown Victorian.* In the latter treatment, white window

areas are carefully saved during work on the brown facade, then tinted with bluish sky reflections and the green-gold glimmer of glass over drawn window shades.

Finally, let me emphasize that this printmaking strategy is just one application of a much broader principle—that of watercolor as an essentially multilevel discipline. Indeed, the medium's transparency makes it uniquely suited to layered approaches, ranging all the way from Dewey's systematically crafted work to the carefree style of an artist like Raoul Dufy, who painted squiggly brush drawings over joyous, haphazard splashes of color.

As we shall see later, most wet-into-wet painting—which begins with accidental effects—is based on the assumption of an initial vagueness followed by a layer of more detailed overpainting, whereas realists typically conceive their images in terms of *spatial* layers. Bluish background/neutral middleground/vivid foreground is a typical Fairfield Porter landscape format. And Carolyn Brady says she usually develops her still lifes from back to front, so that the edges of objects in each spatial layer are painted *on top of*—and thus visually *in front of*—everything that lies behind.

DAVID DEWEY
The Tower, 1982
Watercolor, 60 × 40" (152.4 × 101.6 cm)
Courtesy Tatistcheff Gallery, New York

DAVID DEWEY
Light Brown Victorian, 1982
Watercolor 42 × 30" (106.7 × 76.2 cm)
Courtesy Tatistcheff Gallery, New York

Sectional Development

A third approach to consider is the watercolor, based on a master drawing, that is painted bit by bit, one section at a time. You might think of this as a *quiltmaking strategy,* because it emphasizes flat shapes in a patterned design, rather than spatial depth. Compare the dimensional impact of Carolyn Brady's *Dark Ground* (p. 42), for example, with the almost abstract, flattened design of Sondra Freckelton's *Still Life with Star Quilt.* Here, everything is pressed against the wall, as it were, as a broken chair fades into brown floorboards, and

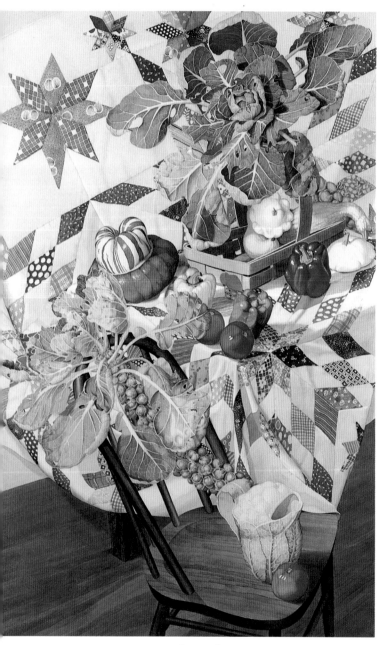

SONDRA FRECKELTON
Still Life with Star Quilt, 1989
Watercolor, 59½ × 40" (151.1 × 101.6 cm)
Courtesy Maxwell Davidson Gallery, New York

a bulky table laden with squash, tomatoes, peppers, and cabbages is lost in the folds of an enormous white and particolored quilt.

With the introduction of giant-size paper after 1970, the "minor" medium of watercolor suddenly took on major proportions, and working on the new scale obviously involves a greater investment of the artist's time. It takes Freckelton a month or more to complete a 40 × 60-inch still life like this, so painting each pepper and cabbage leaf separately, then fitting things together like the sections of a piecework quilt, becomes the natural way to develop the overall image.

Fortunately, this strategy works just as well on a modest scale, and I recommend it, at least as an experiment, for both beginners and advanced watercolorists. Your subject matter must of course lend itself to a drawing of rather compartmentalized, structural shapes. But within that limitation, the technique has the advantage of lending an air of assurance to whatever you do, and the degree of difficulty depends entirely on the number of "pieces" in your picture-puzzle. Though there are hundreds of chevron stripes in my *Pomegranate and Prickly Pear,* I have also used the technique in pictures with just four or five simple shapes. In the classroom, this approach is particularly effective with either abstract designs of futuristic planes or still lifes of structural objects like boxes and bottles reflected in mirrors.

Some words of advice, then, about things to bear in mind:

1. *Each section of your composition must be vivid and sharply defined.* You will find your own way, but I use masking tape—like the copper wire in cloisonné enamel work—to wall off a space that will hold a juicy dollop of paint while maintaining its crisp edge. Typically, I use just one tape strip, turning the paper so that fluid will drain down to it as I paint the area above it freehand. Excess fluid is then sucked up with a dry brush. While the wash is still damp, I often modify it with a blotter or tissue.
2. *Lay in sections selectively,* with the overall effect in mind. Instead of finishing any one area, try to suggest the whole image with representative bits and pieces, as in the early stage of *Pomegranate and Prickly Pear* illustrated here. I have carefully sampled the main colors and textures—blue glass, yellow banana, lime napkin, red glass box, striped chevron design—as a kind of outline of what was to follow.
3. And most important: *Be sure to create strong lights and shadows from the word go.* As small sections are painted, it is essential that they be held together by an overall lighting scheme. Thus the lightest areas— here the open book, stringed instrument, and white highlights on the fruits—are "saved" until last. At the same time, strong shadow patterns—cast by box, vase, bowl, and musical instrument—are brushed in as a brownish undertone for the varicolored stripes that will be laid over them later.

Pomegranate and Prickly Pear, first stage

CHARLES LE CLAIR
Pomegranate and Prickly Pear, 1988
Watercolor, 35 × 29¹/₂" (88.9 × 74.9 cm)
Collection of Mr. and Mrs. Anthony Richards,
South Orange, N.J.

STILL LIFE PROJECTS

At this point, you should paint several modest still lifes in order to gain confidence with the medium before tackling more difficult landscape or figural themes. As you proceed, you will need to have a plan in mind, and several approaches that might prove helpful are described in this chapter. The exercises outlined below represent practical applications of these strategies which my students generally have great fun with. As preparation for your own work, you would do well to try two or three of them.

EXERCISE 1
The white-on-white still life trains you to see modeling and cast shadows without the distraction of local colors. The set-up should be of white or off-white objects such as eggs, turnips, or onions on white drapery. Look for the contrast of cool bluish shadows vs. warm, sunny lights.

EXERCISE 2
Painting white objects and then coloring them arbitrarily, like Easter eggs, is an enlightening exercise. By painting things like tennis balls, boxes, or even white flowers with neutral shadows and then "dyeing" them imaginary

colors, you learn that the various layers in watercolor can have separate functions.

EXERCISE 3
The close-up arrangement, selected with a viewfinder from an assortment of random objects, provides experience in composing with unusual visual angles.

EXERCISE 4
The mantelpiece strategy of lining up objects at eye-level allows you to simplify the drawing and concentrate on interesting shapes and colors.

EXERCISE 5
Painting the same set-up under different lighting conditions shows how shadows can create abstract shapes and minimize unimportant details.

EXERCISE 6
The patterned still life offers another way of developing a dynamic composition. Place simple objects on boldly ornamented rugs, drapes, or quilts, and develop the painting as "piecework."

5 REALISM AND CLASSIC WATERCOLOR TECHNIQUE

Now that your studio experience is under way, it is time to look at the work of past and present masters of the medium to see how they solve problems you yourself are encountering. As in a thoughtful college course, the chapters of this book are divided between "studio sessions" centering in technique and "slide talks" that focus on historical backgrounds and contemporary ideas. Later we'll consider more experimental modes, but for starters you should be familiar with traditional, or classic, technique.

Watercolor is an ancient medium, but its modern use began in England in the 1780s with two very practical developments—the introduction of English dry cake colors and Whatman's innovative "wove" paper. Watercolor had been used since the Renaissance for studies and preparatory sketches, but having to grind one's colors fine enough and with the right amount of gum arabic was discouraging, and in any case washes sank into even the best paper, as if into a blotter. The new wove paper, on the other hand, revolutionized technique with a hard, glazed finish that permitted washes to float on the surface and be manipulated for some time before drying in.

Now English landscapists felt encouraged to specialize in watercolor, and the battle to recognize it as an independent exhibition medium began. William Blake, John Constable, and J.M.W. Turner did impressive work which, by 1812, was finally permitted in Royal Academy exhibitions. At this time, the medium was also promoted by a new phenomenon, the "colour man," or commercial art supplier. There were innumerable handbooks and further technical advances, such as the introduction in 1846 of Winsor & Newton's moist colors in metal tubes. These innovations, and the works of British painters, were shown in the Paris *Exposition Universelle* of 1855 just as the realist movement got under way.

CAROLYN BRADY
Detail, *White Tulip*
(page 69)

REALISM IN FRANCE

There is probably no more misunderstood art term than *realism,* because it is so readily associated with smooth "photographic" rendering. Although a fool-the-eye technique is sometimes a factor, it is as much the tool of a fantasist like Salvador Dali as of a factual painter like Jan Van Eyck; and more often than not, painters closely associated with realism—like Diego Velázquez, Frans Hals, and Edouard Manet—have preferred a broad painterly style. To avoid confusion, then, it is important to understand that realism has more to do with an attitude of impersonal candor than with this or that technique. The realist paints from direct experience, recording what he or she sees without undue editorializing—portraits that are unretouched, cityscapes with factories and smokestacks, and landscapes of familiar scenes instead of exotic places.

This was the attitude of the French novelist Gustave Flaubert, whose clinical study of small-town adultery, *Madame Bovary,* heralded the realist movement of the 1850s and 1860s, along with Gustave Courbet's "socialist" canvases and Manet's paintings of models and prostitutes. The realists matched frank subject matter with a new bluntness of treatment. Flaubert set down cold facts, while Manet used harsh front lighting, as in a modern-day flashbulb shot, and plaster-thick paint. For centuries, the subtleties of an "indirect" technique based on underpainting followed by layers of glazes had been in vogue. Now the realists painted "directly," seeking immediate impact with pigments straight from the tube. This became a widely accepted practice that encouraged interest in watercolor as another medium of comparable directness and immediacy.

Open-air painting, or *plein-airism,* was another phase of realism that helped to popularize watercolor. While Courbet and Manet were making news in Paris, Eugène Boudin (1824–1898) worked quietly at Trouville and Honfleur on the Atlantic coast painting small beach scenes and jotting notes on the back about time of day,

light conditions, and weather. Earlier landscapists like the Barbizon group had sketched outdoors but finished their paintings in the studio. Now, in 1858, Boudin and his eighteen-year-old protégé, Claude Monet, were working in an innovative way, directly from nature, intent on recording sunshine, fog, and rain. Later, in the 1870s, Monet went on to lead the impressionists, and painting directly from nature became linked with theories of instantaneity, accidental composition, and broken spectrum colors.

Clearly, watercolor is an ideal medium for the open-air painter wishing to capture a spontaneous, not-too-detailed impression, and Boudin's *Beach Scene, No. 2* is a perfect starting point for our look at historic work because it is the kind of picture any beginning watercolorist might want to attempt. Although the colors are those of a gray, cloudy day, one is struck by the verve of this little picture. Watercolor can be fun, and here we see that freshness is encouraged by simple procedure. There is only a quick pencil sketch, loose and animated, followed by a gray wash for the sky, a sepia wash for the sand (with a few added textural marks) and, finally, some pepper-and-salt accents and a single touch of red to suggest bathing tents and costumed figures. That is all. In contrast to canvas, which requires a fairly solid application of paint, a watercolor paper may be lightly brushed, with empty areas and only a few touches of color creating an effect.

This is essentially the image of watercolor we have grown up with. Although contemporaries like Pearlstein and Brady are currently showing 5-foot papers, monumentality is a very recent development. Before 1800, British landscapists established watercolor as a small-scale medium, and the 19th-century French open-air painters saw it as a vehicle for sketching the natural world and everyday events—the little things in life, like Boudin's beach scene. The Americans Homer and Sargent, as we shall see, descend from this tradition.

EUGENE BOUDIN (French, 1824–1898)
Beach Scene, No. 2, ca. 1890
Watercolor, 8¹/₈ × 12³/₈" (20.6 × 31.4 cm)
Philadelphia Museum of Art, Samuel S.
White III and Vera White Collection

HOMER AND THE WELL-MADE WATERCOLOR

Henrik Ibsen (1828–1906), the Norwegian author of *Ghosts* and *Hedda Gabler,* is known for his mastery of a tightly crafted form called "the well-made play"—a kind of small-cast, one-set drama that dealt with a single issue and was pursued later by such modern writers as Lillian Hellman and Arthur Miller. The American painter Winslow Homer (1836–1910) was a contemporary of Ibsen, and his treatment of man's struggle with the sea often parallels Ibsen's dark themes. More importantly, Homer and Ibsen also showed a common concern for economical, tight compositional structure. It is in this sense that I see Homer as the creator of the "well-made watercolor."

A self-taught Boston illustrator, Homer worked for *Harper's Weekly* during the Civil War, doing illustrations of everyday camp life whose startling realism attracted national attention. Visits to France in 1866 and 1867 introduced him to the work of Manet and other avant-gardists of the day. Upon his return, Homer explored a variety of themes—small genre scenes of rural life, portraits of women and children, and large-scale oils depicting the forces of nature, hurricanes, and heroic rescues at sea. The watercolors came rather late in a very long career, after he had settled permanently in 1883 at Prout's Neck, on the Maine coast, where his studio was an open deck over the ocean. For over thirty years, his winters were devoted to oil painting, while summers were for outdoor life—hunting and fishing in the Adirondacks, Bermuda, or Florida—and executing hundreds of watercolors.

Homer's orderly, workmanlike watercolor style is exemplified by *Fishing Boats, Key West,* a painting that reduces complex visual information to a few basic shapes. The scheme is simplicity itself. First, horizontal bands of violet-blue sky, slightly blotted to suggest clouds, and cerulean water, marked with a patch of wave-like reflections on the right. This establishes the setting, or "space," which I advise students to put in first, and in this case it would have taken all of ten minutes to execute the sky and water. But note that the artist carefully "saves" the central sailboat as a bright white center of interest, thus contrasting it with a shadowy boat and its dark reflections on the left. Then, as a final step, he brings the middle zone of human activity to life with small touches of rust-red and black. Thus the tyro who yearns to put in eyes, noses, and facial expressions should take note that in a Homer watercolor, figures and sailing gear—though carefully located in pencil—are in the end rendered as blobs and splashes by a dripping brush.

Such a sketchy rendering of sails dissolving in atmosphere, if not as daring as Monet's famous *Sunrise: An Impression,* seemed bold and innovative in the America of Homer's day. The style has been widely imitated over the years. But the remarkable thing about Homer is that he has been a model both for the watercolor "academy" and for some of our most progressive painters. This is because his work is direct, avoids rendering tricks, and has tremendous range, moving from an early conventional stance toward increasing adventurousness.

WINSLOW HOMER (American, 1836–1910) *Fishing Boats, Key West,* 1903 Watercolor, $13^7/8 \times 21^3/4$" (35.2 × 55.2 cm) Metropolitan Museum of Art, Amelia B. Lazarus Fund, 1910

Whether painting leaping trout, sponge fishing in the Bahamas, or Florida mangrove jungles, Homer had an eye for the design motif that would express his subject in purely visual terms. His *A Wall, Nassau,* for instance, is about narrow slits and things growing out of them. The idea is conveyed by pure geometry—blank bands of sky and wall pierced by two thin openings: a narrow vertical gate at the left and a horizontal slit of deep blue sea, drawn at the exact center of the paper. Gestural shards of broken glass lined up atop the wall form a secondary motif that is echoed in the windblown frangipani petals up above and rough textural marks on the plaster wall below.

Hurricane, Bahamas is composed in much the same way, but this time with somber, vehement shapes and colors that anticipate the expressionism of Charles Burchfield's early watercolors. Threatening curves of darkness descend in the sky from the left, while triangular rooftops press upward to form a funnel-like area of brightness against which squat palm trees whirl like dervishes.

Ultimately, Homer's greatness lies not in the bare bones of his compositional schemes but in the richness and invention he brought to them. Despite an isolated personal life, Homer was not, like Thomas Eakins, neglected in his time. As America's most celebrated painter, his self-estimate was shrewd. Asked by a biographer to evaluate his own work, Homer replied: "You will see; in the future I will live by my watercolors."

WINSLOW HOMER
A Wall, Nassau, 1898
Watercolor, 14³/₄ × 21¹/₂"
(37.5 × 54.6 cm)
Metropolitan Museum of Art,
Amelia B. Lazarus Fund, 1910

WINSLOW HOMER
Hurricane, Bahamas, 1898
Watercolor, 14¹/₂ × 21"
(36.8 × 53.3 cm)
Metropolitan Museum of Art,
Lazarus Fund, 1910

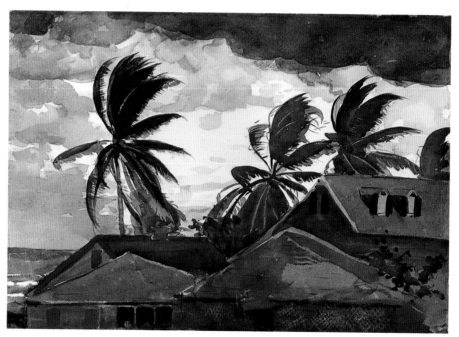

SARGENT AND EAKINS

John Singer Sargent (1856–1925) succeeded Homer as the premier American watercolorist in an almost perfect time sequence: Homer died in 1910, and Sargent took up watercolor around 1905, giving it his primary attention thereafter.

World-famous at fifty, Sargent had become bored with painting the society portraits that had made his reputation. During vacations in Italy, Spain, and the Swiss Alps, he found a second career in the watercolors that recorded these journeys. At first, he gave his travel sketches to friends, but a 1909 exhibit at Knoedler's created a furor whose magnitude it would be hard to envision today. Afterward, the Brooklyn Museum bought eighty watercolors, the Boston Museum of Fine Arts forty-five, and the Metropolitan Museum eleven.

Sargent was a dyed-in-the-wool realist. He often said he painted only what his eye could see, and while this isn't always evident in the portraits, which lapse into mannerism, it is a principle applied with distinction in the watercolors. He worked quickly, in one "go," and believed in painting almost anything he came upon rather than searching for the right subject. The result is a well of inventiveness in the face of unexpected situations. Where Homer's watercolors are orderly, Sargent's erupt and flow in unpredictable ways. The paint may be applied to dry or wet paper; marks may be distinct, blurred, or dry-brushed; and when the subject requires it, the artist is not averse to scratching into the paper or adding opaque colors.

In the Generalife gives us an idea of the total impression of people, incident, and environment Sargent was after. A portrait of Sargent's sister sketching in a Granada park with friends looking on, the watercolor owes something to Degas in its unrehearsed look and Japanesque perspective from above. Realistic elements move in and out of focus as they do in life when we glance casually at a scene. The head of a white-haired Spanish lady on the right is marvelously detailed, for instance, while the face of the central figure, Sargent's sister at her easel, is a blur.

In its general plan, the picture has the well-made look of a Homer, with the space divided by an imaginary diagonal from upper-left to lower-right corner into light and dark halves. Yet Sargent's brushwork breaks loose from this simple geometry with utter abandon. In contrast to Homer's clean wash style, Sargent uses a lunging stroke which is augmented by an under-drawing in wax crayon. As you see, the crayon's water-resistant marks trace white pavement circles on the left and create a zigzag flash of light on the greenery above the Spanish lady's head.

America's third great turn-of-the-century realist, Thomas Eakins (1844-1916), must also be considered here—despite a limited watercolor output—because of his distinctive ideas. Except for brief study abroad, Eakins (pronounced AY-kinz) lived out his life in Philadelphia. A teacher and director at the Pennsylvania Academy of

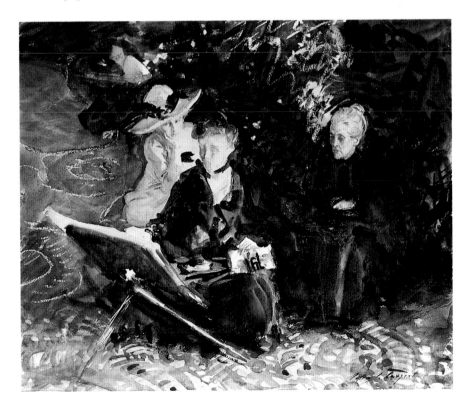

JOHN SINGER SARGENT
(American, 1856–1925)
In the Generalife, 1912
Watercolor, 14³/₄ × 17⁷/₈"
(37.5 × 45.4 cm)
Metropolitan Museum of Art,
Joseph Pulitzer bequest, 1915

the Fine Arts, he was forced to resign in 1886 because of his commitment to anatomical studies and—what was most shocking then—the notion that students should draw from naked models. This put a damper on a career that never achieved national recognition. There were few commissions, and—though he is hailed today as the most profound American painter of his era—the first major Eakins exhibition was held only after his death.

In contrast to Homer and Sargent, Eakins's brand of realism was based on scientific method rather than visual impression—on "knowing" rather than "seeing." And though watercolor attracted him as a vehicle for depicting sunlight, his major efforts in the medium—like *John Biglin in a Single Scull* or *Whistling for Rail*—employ such small dry strokes, carefully rendered musculature, and foreshortened objects, like guns and oars, that the result is closer to a tinted drawing than a full-bodied painting.

For our purposes, a modest figure study like *In the Studio* is more enlightening. A rather plain little woman poses eagerly for her portrait, and we sense Eakins's concern for the sitter as an individual. Where Homer or Sargent might describe her more charmingly with a few spots of color, Eakins painstakingly renders her gesture and facial expression, thus establishing a figurative "center of interest" to which all else is subordinate.

An unfinished work, signed by his wife after Eakins's death, this incomplete page perhaps gives a better idea of the artist's working method than if it had been finished. As you see, broad zones of light and dark have been established early on, and had Eakins continued, doubtless he would have maintained this structure—darkness above, as a frame for the portrait head, and a blaze of light below to unify the ornamental details of ball gown and sofa. The figure is blocked in with equal assurance: the crucial positions of head, hand, and toe (in the lower right corner) already determine the lady's gesture, and all that remains is to connect the points. There is an important drawing lesson here for students who, all too often, start in the middle of a figure and find themselves, at the end of a pose, without time for the head or room on the page for hands and feet.

Having painted only a score of watercolors during a brief period in the 1870s, Eakins has been less influential than Homer and Sargent, and his is an influence in the opposite direction, toward factual accuracy rather than fluency. Yet the faces of realism are various. And while many current watercolorists work with a classic broad wash style, others, as we shall see, approach the medium much as Eakins did, in a spirit of painstaking observation, rather than of easy charm.

THOMAS EAKINS (American, 1840–1926)
In the Studio, ca. 1875
Watercolor, 19 × 13¼" (28.3 × 36.2 cm)
Philadelphia Museum of Art, given by
Louis E. Stern

THE NEW REALISM: RETURN TO THE FIGURE

The most noticeable development in the contemporary watercolor scene is that, after centuries of small studies, suddenly *major* artists are doing *major* work in the medium. Not that the intimate watercolor has disappeared, for there will always be painters like Neil Welliver and Janet Fish, who divide their energies between large canvases and informal small-scale works on paper. But there is a new breed of watercolorist—Carolyn Brady, Sondra Freckelton, and P. S. Gordon, to name a few—for whom major achievement in the medium means working at the scale of an oil painter. Some artists even show works of up to eight feet long. Clearly, the genteel "minor" art of watercolor has come a long way.

The look of these watercolors is also quite new. Although it will always be important to save whites in the center of an image, the practice of leaving a halo of blank paper around the subject—in the manner of Demuth or Marin—has all but disappeared. As watercolors approach the scale of canvases, they tend to be painted to the edge of the composition like oils or acrylics. And the wide mats that make small sketches sufficiently impressive for hanging are hardly necessary anymore. Carolyn Brady still shows her large watercolors in heavily matted gilt frames, but in a recent one-man show, Philip Pearlstein's oils and watercolors were uniformly framed with narrow moldings, so that, from a distance, one had difficulty determining which medium was which.

More important than these developments, however, are changed attitudes toward figurative painting that were encouraged by the *new realism* of the 1960s and '70s.

After the heyday of abstract expressionism, this movement—led by artists like William Bailey, Jack Beal, Neil Welliver, and Janet Fish—saw representational painting as a vehicle for modernist ideas. In their view, realist art should be much more than mere factual reporting; instead, it should be about the same formal issues that challenge an abstract painter. And while the flood of books and exhibitions defining the movement is long since past, its founding artists have maintained their prominence, and its philosophy is now generally accepted.

Over the years, Philip Pearlstein has been the new realism's most articulate spokesman. A thoughtful painter and teacher, he has written a score of articles about the movement and his place in it. He has also been extensively written about. And his distinctive idiom—the foreshortened studies of models in a compressed studio space—is as instantly recognizable as that of a Jackson Pollock or Frank Stella.

Among the new realists, Pearlstein is also the most closely identified with watercolor. He not only gives equal attention to watercolors and oils, but the works on paper and canvas deal with similar themes and are of comparable scale and complexity.

Pearlstein is a man in love with the past, yet fully in tune with the present. A major achievement is his reconciliation of such traditional concerns as perspective, anatomy, portraiture, and landscape with post-cubist concepts of abstract form. This is nowhere clearer than in *The Great Sphinx, Giza*, which is at once a testament to historical grandeur and a model of spare, modernist composing.

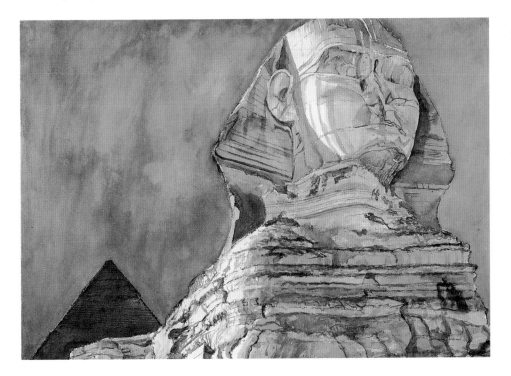

PHILIP PEARLSTEIN
The Great Sphinx, Giza, 1979
Watercolor, 29 × 41"
(73.7 × 104 cm)
Courtesy Hirschl & Adler
Modern, New York

Like Homer and Sargent, Pearlstein carries a paintbox on vacation trips, and it is interesting to compare his view of the Sphinx, painted during a Nile cruise, with the Winslow Homer watercolor of a Bahama hurricane we looked at earlier (p. 60). Both pictures feature triangular shapes stepping upward from the left. But where Homer gives us a full report—complete with waves, storm clouds, and whirling palm trees—Pearlstein offers a modernist's pared down image in which irrelevancies have been stripped away. There are just two objects—the pyramid and the Sphinx, whose headdress and body form roughly the same triangular shape. And instead of a traditional perspective of desert sands vanishing into the distance, he uses the stylized, shadowbox-like space of a Cézanne or Balthus. Drawn with an eye-level at the bottom of the page, the Sphinx appears as if on a bare stage, with the sky a flat blue backdrop behind it. Thus there *is* space, but it is a compressed space in which forms are pushed forward and stretched toward the edges of the picture frame—the tiny pyramid pulled toward a far corner, the enormous, surreal Sphinx looming like a giant cinema close-up.

Pearlstein is of course best known for his figure studies of nude and clothed models posed with bizarre costumes, furniture, and art objects. After decades of enthusiasm for abstract art, the 1960s were marked by a lively renewal of interest in the figure. Alfred Leslie, Jack Beal, Richard Diebenkorn, and Alex Katz are a few of the names that come to mind in this connection, but no one has been more influential or singularly devoted to figural themes than Pearlstein.

His innovations begin with a novel choice of subject matter. In *Two Seated Female Models in Kimonos with Mirror,* the figures aren't personal friends, members of the family, picturesque characters, or interested patrons. There is no portraiture, symbolism, or social cement here, or any of the themes usually associated with figure painting. Instead, Pearlstein's milieu is the studio itself—that is, the place where art is made—and his subjects are professional models who are posed and moved about like the inanimate props in a still life set-up. For anyone looking for the human interest of traditional portraiture, work like this may at first seem cold. But "objective" would be a better word, for Pearlstein's great contribution is a vision of the human figure as pure form—arms, legs, and breasts providing the same kind of visual interest as purely nonobjective shapes. In this, he was a pioneer. For though Picasso and other modernists had bent their figures into abstract shapes, Pearlstein was the first to make "abstract" arrangements out of naturalistic figural images.

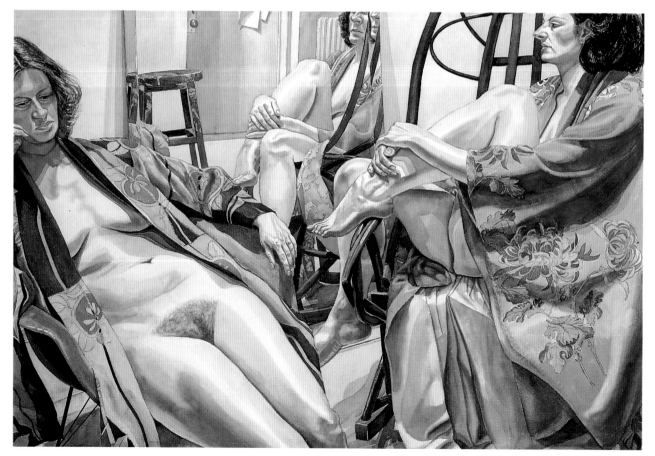

PHILIP PEARLSTEIN
Two Seated Female Models in Kimonos with Mirror, 1980
Watercolor, 40 × 59³/₄" (101.6 × 151.8 cm)
Collection of Mr. and Mrs. Henry Buchbinder, Chicago

To achieve this goal, it was necessary to adapt the techniques of direct painting to the forms and devices of abstract art. For starters, Pearlstein works in a small, tightly confined working area no bigger than a boxing ring. In an age of bigger and better artists' lofts, he crowds furniture, bric-a-brac, models, and his painting gear into a low-ceilinged, 16 × 16-foot space that provides a confrontational, close-up perspective. With his paintbrush only inches away from an outthrust hand or knee, heads may be cut off from his line of vision; foreshortening seems distorted, even when truthfully rendered; and fragmentary glimpses of furniture, like the metal tubing here, yield purely nonobjective shapes.

The result is a fractured imagery that is almost cubistic. Where Braque used literal paste-ons, Pearlstein creates the illusion of a "collage" of torsos and limbs, costumes, and mirrored reflections. The effect is further enhanced by artificial lighting. In Pearlstein's studio, windows are blocked out, and the only light source is two sets of three 150-watt spotlights, facing each other on opposite sides of the set-up. These tend to bleach out flesh colors, so that figures take on the pallor of sculpture. They also create crisscross shadow patterns that cut through the composition, pulling disparate elements together. Thus, in spite of Pearlstein's earnest rendering of anatomy, which is reminiscent of Eakins, his whirlwind treatment of drapery shadows has all the swinging, rhythmic power of a de Kooning.

You may be wondering how such powerful effects can be achieved in watercolor. If so, perhaps a footnote on Pearlstein's unorthodox handling of the medium is in order. The artist explains that, in a 5-foot figure study, he couldn't reach the top of his paper if it were laid on a table in the normal way. Instead, it is fastened to a foamcore backing with spring clips, positioned on an adjustable table, and turned up almost vertically. He then draws from life directly onto the paper with a round brush dipped in raw umber or raw sienna watercolor, sponging off and redrawing any marks that don't suit. He likens the effect to a fresco cartoon with its earth-color outlines, and the muscles, drawn with dotted lines, resemble fresco "pounce" marks. Also as in fresco, he develops the composition in sections— an arm, a leg, a kimono sleeve—rather than with the usual attempt at a general effect. And because spills are a problem in the vertical position, Pearlstein uses a tiny palette of dry cake colors that produce a thin watery mixture, rather than the juicy wash most watercolorists prefer. This is then carefully worked *into* the paper rather than floated glassily *over* it as in standard technique.

We see, then, that Pearlstein has evolved a highly personal way of using watercolor that is somewhat at odds with traditional approaches. One need only compare the mottled background in his *Sphinx* with a crisply washed Homer sky to understand that, as a tough-minded new realist, Pearlstein wants to avoid passages that might seem glib.

THE CONTEMPORARY STILL LIFE

Still life painting has an importance today that would have been unthinkable in an earlier age. One reason is that it is an ideal vehicle for the new realist concept of *direct painting*—the art of portraying precisely what one sees. Models move, skies cloud over, but studio light is constant and the tabletop set-up doesn't change.

Another reason is that still life is an analogue in representational painting for the nonobjective artist's experiments with shapes and colors. If art is to be judged for esthetic rather than literary content, as many believe, then pictures of apples and oranges are closer to pure form and less suggestive of "story" than paintings of people and places. Still life objects are like chess pieces that can be arranged more arbitrarily than other subjects, and there is the further advantage of a convenient scale. As we have seen, Pearlstein arranges his models in a similarly abstract manner. However, painting life-size figures is beyond the reach of many watercolorists, whereas a full-scale study of flowers or fruit will fit comfortably on a 22 × 30-inch sketch pad.

This is not to say that today's still life painters haven't made good use of oversized papers. But as Sondra Freckelton's *Still Life with Star Quilt* suggests, there is

a world of difference between an intricate arrangement of small objects and Pearlstein's massive figure studies. In the latter, a large format is required for a fully developed rendering; in the former, the choice of paper size is optional—depending on the number of objects you are dealing with. Although Freckelton's *Star Quilt* is twice as big as Janet Fish's *Bowl of Tomatoes* (p. 49), the tomatoes in each are painted life-size. There is just a lot more going on in the larger picture.

In any case, Fish and Freckelton are two of our more interesting painters, and one finds most of the hallmarks of contemporary watercolor practice in their still lifes. One of the original new realists, Fish captured worldwide attention as early as 1969 with an innovative still life format consisting of giant frontal views of plastic-wrapped supermarket produce. Since then, she has gone on to paint everything from gin bottles and water glasses to butterflies, goldfish, and crying babies—always emphasizing everyday subjects and unlikely combinations. All of this is done in oils, until the late 1980s, when she discovered watercolor. Since then, she has balanced her work on ambitious canvases with scores of watercolors, vacationing with paintbox in hand, much as Homer and Sargent had done.

JANET FISH
Package of Mixed Fruit with Chrysanthemums, 1990
Watercolor, 22³/₄ × 30 "
(57.7 × 76.2 cm)
Courtesy Hirschl & Adler Modern, New York

SONDRA FRECKELTON
Cabbage and Tomatoes, 1982
Watercolor, 36 × 33" (91.4 × 83.8 cm)
Courtesy Maxwell Davidson Gallery, New York

Fish's brisk, loosely handled technique is also in the tradition of these classic realists. In *Package of Mixed Fruit with Chrysanthemums,* the look of each object is set down with swift brushstrokes and a sense of overall wetness and brio. However, the commercially packaged subject, close-up perspective, and prismatic color strike a thoroughly contemporary note. Although not part of the pop-art movement that promoted Andy Warhol's Campbell's soup cans and Jasper Johns's American flags, Fish and other new realists have generally accepted its premise that the icons of mass culture are an appropriate subject for high art. Thus, where Homer delights in the watery glitter of a leaping channel bass (p. 106), Fish relishes the synthetic shine of plastic wrap on consumer goods, complete with supermarket logo and price tag. We note the mixed messages in this kind of imagery: enthusiasm for the new, affection for the artifacts of daily life, and also a certain irony or humor in making art out of lowly things. Above all, there is an effort here, as in much contemporary watercolor, to introduce an element of toughness that will counter the medium's traditional reputation for prettiness.

In Fish's work, color inevitably goes hand in hand with subject matter. Here the pop-art brightness of red, orange, lime, and green mixed fruits is matched by unnaturally vivid electric-blue shadows. You will find a similar all-out color intensity in most contemporary still life painting. Indeed, one of still life's main attractions is that it is more inherently colorful than other genres. Where the blues and greens of a landscape or the white walls and flesh tones of

a figure study tend to be limiting, still life backgrounds—tablecloths, rugs, and patterned drapery—can be as wildly colorful as the objects themselves. In *Still Life with Star Quilt,* Freckelton has chosen every element for its color intensity, and the rounded shapes of red, yellow, and green vegetables take their place, as pure design, alongside the bright diamond shapes of a patchwork quilt.

Freckelton and her husband Jack Beal are two of our foremost realists, but their areas of interest are different. Whereas Beal is known for his figure studies in oil and charcoal, Freckelton has devoted herself exclusively to watercolor still lifes in recent years. They have studios in Manhattan as well as in the country, where Freckelton finds material for the celebration of early American quilts, antique furniture, and farm-fresh produce that has made her famous. Her cheerful subjects are a far cry from pop art's funky cheeseburgers and Brillo pads, yet they too are icons of popular culture, presented with a glossiness and kinetic energy that give them a contemporary edge. Here, Freckelton's squashes, peppers, and tomatoes are typically thrust forward, as if rolling out of the picture, with one piece about to fall into the viewer's lap. As in *Cabbage and Tomatoes,* the artist's "natural" produce is shown in an unnatural spotlight glare that casts theatrical shadows and puts a perfect highlight on each plump, blemish-free tomato.

The most impressive aspect of Freckelton's work, however, is the way in which she has updated classic watercolor technique. *Cabbage and Tomatoes,* for example, is a perfect model for the basic techniques we considered in Chapter 2—the background wall an immaculately rendered *flat wash,* the giant cabbage leaves shaped with marvelously smooth *gradations,* and their contours varied with intricate reverse *edge shading.* The color here also has the freshness and transparency of a Homer or Sargent. Yet there is no splash or dash in Freckelton's work, and the traditional emphasis on spontaneous brushwork is replaced by a computer-age smoothness in which the artist's "handwriting" is erased.

Despite countless individual differences, most of today's new breed of watercolorists use the medium with a greater sense of weight and formal structure than has been seen in the past. In this context, Freckelton and Fish show us alternative paths toward a common goal. One way to go is to give the work a smooth, impersonal surface that emphasizes abstract color areas and sculptural shapes. We see this in Freckelton's smooth-as-silk washes and Pearlstein's fresco-like modeling. The opposite path, taken by watercolorists like Janet Fish and Bernard Chaet, is to emphasize rather than eliminate personal brushstrokes. This harks back to de Kooning, Pollock, and the concept of art as "action painting" based on gestural marks. As we shall see, the changeable forms of foliage, clouds, and water in landscape painting are particularly well suited to a gestural approach.

THE GREAT AMERICAN LANDSCAPE

There are many outdoor painters today, but I can think of no one more directly in line for Winslow Homer's mantle as interpreter of the great American landscape than Neil Welliver. Mind you, I don't mean just any landscape, but our country's mythic vision of pioneer vastness, sporting pleasures, and grandeur unspoiled by city folk—the landscape of the Hollywood western, Hemingway, and the Hudson River School.

Welliver keeps the dream alive with paintings that celebrate the natural preserve he owns in Maine, not far from Homer's studio in Prout's Neck—an estate of 1,200 acres that includes a mile along Duck Trap River as well as several lakes and streams. Thus, like Monet, with his famous water lily gardens at Giverny, he has surrounded himself with an ideal environment that provides the imagery for his paintings.

The artist is known for a uniquely "gestural" or "painterly" brand of realism. On canvas, this means working with heavily loaded brushstrokes that alternately "create and destroy" shapes with their exuberant rhythms. Like the color patches in a mosaic, these separate marks fuse into a coherent image only when one stands back a little. And they are developed, as in a mosaic, area by area. Working from a color sketch and a scaled-up drawing, Welliver starts at the top of an 8-foot canvas and continues painting to the bottom edge without ever going back.

While the watercolors are also composed of separate marks, they are applied in a different order—rhythmically around the page, so that each stroke will be dry before a neighboring stroke is added. The artist, incidentally, prefers printmaker's cover paper, because its hard, pebbled surface gives sharper definition to his brushmarks than regular watercolor stock. As you can see in *Study for "Trout" #2* (p. 32), these marks are actually small puddles. They are made with a vertically held brush on a level surface, and the excess fluid in each mark is allowed to dry with a little ring like a rain puddle.

In discussing his work in the medium, Welliver says: "I don't do many watercolors, but those I *do* paint are choice." Thus, in contrast to Fish's prolific output of swiftly noted impressions, his watercolors are carefully structured studies for images that will be developed further in either oils or print editions. There are often several variations on a theme, and as with the paintings of trout we saw earlier, the subjects are usually close-up views of woodland creatures in a rather small format. In studies of merganser ducks, a long-legged heron, or a

startled deer, Welliver re-creates his subject with a fireworks display of stylized marks—dot-dot-dot lines for rippling water, wheat-like sprays to indicate foliage, and softly brushed marks to suggest feathers.

Welliver's marvelous *Study for "From Zeke's" #2* is something else again, since it is the study for a large, panoramic canvas, rather than an intimate scene. Accordingly, the gestural marks are greatly reduced in size and boldness. Still, the diagonal rhythms of the turbulent clouds are powerful, and each of the forest zones has a distinctive calligraphic motif—dark peppery marks where pine trees catch the sun, frond-like strokes where they are in shadow, and twisted driftwood shapes in the rocky foreground.

Finally, we see how much Welliver makes of a very few, rather muted colors. This is in distinct contrast to the vividness of Freckelton's and Fish's work, and, indeed, to the contemporary preference for colorful effects. Yet it is no accident, because the artist's technique of varicolored gestural marks carries with it an automatic repetition of color threads, as in a tapestry. Hence, you won't find solid or isolated color areas in a Welliver landscape. Instead, he creates a chord of six or seven distinctive color mixtures for each painting and then combines them in various interwoven layers. In *Study for "From Zeke's,"* the color chord is blue, two or three shades of gray, raw umber, greenish black, chartreuse, and a touch of coral in the foreground branches. Each spatial zone is then layered with two or three hues—the clouds modeled in blue and gray; the sunlit treetops in chartreuse and black; the shadowed pines, first in a band of bright blue and black, and then in a darkened zone of umber and black. In addition to these horizontal relationships, Welliver also integrates colors vertically by lifting foreground grays into the sky and dropping bits of yellow-green from the treetops onto the ground.

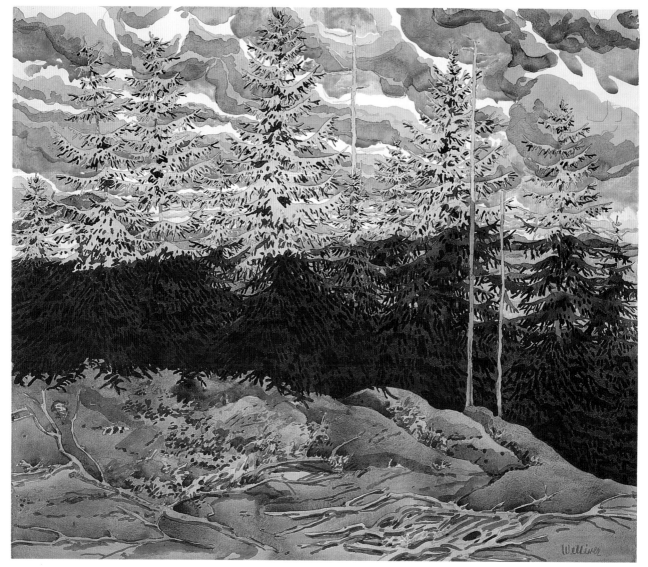

NEIL WELLIVER
Study for "From Zeke's" #2, 1980–92
Watercolor, 29½ × 34¼" (74.8 × 87 cm)
Courtesy Marlborough Gallery Inc., New York

PHOTOGRAPHIC REALISM AND UNREALISM

Artists have used photography in one way or another since the time of Delacroix, and today it is at once an independent art form and integral to other fine-art processes. Nevertheless, among figurative painters, dependence on photography is a hot issue. Critics and museums separate the realists from the photorealists, and these aren't always folks you would invite to the same party.

I say "dependence" on photographs because the issue isn't that of using snapshots for reference (which almost everybody does) but of making photographic imagery central to one's style. Some people feel this is uncreative, while others see the camera as expanding our visual horizons. My own feeling is that photography can be either a trap or an inspiration, depending on how you use it. In general, art students should be discouraged from drawing from slide projections or painting from photographs instead of seizing every opportunity to work from life. Still, these techniques do have their place. And it is important to understand the esthetic possibilities that have interested

many of our leading painters in photographic processes. Carolyn Brady's work is a case in point.

Brady is a Baltimore artist whose career took off with a bang during the 1970s and who has gone on to become one of our most technically brilliant and conceptually interesting watercolorists. Indeed, a handsomely illustrated catalogue raisonné traces her progress from tiny 9 × 12-inch parodies of *House and Garden*-style illustrations, done in 1972, to the monumental 78 × 44-inch Versailles garden watercolors of 1990.[1] And throughout this development one sees that Brady's themes are drawn from a world of household and family life in much the same way that Welliver's come from the outdoors, and Pearlstein's from the studio.

The iconography of *White Tulip* is typical: lush flowers and plants, reflections on glass and polished furniture, fond possessions like husband Bill Epton's small torso sculptures (seen behind and through the fishbowl), and books whose titles can be read either as abstract texture

CAROLYN BRADY
White Tulip, 1980
Watercolor, 32 × 44" (81.3 × 111.8 cm)
Courtesy Nancy Hoffman Gallery, New York

or as words like "sewing," "sculpture," and "Chinese Painting" that evoke a way of life. The painting's design—with its densely layered foliage, intriguing objects, and glittery lighting effects—is characteristic of the artist's work. "I was trying to overwhelm and confuse the whole picture surface," Brady says of this complicated set-up, in which crystal jars of flowers and a fishbowl are surrounded by a splintered jumble of mirror reflections from a glass-fronted bookcase.

During a visit to Brady's studio some years ago, I saw that the enormously complex, faceted patterning of a realistic work like this was made possible by the artist's use of camera-generated images. And though I had always painted from direct observation, I soon became a convert to her working methods. For a still life like *White Tulips,* Brady photographs her set-up, using natural light, Kodacolor film, a tripod, and long exposures of about ¼ second. She avoids the color slides many artists use, preferring instead to paint from 11 × 14-inch color prints, which provide more information and are less deceptively glamorous. For the initial pencil drawing, she projects the 35mm film negative onto paper pinned to the wall. Afterward, the artist sits at a giant antique drafting table with cast-iron legs, her paper laid loosely on the top and the slant adjusted low enough to permit work

from any of the four sides. The watercolor is then painted in sections, completed one at a time, and fitted into the pencil outlines like pieces of a jigsaw puzzle.

Photo techniques are fascinating, but it is important to understand what the role of photography *is* and what it is not. The camera's great advantage is the ability to provide information more swiftly and completely than the naked eye. Lettering the titles on Brady's bookshelf by hand would have taken hours, compared to tracing them from a slide projection in minutes. Furthermore, the amount of detail recorded in the fishbowl is doubtless greater than if the artist had worked from the actual object, because in real life, glass reflections constantly shift and change. Flowers wither and fade, too, but not in photographs. With a camera, the artist can also gather material in situations where it would be impossible to sit down and do a direct painting. Hence, in recent years, Brady has turned increasingly to outdoor subjects based on photographs taken during summers in Maine or visits to France.

Despite the camera's usefulness as a recording device, however, Brady and other photorealists will tell you that the main reason for using the little black box is that it abstracts so much. No matter how factual a snapshot may seem, it is actually faithful only to those details that

CAROLYN BRADY
Souvenir of Paris/Coffee Macaroon, 1991
Watercolor, 20 × 30" (50.8 × 76.2 cm)
Courtesy Nancy Hoffman Gallery, New York

are in a good light. Hence, the horrible flashbulb shot that illuminates everything, recording our freckles and shoelaces in living color. Abstraction rears its head, on the other hand, the minute interesting shadows appear or when areas are simplified by a spotlight's glare. Thus in Brady's *Souvenir of Paris/Coffee Macaroon*, dark shadows, dark coffee, and dark pastries are in sharp focus, whereas the whites of china and napery have been bleached out by overhead lighting. Remember, too, that the photorealist can select from any number of shots taken at various times of day or from different angles.

The camera's dynamic perspectives are yet another source of visual excitement for the realist. You see, in a traditional interior or still life painting, horizontal floors and tabletops are drawn diagonally toward a distant vanishing point, whereas vertical surfaces like windows and doors appear in their normal proportion and upright position. This perspective assumes a head-on view, however, and the minute you raise or lower your gaze, vertical surfaces also become foreshortened. It is easy to recognize extreme examples: looking upward at a skyscraper soaring into the heavens, or downward at an elevator shaft. But the point is that the camera picks up such foreshortening even in everyday situations that would normally go unrecognized.

This is especially noticeable in close-ups of small still life objects. In the *Time Sequence* watercolor we saw earlier (p. 48), for example, Leigh Behnke draws her still life in the traditional way—tabletop, plates, and silverware with diagonal foreshortening, but wall panels, file cabinet, and wineglass stems in a severely upright position. Any candid photograph of this set-up, on the other hand, would give these verticals a distinct downward slant toward a vanishing point at the viewer's feet.

And Behnke says that, as a photorealist working from slide projections of typically architectural subjects, it is her practice simply to "correct" such off-kilter lines.

In an otherwise similar tabletop still life, *Souvenir of Paris*, Brady takes the opposite approach—emphasizing rather than minimizing the distortions of a close-up camera lens. Her coffee cup is drawn at a rakish angle rather than straight up, and we are made to feel the spatial tension between this foreground cup tilting toward us and a distant plate pulling in the opposite direction. The result may be less orderly than the traditional Renaissance view of things in a box-like space, like a stage set, with walls parallel to the sides of the picture frame. But it does make for greater immediacy or verisimilitude, on one hand, and more dynamic shapes and rhythms, on the other.

Tracing the realist movement from Boudin's *plein-air* painting to Brady's photorealism has brought us full circle—from the 19th-century artist confronting nature in the raw to a modernist interpreting it at total remove from her subject, with only a color print as a guide. That is why I propose photo-*un*realism as the more logical name for what today's painters are doing with camera information. The significance of their pictures is not that they look so terribly *real*, but that they are in fact so *abstracted*—stylized and impersonalized by an indirect mechanical device.

In this respect, Brady's method is akin to Roy Lichtenstein's reduction of images to Ben Day dots and Chuck Close's use of a tonal grid. Thus Brady is an innovative modernist, yet, at the same time, every inch a watercolor stylist in the classic tradition. Her compositions are as well-made as Homer's and her washes as luminous and assured as Sargent's.

CONCLUSION

The realist movement cannot be fully defined by the achievement of a few individuals. Yet the artists considered here are all masters of a broad, painterly watercolor style that is at once historically important and immediately pertinent to your study of the medium. There is no more important first lesson than reducing a subject to a few planes that can be realized with broad washes.

These artists also share a concern for systematic procedures—another essential attitude for the watercolorist. Throughout this chapter, I have hammered away at the idea of a well-made watercolor—not because there is any

morality in it, but because of its practicality. Joseph Raffael says one of the "great lies" art schools teach is that watercolor is difficult while it is really the "easiest of mediums." I would agree, but with an important proviso. The truth is that watercolor is easy, if you are willing to use it in an orderly way; yet it can be discouragingly difficult for the person who likes to simply start out and then see what happens.

1. Irene McManus, *The Watercolors of Carolyn Brady, Including a Catalogue Raisonné: 1972–1990*, New York: Hudson Hills Press, 1991

6 THE "MARK" OF A LANDSCAPE PAINTER

In spring a young man's fancy turns to love, and good weather in any season turns an artist's thoughts to working out-of-doors. For some painters this is such a key factor that watercolor becomes a seasonal activity. Sargent and Homer painted on paper during the summer and on canvas in winter, unless there was a trip to sunny Spain or the Bahamas. Others use watercolors year round but adapt their working habits to the weather. Patricia Tobacco Forrester paints landscapes in July and greenhouse flowers in January, while Susan Shatter does small on-site studies in summer that she enlarges later in her New York studio.

Art school students usually get a chance to work from nature when autumn leaves turn and again when spring flowers are out—in short, somewhere in the middle of our "watercolor course," which is where I have put this chapter. Landscape isn't the place to start with watercolor, in any case, because—in contrast to an interior study—it involves unlimited space. In a landscape you must cope with hundreds of things—plants, trees, clouds, waves, rocks, houses—that require a tremendous amount of simplification. Thus it is a great help to have painted a box before tackling a barn, or to have rendered a leafy branch before coping with a tree.

When you finally do confront the vast outdoors, it will be hard to avoid a few failures, what with the sun in your eyes and ants crawling on your palette. However, there is an enormous sense of freedom that studio work cannot provide. My recommendation, then, is to try a few landscapes after you have developed confidence with watercolor, and then to alternate outdoor and indoor subjects—the one encouraging improvisation, the other, more definite structure.

Typical Landscape Formats

Composing a landscape begins with proportions. Just as a strip of blue will suggest sky or water in an otherwise abstract painting, so horizontal bands of light and dark evoke a landscape image—sky, land, and horizon—even when there isn't a sailboat or lighthouse in sight. Turn the paper around to a vertical position, and the viewer will imagine upthrusting trees or cliffs.

Before starting, then, you must decide on a format. For a fully developed *land*scape, the picture will probably be horizontal with bands representing sky, distance, middle-distance, and foreground, as in Fairfield Porter's *Maine Towards the Harbor.* But if certain motifs interest you, a vertical *tree*scape like Porter's *Door to the Woods* or a squarish *house*scape like Demuth's *A Red-Roofed House* (p. 27) may be in order. Janet Fish's *Violets and Toy Plane* (p. 78) illustrates yet another rather compact format that focuses on the interwoven patterns of tangled vegetation. So when you take out your sketch block, don't just start to work mechanically. Decide first whether the paper is to be horizontal or vertical, and then consider its proportions. If the picture you envision is narrower or squarer than the shape of your pad, use ruled pencil lines to define new margins.

The advantage of a basic landscape format is that it organizes random objects into clear spatial zones according to a classic formula. Things in the distance and middle distance are shown as flat, banded shapes in neutral values and in colors modified by the bluishness of the atmosphere. The foreground, meanwhile, is developed with contrasting darks and lights as well as with more detailed information. Thus, though Porter's *Maine Towards the Harbor* is painted rather freely, with splash and dash rather than attention to detail, the illusion of spatial depth is carefully maintained. A narrow strip of gray-violet suggests a distant shoreline; a firmer version of the same color is used for the harbor islands; and, in contrast to these hazy passages, the foreground knoll is awash with golden tones and topped by a fringe of snappy green-black and blue-black pines. The overall effect, then, is like a series of stage backdrops in which strong darks are kept up front, while distant shores get thinner and lighter as they fade from view. One further refinement should be noted for a landscape (or *sea*scape) that includes a body of water: namely, that the hues of sky and water need to be differentiated. As you see, Porter does this rather cleverly by bringing a touch of the foreground yellow into the sky.

If Porter's watercolor shows what can be done in an hour or so, Homer's *Flower Gardens and Bungalow, Bermuda* is the kind of project I would recommend for anyone interested in a more detailed rendering that will take two or three sessions. In overall design, it adheres to the same basic format—the sky, sea, and distant shore rendered as flat bands of atmospheric color, while the

Fairfield Porter (American, 1907–1975)
Maine Towards the Harbor, 1967
Watercolor, 11⁷⁄₈ × 18⁷⁄₈" (30.2 × 47.9 cm)
Collection of Mr. and Mrs. David A. Swiger, Rye, N.Y

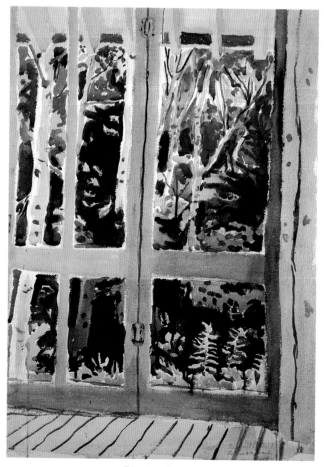

Fairfield Porter
Door to the Woods, 1972
Watercolor, 27³⁄₄ × 22³⁄₄" (70.5 × 57.8 cm)
Collection of Mr. and Mrs. David A. Swiger, Rye, N.Y.

foreground is painted with vivid hues and strong darks and lights. There are significant differences, however. For one thing, in contrast to Porter's rough pencil sketch, Homer's approach requires a precise drawing of all foreground elements—here, the bungalow, banana leaves, palm fronds, and even the stems and blossoms of small flowers. And for another, it calls for rounded forms and subtle modeling, rather than the flat shapes Porter uses. Despite the effect of jungle overgrowth, we also see that Homer's garden is skillfully edited with a banana tree singled out for dramatic shading and a floral border in which certain plants are caught by the light while others are lost in shadow.

Although most of Homer's watercolors feature horizontal vistas, when the subject is a towering palm or a grove of trees hung with Spanish moss, he turns to a vertical format. An upright composition is also appropriate for the interior/exterior view in Porter's *Door to the Woods*. This is a theme favored by contemporary realists because it cuts through the conventions of traditional genres. A view through a window or doorway not only combines landscape and interior imagery but sets the stage for still life and figures as well—a woman in the garden, children's toys inside the house, and so on. The interior/exterior format also produces a compressed, shadowbox space that is very much in line with modernist thinking. Without the doorway's grid-like framework, the artist would have had to cope with foreground and distance. But as it is, spatial depth is restricted, and the trees outside seem pressed against the glass as if in a shallow display case.

Porter (1907–1975) had an unusual career. Known first as an affluent art collector with a circle of friends like de Kooning and Bernard Berenson, he became a critic for *Art News* and then, in his forties, began to win a reputation for his own work, which has steadily grown in importance. He is a particularly good role model for art students because, though a sensitive painter, his technique is quite simple and within the average person's reach.

A more fully developed painting than *Maine Towards the Harbor, Door to the Woods* offers a number of insights. It is notable, first of all, for having a clearly defined, visually arresting motif—silvery vertical bands that are repeated in various ways as birch trees intermingle with the framing strips of a folding door. Its focus on the positive *light* image of white birches and off-white woodwork, set against recessive darks, is also interesting. This of course illustrates the "think white" principle we considered in Chapter 4. It isn't "better" than the reverse system of aggressive darks and recessive lights Porter uses in *Maine Towards the Harbor,* but it is a more sophisticated approach, one especially suited to the medium.

The most valuable lesson to be learned here, however, is evident in Porter's treatment of his doorway—the vertical strips fairly upright on the left, but more and more wobbly on the right side. In this situation, nine out of ten artists would have painted the interior architecture with straight lines as a contrast to the fluid shapes of the forest outside. Yet look at Homer, Cézanne, Marin, or any master watercolorist, and you will find that a measure of their success is the ability to portray disparate things with the same painterly rhythms. So, since a precisely drawn doorway would call for an equally careful rendering of the scene outside, Porter takes the opposite course—painting both landscape and doorway in a loosely brushed, consistently animated style.

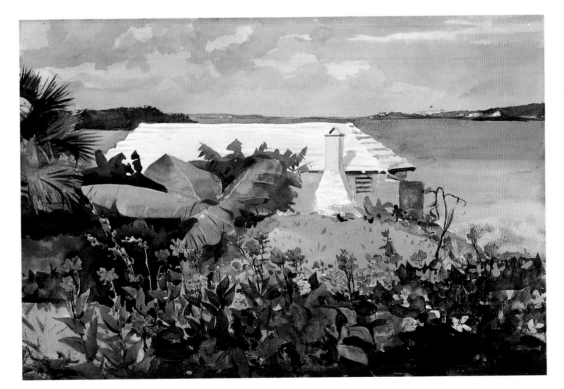

WINSLOW HOMER (American, 1836–1902) *Flower Gardens and Bungalow, Bermuda*, 1899 Watercolor, 14 × 12" (35.5 × 53.3 cm) Metropolitan Museum of Art, Amelia B. Lazarus Fund, 1910

BRUSHMARK TECHNIQUES

The painter's mark is as unique as a thumbprint. And Janet Fish's *Wild Grapes and Flowers* demonstrates the expressive power that can be generated by brushstrokes set down as a kind of personal handwriting. Although handling broad washes is the first order of business for a watercolorist, Fish shows how forms can also be shaped by linear brushmarks. In a stunning burst of energy, she has given her picture both an overall circular rhythm that swings around and away from the corners and a distinctive linear motif for each object—swirling purple drapery folds, green and yellow striations on a crystal vase, concentric circles on a magenta glass plate, and so on.

There isn't always a clear-cut distinction between washes and marks, but in most situations you will want to start a picture with generalized tones—as Fish does with broadly painted grass-green and lavender washes—and then gradually shift to more definitive brushmarks. It is also axiomatic that the technique must fit the subject, and hence, though still lifes and figure studies can sometimes be done in a linear mode, landscapes offer far more opportunities for gestural treatment. You will find, on one hand, that the basic elements of a landscape painting—clouds, waves, rocks, mountains, trees, and foliage—translate quite naturally into the Morse code of a stylized brushmark vocabulary. And on the other, you will discover that there are so many small things to cope with in a landscape that it is more effective to suggest them with marks than to try to "paint them out."

Where Fish's brushmarks refer to specific objects, the thrusting ribbons of color in Bill Scott's *Riverbank* evoke a more mystical, atmospheric space. We *do* assume a vague landscape image here—perhaps a foreground fringe of trees, then a body of water and a distant shore with the sky above. But nothing as concrete as the scene that actually inspired the watercolor—a view of the Seine at Vétheuil, France, with riverboats and smoke from a pile of burning leaves rising in the distance. For Scott is an abstract painter rather than a realist—an artist interested in lines and colors that are a response to nature but that cut loose from specific references. The result is a fireworks display of slashing, stabbing, whirling—and, ultimately, emotionally expressive—marks.

From a technical standpoint, working with linear marks is like painting washes, only easier. Your brush should be loaded with a rich pigment solution and your strokes are best done fairly slowly, though with an impression of speed, so that fluid can flow evenly onto the paper. And there is no need, as with broad washes, to smooth things out by sucking up excess fluid. As in *Riverbank*, damp spots, dry spots, blots, drips, and splashes all add textural variety and heighten our awareness of the artist's physical involvement in what is an essentially gestural process.

The watercolors of John Marin (1870–1953) are particularly rich in textures, since they were executed outdoors in wind and ocean spray on very rough paper that was often in various stages of dampness and dryness.

JANET FISH
Wild Grapes and Flowers, 1988
Watercolor, 30 × 37¼"
(76.2 × 94.6 cm)
Courtesy Robert Miller Gallery,
New York

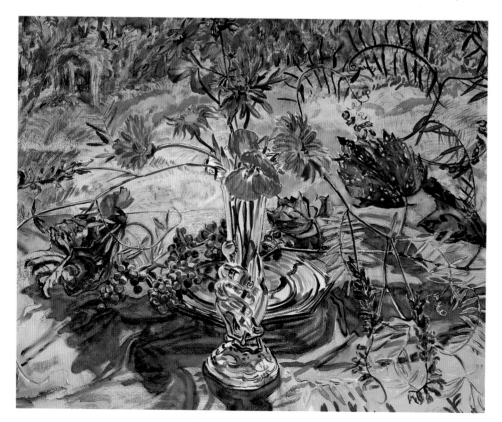

In *West Point (Casco Bay), Maine,* for instance, you can see how Marin develops the sea in three layers: first, pale wave marks that have dissolved and lost their shape; then a layer of light but distinct marks in the center; and a final block of dark ultramarine strokes on the right. For a beginning landscape painter, the lesson is clear. A similar build-up will work for any large textural area—a cloud-swept sky, mass of foliage, field of wheat, or mountain range. The trick, however, is to use no more than three clearly defined light/medium/dark values, and to be sure that these layers maintain their separateness and don't run together.

Like Demuth, Arthur Dove, Charles Sheeler, and other early 20th-century American modernists, Marin sought to transform everyday subjects with the expressive devices of abstract art. Fascinated by the elemental power and changing moods of the sea, he developed a technique of simplification and distortion that reduces natural forms to stylized shorthand. His view of Casco Bay, for instance, is composed like a Wagnerian opera with symbolic leitmotifs—zigzag needle-like marks for pine branches, plump brush-plops to indicate waves, ray-like strokes to suggest sunlight breaking through rain, and snake-like brown outlines for the rocky shore. Thus Marin's landscapes are neither as abstract as Scott's nor as realistic as Fish's. Instead, they emphasize a middle ground of personal interpretation, rather than literalism, that is shared even today by the majority of our artists.

Finally, to round out this discussion it should be noted that, while light brushmarks can be used effectively in opaque oils or gouache, the marks of a watercolorist

BILL SCOTT
Riverbank, 1989
Watercolor on Stonehenge paper, 15 × 11¼" (38.1 × 28.6 cm)
Courtesy Prince Street Gallery, New York

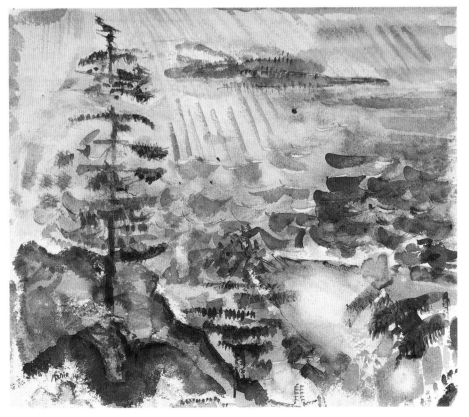

JOHN MARIN (American, 1870–1953)
West Point (Casco Bay),
Maine, 1914
Watercolor on off-white wove paper,
14⅛ × 16⁷⁄₁₆" (35.9 × 41.8 cm)
Metropolitan Museum of Art,
Bequest of Charles F. Ikle, 1963

inevitably appear as dark lines on a light ground. Hence Fish's portrait of wildly tangled grasses, *Violets and Toy Plane,* is an anomaly—a study of gestural rhythms that is, nevertheless, painted with calm deliberation. The reason, of course, is that the outlines of the pale grasses

can't be tackled directly with *positive* brushmarks, as they would be if the medium were gouache. Instead, they must be shown indirectly by painting the *negative* shadows around and between each separate blade or clump of grass. This requires a detailed pencil drawing and a degree of precision that is a far cry from the fun of working with positive brushstrokes. In short, it is a difficult approach, but one that can be useful for the advanced watercolorist. This is the way you would paint the stems and leaves of a bouquet, for instance.

Although *Violets and Toy Plane* is a technical tour de force, the question still arises as to why such an elaborate process should be necessary when the painting could have been done much more simply in gouache with light strokes on a dark, tonal ground. The answer is simply that the loveliness of a transparent rendering is worth it. Gouache is a wonderful medium, too, but it has a more solid, pastel-like character. This is not to say that the two mediums can't be mixed. In fact, many watercolorists (including yours truly) heighten their work with occasional touches of gouache, and Fish is no exception. In *Wild Grapes and Flowers,* you can see the judicious use of opaques on the lower right, where light green branches are painted over a darker violet tablecloth. And in *Violets and Toy Plane,* a patch of grasses on the upper right is highlighted with opaque white. To be successful, however, such opaque additions must be scattered touches that can be tucked in without disturbing the overall effect of transparency.

JANET FISH
Violets and Toy Plane, 1989
Watercolor, 23 × 30" (58.4 × 76.2 cm)
Courtesy Robert Miller Gallery, New York

MODERNIST LANDSCAPE IDIOMS

The paradox of landscape painting is that infinite space is depicted on a flat surface. The classic format, as we have seen, resolves the contradiction by simplifying vistas into near and far zones, like friezes, parallel to the picture plane. This approach, used since the Renaissance, is by no means out-of-date. It is often favored by photorealist painters, and it can also be employed abstractly with flat shapes, such as the silhouettes of dark foreground trees against pale distant mountains in Japanese prints. Thus the traditional format of land, sky, and horizon continues to be a contemporary option.

Yet there are other ways of looking at landscape, as Fish's close-ups of outdoor subjects—omitting the sky and all sense of extreme distance—show us. In part, this is a response to today's candid camera shots and cinema close-ups. But the emphasis on a shallow visual field is also a basic tenet of modernism that has historical roots in the strategy of Cézanne and the post-impressionists. I call this the "bas-relief principle," because a typical Cézanne, like *Trees and Rocks, No. 2,* is conceived like a design lightly cut into a flat surface. Cézanne's paper has yellowed with age here, since he didn't always work on

good rag stock, and his violets and greens have dimmed. Yet we can still see how he outlines positive tree branches, then scoops out negative spaces with small strokes that seem to recede but never actually go back very far. Typically, the foreground is unpainted, and there is no real background, because solid areas, like an identifiable blue sky, are studiously avoided. Furthermore, the horizontals and verticals one expects to find in a landscape are eliminated in favor of a network of diagonals that has no horizon line or specific gravity.

This is the language of abstraction—or "significant form," as the critic Roger Fry called it—that dominated modern art after 1910. Instead of imitating nature, painters from Demuth to de Kooning learned to translate it into pictorial equivalents that could then be rearranged at will. The key to this translation—or "analysis," in cubist parlance—was the separate brushmark that could reduce coherent objects like trees and mountains to disconnected small planes. Cézanne fathered these ideas and was largely responsible for the emergence of a modernist watercolor style based on little touches rather than conventional broad washes.

Aside from its esthetic importance, Cézanne's technique can be helpful on a purely practical level. Whereas Homer shows you how to work with clean-cut washes extending solidly across the page, Cézanne is a guide to handling disconnected, spontaneous marks and jottings—the kind of situation a beginner often encounters. If you want to simplify your watercolor life, consider three of Cézanne's principles:

1. *Don't try to "finish" a watercolor.* In a Cézanne, the image grows organically from the first pencil marks, gains strength from accumulated touches of color, and may be considered "finished" at any time. Such an approach helps you to avoid overworking a good start, and it is useful in landscape sessions where time is short and you want an impression rather than details. The trick is to scatter your marks over the page, leaving rhythmic passages throughout. At all costs, avoid clotting the image with too much work in any one place.

2. *Draw painterly contours.* In solid wash technique, a lightly pencilled drawing is usually sufficient. However, a sketchy, open style often calls for painted outlines like those Cézanne uses for his trees. The thing to remember here is that a continuous dark line will register as "draftsmanship" and stand out like a sore thumb. Instead, use short, broken strokes done in varied tones and with separate directional thrusts. These will mesh with other marks and thus seem painterly.

3. *Suggest shading with tonal clusters.* Everyone enjoys putting down spontaneous touches of bright color on snowy white paper. A problem arises, however, when these separate impulses must be unified. One simple way of connecting marks is to paint them in a tonal cluster. This consists of two or three color spots laid over one another so as to shade from light to dark and from vagueness on one side to a definite edge on the other.

Although Cézanne's sensitive, improvisatory style influenced early modernists like Demuth and Marin, there is a current shift away from it. On the whole, today's watercolors are larger, more heavily painted, and tend to avoid any hint of sketchiness or easy charm. At the same time, the Cézanne concept of abstract form—the compression of observed reality into a shallow pictorial space like a bas-relief—is as widely accepted as ever.

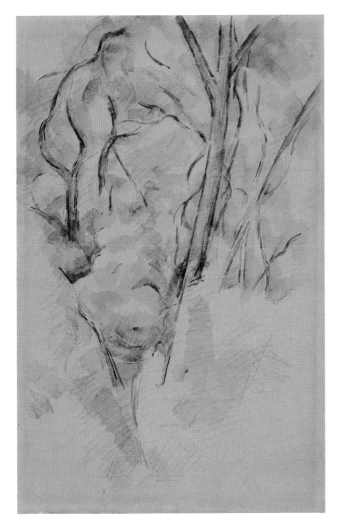

PAUL CÉZANNE (French, 1839–1906)
Trees and Rocks, No. 2, ca. 1900
Watercolor, 17¼ × 11⅛" (43.8 × 28.3 cm)
Philadelphia Museum of Art, Samuel S. White III and
Vera White Collection

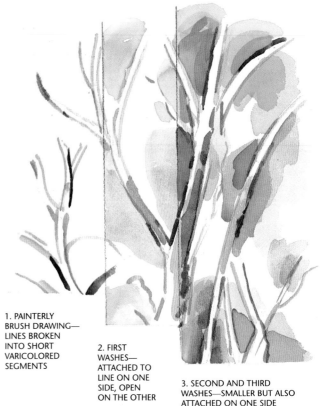

1. PAINTERLY BRUSH DRAWING—LINES BROKEN INTO SHORT VARICOLORED SEGMENTS

2. FIRST WASHES—ATTACHED TO LINE ON ONE SIDE, OPEN ON THE OTHER

3. SECOND AND THIRD WASHES—SMALLER BUT ALSO ATTACHED ON ONE SIDE

A modernist landscape format: Open brushmarks in a shallow space, rather than traditional foreground and distance.

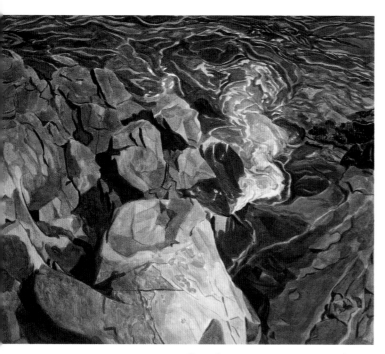

We see this in the work of such current watercolorists as Susan Shatter and Patricia Tobacco Forrester. *Swirling Water,* for example, demonstrates Shatter's ability to transform observed reality into a powerful abstract statement. Where Homer would have shown us the sky, Shatter minimizes spatial depth by omitting the horizon and tipping the scene up toward the picture glass, as if it were a topographical map viewed from above. As in a Cézanne watercolor, our sense of gravity is so minimized that the picture reads like an abstract painting whose patterns can be turned around and enjoyed from any of the four sides.

Forrester achieves a similarly flattened space, but with a different strategy. Her signature style is defined by a dense surface treatment of interwoven floral displays, twisted tree trunks, or rippling waters that provides only a few glimpses of the landscape beyond. The design of her watercolor *Foothills* is typical. The composition features an interesting downhill view of a sunny slope with distant ridges and sky in the background; yet this depth perspective is obscured by an essentially two-dimensional screen of tangled branches that has the abstract, linear insistence of a drip painting by Jackson Pollock.

SUSAN SHATTER
Swirling Water, 1982
Watercolor, 49¹/₂ × 58" (125.7 × 147.3 cm)
Courtesy Fischbach Gallery, New York

PATRICIA TOBACCO FORRESTER
Foothills, 1989
Watercolor, diptych 60 × 80" (152.4 × 203.2 cm)
Collection of Mr. and Mrs. C. William Black, Potomac, Md.

Forrester is a Washington, D.C., artist whose commitment to on-site painting is unique among contemporary watercolorists. Where other landscapists work in various mediums, she is singularly devoted to watercolor. And where artists like Shatter and Fish do relatively small watercolor studies out-of-doors, Forrester works from nature for six to seven hours at a stretch and on huge, difficult-to-manage papers. To cope with the logistics of field trips to Washington's parks, forests in Northern California, and South American jungles, she says she has learned to carry just three things: a backpack of paints, brushes, and water supply; a light table-easel with adjustable top and extension legs in one hand; and sheets of 27 × 40-inch Double Elephant paper in a huge plastic bag in the other hand.

What I find truly amazing is the vision of this tall woman braving the elements while standing at a small board propped on stork-thin wooden legs and attacking an enormous piece of paper flopped over the top of it. Her picture is lightly pinned with a single thumbtack, so that, if blown away, it won't tear as it might do with a firmer mooring. To hold the paper down, she plops a heavy china palette on it and, while painting the upper part, dangles the bottom half in front of her, wrapped for protection in a plastic bag. When painting the lower section, the process is reversed, with the paper hanging down in back. To further complicate things, Forrester's images often extend over several sheets, and this involves switching from one huge page to another in order to match up the edges.

Forrester's strategy is rather specialized, but it will give you an idea of the problems of wind, sun, and awkward terrain that beset any dedicated open-air painter. It also explains why watercolorists from the time of Homer to our own day have usually favored a less complicated, small-scale format for working outdoors. You will do well to take this easy-does-it approach, which requires minimal equipment—no easel or portfolio, just a sketch block or small drawing board on your lap.

Meanwhile, Forrester's idea of combining several papers in a single composition is well worth exploring if you are interested in increasing the scale of your own work. *Foothills,* for example, is composed of two vertical 40 × 60-inch sheets of Arches paper framed under Plexiglas 80 inches wide. Forrester also arrives at the same overall dimension by combining four horizontal sheets of 30 × 40-inch paper. Although this is a bit on the colossal side for most painters, four sheets of standard 22 × 30-inch paper can be combined in a handsome and entirely manageable 44 × 60-inch format. Standard sheets are also easy to work with outdoors, and in the 300-lb. weight they will not warp, as anything larger is almost bound to do.

The technical term for what we are talking about is a *polyptych,* or multipanel painting, and its sections may be combined in various ways. *Foothills* is a two-part picture, or *diptych,* in which a single image is spread across two papers. However, the diptych is traditionally a study in contrasts—an Adam and Eve arrangement, for instance—and we saw earlier how Leigh Behnke used it to show the same table setting at different hours of the day (p. 48). A three-part painting, or *triptych,* on the other hand, tends to be symmetrical, as in a Renaissance altarpiece with Christ in the center and lesser figures on foldout wings. Forrester has also tried a four-part format that gives her images a cubist logic by cutting them into quarters. And one of her more interesting ideas is to arrange papers in a horizontal row that reads sequentially like an Oriental scroll.

Thus, combining watercolor papers offers exciting possibilities, not only for landscapes, but for other subjects and nonobjective work as well. In exploring such a format, a key question is the extent to which panel divisions should be emphasized or minimized. Forrester favors subtle variations of shading at the intersections, but a multipaper strategy invites more abstract treatment. One could even go so far as to tone each panel a different color.

FIELD-TRIP STRATEGIES

This chapter has described the work of watercolorists whose ideas and techniques might suggest interesting possibilities for your own work. As you march off into the sunset (or twilight or dawn), remember that the important thing is to undertake each landscape project with a sense of specific purpose. And tuck this list of practical suggestions into your backpack:

1. Take along the paper viewfinder discussed in Chapter 4. It will be as useful in landscape as in still life painting.
2. Remember that *landscape* is a general term. Your actual subject will be a seascape, barnscape, treescape, gardenscape, or even a cityscape. Pin down your theme before starting to work.
3. Turn your paper the right way (trees are tall, fields wide) and make objects either small, if you are after space, or sufficiently large, if they are the main subject.
4. Since your last brushmark will seem to be in front of everything else, paint distant sky and hills before putting in foreground trees and houses.
5. Use stronger colors than instinct advises. Paintings seem much brighter outdoors than when you bring them home.
6. If you become discouraged, remember that whatever goes wrong outside can be rectified by thoughtful revisions in the studio.

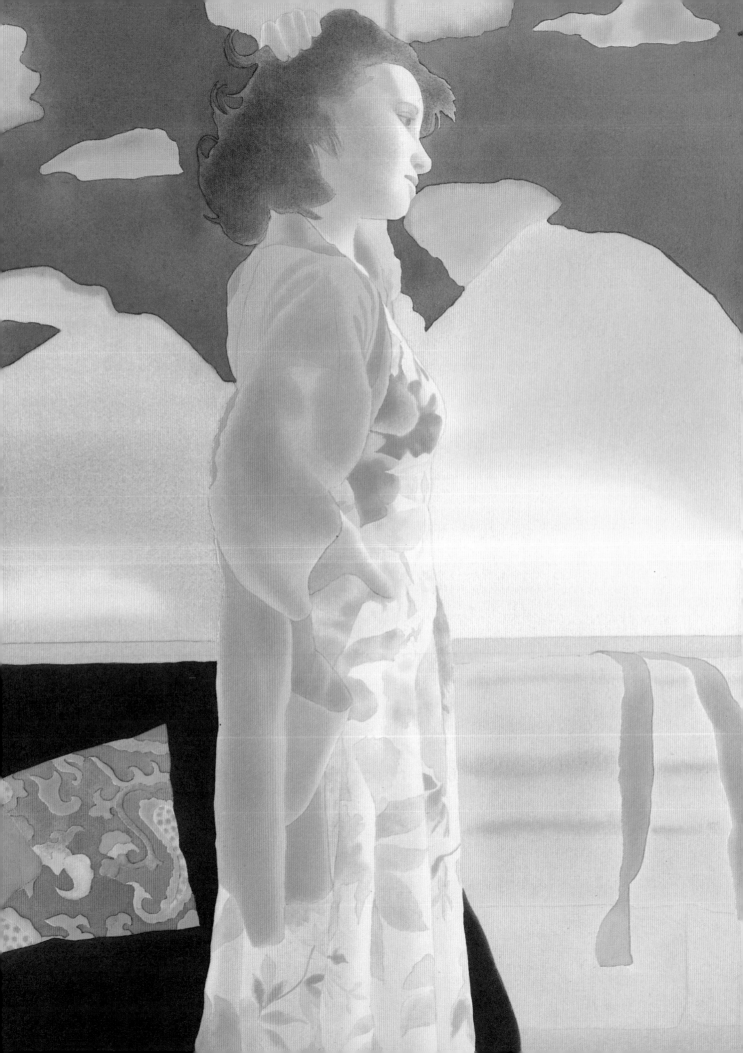

7 WET-INTO-WET TECHNIQUES

When pigments are applied to premoistened paper, they fan out into blurred effects that are excitingly variable, yet more controllable than you might suppose. The nature of the control, however, is more indirect than in painting on dry paper, where an experienced artist can produce a wash pretty much according to plan. In wet work, only the general effect can be counted on. There are always accidents, happy or otherwise, and the secret of success is learning to "ride" with the dynamics of a wash that is in continuing motion after you have brushed it on, while at the same time "reining it in" so that colors spread in the right direction and blend without entirely melting away.

The experience is like playing with one of those toy wind-up cars. You can't actually steer it, but you can control its speed, distance, and direction by the tightness of the key-wound spring and the slant of the surface you put it on. Similar variables affect the capillary action of watercolor pigment when it hits wet paper—the amount of moisture, whether the page has been soaked or spot-dampened, and, of course, the angle of the drawing board.

Most watercolorists work basically on dry paper, as you have been learning to do, with occasional areas that, in the interest of variety or haste, are painted while damp. In the last chapter, for instance, we saw how John Marin painted *West Point (Casco Bay), Maine* while some of the background areas of sea and sky were still damp. Here, however, we will be looking at painters for whom wet work is a primary concern, and you will be asked to take a running dive and full plunge into wet-into-wet technique rather than merely inching toward it.

ELIZABETH OSBORNE
Detail, *Nava in Blue Robe*
(page 85)

PAINTING INTO PREMOISTENED AREAS

Actually, there are three ways of getting into the swim: you can premoisten separate areas so that color goes on with velvety smoothness, you can use paper that is evenly wet all over, or you can work with standing puddles that dry like tie-dyed fabrics. Each approach is distinctive. I suggest you try them all, perhaps starting with the first and simplest of these options.

Every Sunday, in good weather, New York artist Fred Mitchell makes several round trips, starting at dawn, on the Staten Island or Governor's Island ferry. He brings along a twenty-four-color paintbox, a water jar, and a

12 × 16-inch sketch block. By now he is a familiar character, and deck attendants help to keep the public away while he paints. Mitchell's work is a little like John Marin's, although more delicate and often quite abstract. *Ferry to Staten Island,* for example, is composed of rounded, bubble-like shapes that make misty reference to a sunrise on the upper left and to a ship's rail and life preserver down below. In the distance, on the right, we can also vaguely make out a small boat trailing a foamy wake of waves and fishes. Another of his watercolors, *All the Way Across,* distills the experience of an airplane trip

FRED MITCHELL
Ferry to Staten Island, 1982
Watercolor, 12 × 16" (30.5 × 40.6 cm)

FRED MITCHELL
All the Way Across, 1970
Watercolor, 22 × 30" (55.9 × 76.2 cm)
Munson-Williams-Proctor Institute, Utica.
Gift of Mr. James McQuade

to California into a scheme of eight rectangles that suggest land patterns in a sequence of changing time zones.

What makes Mitchell's work pertinent to this discussion is his method of feeling out space with clear water before applying pigment. Unlike most watercolorists, he uses no pencil lines and draws entirely with a brush dipped in colorless water. This is a rather mystical process, like writing with invisible ink, because you create an image even though it is without substance. The watery ghost shapes can be studied and enlarged or altered before they are fleshed out with color. And if you don't like a shape, you can let the paper dry and start over.

The main advantage of a clear water base is that pigments spread out in it with the smoothness of dye drops splashed into a pool. In *Ferry to Staten Island,* the artist shapes the curve of his sky first with water and then touches it with intense cyanine blue, which fans out, blurs, and then fades into a pale glissando. Similarly, he defines the rectangles in *All the Way Across* with corners of red, yellow, and blue that dissolve with a swoosh into clear water. Such dramatic shading, and the textural elegance of pigment settling like silt in the paper's hollows, cannot be imitated by "straight" technique. This is because wet-on-dry painting involves the application of palette-mixed colors, whereas wet work encourages pigments to mingle spontaneously on the paper and, in a sense, paint themselves.

For Mitchell, wet-into-wet painting is as natural as skinny-dipping. He uses it casually, along with "dry" passages, in small-scale works where effects are achieved immediately. The Philadelphia artist Elizabeth Osborne, on the other hand, shows us how the same principle can be used in a more systematic way. Her papers are large, severely designed, and handsomely crafted as "finished" compositions rather than informal sketches.

Like Mitchell, Osborne develops a picture area by area, putting down water first in order to float the color on. As we see in *Nava in Blue Robe,* however, she sharply defines the areas she works with. Here all visual elements—sofa cushions, dress patterns, the model's face and hair, and the sunlit clouds of a background landscape—are reduced to flat shapes bounded by immaculate pencil lines. Thus the drawn contours act like the metal walls into which colored enamels are poured in cloisonné work. Osborne carefully paints clear water up to her pencil lines and then floods color into the area, which will be contained until dry by capillary action.

Artists who work on dry paper normally hold it at a slant to provide drainage. Wet processes, in contrast, are based on color that spreads in all directions rather than running downhill. Thus Osborne prefers a level painting table, on which standing puddles can be made to create various textures and shadings as they dry. (See diagram: "Painting into Premoistened Areas," p. 88.)

Later in this chapter, we shall see how Natalie Bieser works with pools of color that are over-full and evaporate with irregular striations and dark, crusty edges. Osborne's preference, on the other hand, is an even coating of liquid that dries with a delicately accentuated edge. While the initial wash is still damp, she often adds darker or varicolored touches to create subtle shadings. In *Nava in Blue Robe,* for example, yellow clouds have been touched with green in the upper regions of the sky and accented with orange on the lower right. She also likes to contrast such blurred passages with crisp flat areas that are enriched by repeated overlays—each time with clear water followed by more pigment, until they take on a velvety patina. You can see this in the jigsaw shapes of a cerulean sky and an ink-black shawl thrown over the sofa.

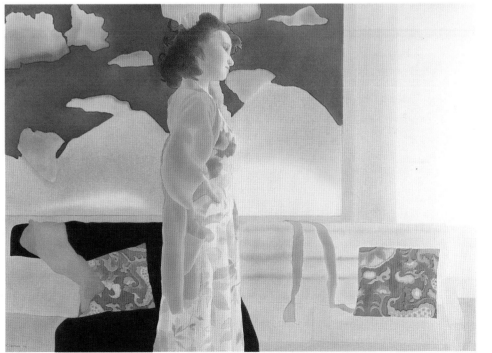

ELIZABETH OSBORNE
Nava in Blue Robe, 1982
Watercolor, 30 × 40"
(76.2 × 101.6 cm)
Courtesy Marian Locks Gallery,
Philadelphia

WORKING ON SATURATED PAPER

It is common practice to work, like Osborne and Mitchell, with certain areas of wet-into-wet painting. Not many major watercolorists, however, paint on fully soaked paper, even though this is one of the most creative processes you can experience, and one that is unique to the medium. Perhaps watercolor's traditional association with realism has been an inhibiting factor, since letting colors run wild on wet paper is about as "realistic" as shooting fireworks into the sky.

George Grosz (1893–1959)—the German expressionist famous for bitterly satirical paintings of social corruption during the 1920s—is an important exception to the rule, and his watercolor *Punishment* is a brilliant example of what can be achieved on tub-soaked paper. Done in 1934, after Grosz had come to New York to teach at the Art Students League, this picture re-creates the strafing and firebombing of World War I which still haunted his memory.

Look carefully, and you can visualize his working methods and how you yourself might use this technique. In wet work the subject must be vaguely imagined at first and then gradually brought into focus. Thus you start with paper that is sopping wet from top to bottom. After blotting excess surface water with tissue or a towel, you brush in basic colors: here, orange and yellow for flames, cerulean for the sky, and ochres for buildings. But even as you work, marks dissolve and blur. Fifteen or twenty minutes later, the paper is damp but no longer fully wet, and you start over. This time the flames must be intensified with deeper oranges and reds and the blues in the sky strengthened. Colors still spread out, but not so far. Finally, when the paper is almost dry, it is ready for umber shadows and the small darks that define edges.

Although my current style is clean-cut, I worked this way for many years, beginning each morning with a blurred image that was brought into focus by evening. Our one bathtub was regularly out of commission while paper soaked overnight, and often the day's achievement went back into the tub for a second soaking and a fresh start. This is an exciting process comparable to roughing out a figure in stone before envisioning where a face or hand might emerge, and the beauty of it is that the rhythmic sequence of your marks and thought processes is evident in the finished piece.

The vague effects of wet work often need to be sharpened by linear accents. In Grosz's watercolor, for instance, the window panes and moldings of bombed-out houses are indicated by dark, linear brushmarks put in as a final touch. You can also do last-minute drawing with the raw end of a wooden matchstick dipped in India ink. This technique is particularly effective as an art class project with a floral set-up, since the blobs of color in a bouquet can be interestingly shaped by scratchy, textural outlines that fade in and out as they hit dry or damp spots. Still another alternative is

to start with a pencil drawing strong enough to show through the subsequent overpainting. As you see in two of my Roman watercolors of the early 1970s, this approach requires a balance of painted and unpainted areas, so that pencil lines will play a sufficiently forceful role—standing out clearly against white paper in certain places.

In any event, the advantage of setting the stage with a detailed drawing is that wet washes can then be splashed on broadly, without regard for specific boundaries. In my watercolor *Bestie* (or "Beasts"), for example, the underlying drawing of Etruscan bronze and ceramic creatures under a Pompeiian maze border is relatively static. Yet the paint has been applied with gestural strokes that cut into, around, and through objects. Some of these strokes were made with the square-cut edge of a synthetic sponge that gives the striated effect you see in the tail feathers and body of a bronze rooster on the left. Others, like the ochre tones above the rooster and the line of sunset yellow-orange, were applied with a 2-inch brush. And in those days, I liked to finish my watercolors with touches

GEORGE GROSZ (German, 1893–1956)
Punishment, 1934
Watercolor, 27¹/₂ × 20¹/₂" (69.9 × 52.1 cm)
The Museum of Modern Art, New York
Gift of Mr. and Mrs. Erich Cohn

of gouache or ink after the paper had dried. Here the rooster's beak, which had been lost in shadow, is recaptured in opaque gouache, as are the contours of objects on the right—a strange half-man, half-wolf carving, the face of a screaming god, and a four-wheeled cart ornamented with Giacometti-like animal heads.

The second of these paintings is of interest as a sampler of the textural effects you can get with tub-soaked papers. The image is of four cardboard advertisements for camera lenses tacked to a Roman wall. Each card carries the word ZOOM, plus the cutout of a single letter of this logo with the brick wall visible through the hole. I used the actual cards both as templates for the pencil drawing and as protective masks when I wanted to splash colors around and behind them. What most interested me, however, was not the image itself, but the thought of

illustrating the word ZOOM with "zooming" paint strokes. Accordingly, I began on the upper left with swooping split-brushmarks in terre verte on soaking-wet paper. (You just squeeze a 2-inch housepainter's brush so that the bristles are separated, dip it in paint, and away you go!) At this point, I laid the cardboard ads on the damp paper, painted into the cutout Z, O, and M holes, and created gestural lines of force by spattering paint from a round watercolor brush across the page with a snap of the wrist. Next, several textural imprints were added. This technique involves cardboard cutouts—like the green half-circle in the first O card—which are thickly painted and then pressed against the still-damp paper. Finally, as in *Bestie*, small areas like the ZOOM logos were painted in gouache after the paper had dried. (See Chapter 11 for further discussion of these techniques.)

CHARLES LE CLAIR
Bestie ("Beasts"), 1973
Pencil, watercolor, and gouache,
26 × 39" (66 × 99.1 cm)

CHARLES LE CLAIR
Zoom, 1972
Pencil, watercolor, and gouache,
24 × 39" (61 × 99.1 cm)

As you can see, working on presoaked paper offers any number of creative opportunities. Better still, it is a process that yields splendid results for the beginner as long as two simple principles are understood:

1. *There must always be more water "in" the paper than "on" it.* When standing moisture is visible on the page, brushmarks dilute instantly and trickle about aimlessly. On the other hand, paper with wet interior fibers but a merely damp surface encourages pigments to spread evenly in a coherent formation. So soak or sponge your paper thoroughly for a long time, and either let it settle until surface water has disappeared or remove excess fluid with a blotter or towel. Remember, too, that every brushstroke you make adds more liquid which must be given time to sink in before you can return to the area. They say curiosity killed the cat. I don't know about that, but in wet-into-wet painting impatience can kill a promising start.

2. *This is a progressive rather than a one-time process.* Each section of your watercolor must be approached with the thought of returning to it again, and perhaps a third or fourth time. Your initial washes should be broad, with smaller and smaller strokes to follow. And as you proceed, keep a color sequence in mind—for example, yellow, followed by ochre and then greenish bronze; or a bluish chord like cerulean, ultramarine, and Payne's gray.

Although this has the sound of advice given in earlier chapters, there is a practical difference here. In standard wet-on-dry technique, effects can be achieved with a single wash, and if another is needed, you always know when the paper is sufficiently dry. In wet work, on the other hand, almost nothing can be completed in a single thrust. Things that look good at first soon melt away, yet the necessary second layer can't be applied immediately. You must wait until the surface is drier than the first go-round, but still damp. This timing is as crucial as taking an omelette off the stove at the right moment.

Fortunately, both stiff and runny omelettes have their charms and so do watercolors in various degrees of wetness. As I have suggested, working *too* wet is the usual error, but sometimes there is the opposite problem of maintaining sufficient moisture. For this situation, remoistening the painting by spraying it lightly with an atomizer is the answer, and I have sometimes found it helpful to work on paper laid over a wet Turkish towel rather than a dry drafting table.

There are also devices for correcting or revising a wet watercolor that you may want to try. After drying out, a brightly colored paper can be slipped into the tub, soaked again, and repainted in darker tones or opposite hues. If things go wrong, it can also be toned down with strokes of a wet sponge and then built up again.

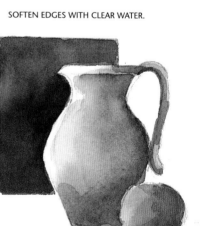

SOFTEN EDGES WITH CLEAR WATER.

CREATE "PROCESS" TEXTURES WITH BACK-UP PUDDLES.

CREATE COLOR HARMONIES WITH MULTIPLE LAYERS.

ACHIEVE SUBTLE SHADING WITH VARICOLORED OVERLAYS.

DRAMATIZE PLANES BY SHADING FROM DARK TO LIGHT.

CREATE ATMOSPHERIC EFFECTS WITH WET WASHES RETOUCHED WITH SMALL DARKS.

Painting into Premoistened Areas

OVERPAINTING WET-INTO-WET WORK

Painting on dampened paper has two quite opposite functions. When used alone, it encourages the kind of expressionism we have seen in Grosz's work. Alternatively, it may be employed as the atmospheric first stage of a picture that will be finished with layers of firmly detailed overpainting.

Charles Schmidt is a master of the latter technique. He speaks of watercolor as a "tiger to be tamed." By this he means letting wet work run wild at the outset and then—after the paper is thoroughly dry—starting over, with every trick up one's sleeve, to give the page coherent shape while at the same time preserving the initial energy. Thus the gorgeously fluid, shadowy underpainting in a picture like *Two Movements* becomes the "id" and the realistic overpainting the "ego" in a fascinating interplay of expansive and contractive strategies. Two antique clock motors, or "movements" as they are called, are shown here—a brass motor in the center and a small wooden one on the upper right. As you see, the larger mechanism has been built up gradually with warm ochre and sienna washes over a cool blue underpainting which shows through in the shadows. A detailed account of screw heads, pockmark holes, fine wires, and metallic edge patterns completes the illusion. The adjacent brass pendulum is painted more solidly, but in a golden ambience that floods the wet shadow area as well.

CHARLES SCHMIDT
Two Movements, 1975
Watercolor, 29 × 21½" (73.7 × 54.6 cm)

Although Schmidt is a dazzling technician, his basic concept of a splashy wet start followed by a neatly rendered second layer can be explored successfully by most any watercolorist. You will need to look for an appropriate subject, however. When used by itself, wet-into-wet painting calls for brightly colored subjects like fruit or flowers. But in combination with a detailed overpainting it is a more textural expression that works best with objects of muted tonality and weathered surfaces. To this end, Schmidt scours flea markets, beaches, antique shops, and abandoned factories for oddments—like the battered clock parts in *Two Movements*—that have been transformed by time or corrosion into evocative and almost surreal images.

Such visual material—discarded stuff with a sense of displacement and deformation—is a vital resource for the art student as well. It is easy to come by if you think in terms of "found objects" rather than collectibles. A walk around a city block on trash day will yield material for a set-up, and marvelous things can be found at the shore—rusty bits of metal, bleached and tarred boards, bottles worn by the sea. The advantage of such discoveries is that they offer representational challenges, while at the same time encouraging abstract design, since nothing "goes together" in the conventional sense.

When it comes to arrangement, the simplest principle is best. Just lay objects on a table or, as Schmidt does in *Two Movements,* hang them on a wall. By keeping the table or wall parallel to the picture plane, you can move things about like pieces on a checkerboard, composing them as flat shapes in head-on perspective without complicated foreshortening. In general, it is wise to leave open areas where background washes can spread out, and to punctuate the space with small objects that will provide interesting detail in the overpainting. Linear elements like string, straps, tape, and beads are also helpful. Schmidt's grid of bent wires is particularly clever, since it serves both as a practical support for hanging objects, and as a modular pattern of squared-off openings that echo the shapes of the clock movements.

In most situations, this approach works best when the two stages are clearly differentiated as wet work followed by crisp wet-on-dry passages. As Schmidt's *Temple of Jupiter* demonstrates, however, an experienced painter can sometimes integrate these processes quite seamlessly. Painted from a drawing done in the Roman Forum, this luminous interpretation of a foliated Corinthian capital was begun with a subtly-toned wet underpainting. Later the paper was remoistened with an atomizer so that colors in certain sections could be varied or intensified—but still in a blurred wet-into-wet mode. We see this in the rich greens on the right side of the capital, the rusty reds of the lower acanthus leaves, and the sunny glow on the more brightly lighted moldings. At this stage, worn and pitted textures were also suggested by spatters and dark, partially dissolved accents. Finally, after developing a velvety image with damp work, the artist's task was to firm up shapes with a detailed wet-on-dry overpainting. Each of the volutes, for instance, has been given a light edge by painting darks on either side of a projecting rim. And throughout the composition, Schmidt contrasts horizontal architectural lines with a vertical pattern of lushly fluted plant stalks. All in all, a masterful achievement!

CHARLES SCHMIDT
Temple of Jupiter,
1982
Watercolor,
30 × 40"
(76.2 × 101.6 cm)

THE PUDDLE AS PROCESS

One of the best approaches to abstract painting is through process. This principle assumes that a work of art should be shaped by the way it is made rather than by what it *represents*. Some obvious examples are Jackson Pollock's dripped paintings, Braque's cubist collages, and Matisse's late paper cutouts.

In watercolor there are many distinctive processes, but none is more fundamental than brushing on colorful puddles and then waiting to see what surprises are in store when they dry. For an artist like Natalie Bieser or Joseph Raffael, the rhythm of a paint spill is as significant as the spin of a wheel for a potter, and their experiments with puddle technique represent a truly innovative approach to the medium.

The process they have seized upon, interestingly enough, is a technical "error" of yesterday that has been transformed into a latter-day virtue. In classic watercolor style, one of the first lessons is to avoid "back-up" puddles, since surplus liquid left on the page will dry with a ring around it. Raffael says he used to do careful watercolors. Then one day he looked down at his porcelain palette and noticed how beautiful the rings of color that had dried on it were. Thus the notion of a whole new approach was born.

Bieser is a California artist who hit upon this strategy some years ago, and in paintings done over a three-year period, you can see how she has developed and expanded it. An untitled 1979 watercolor, with a single snake-like motif and muted color, represents the process at its simplest. Here Bieser has started with a page of tubular puddles that leave pale, barely visible lavender rings as they dry. Then, after dividing the page into four abstract zones, she has painted around these initial worm-like shapes so that they are pushed forward as light figures on a darker ground. Thus the crinkly edges are "reverse" rings left by background washes, rather than the original puddle formations.

Like Pollock's paint spills, puddles can be built up in rhythmically orchestrated layers. Bieser uses neutral browns and grays to articulate the quadrants of her 1979 watercolor, but by 1980 a similar four-part painting, *Untitled #66*, is infused with vivid color. At this time, her abstract design also takes on representational overtones. The space divisions look like rounded hills, and the color scheme suggests green grass, blue skies, and sunshine breaking through clouds. A year later, in *Tecata*, the allusion to nature is more dramatic. Instead of all-over wiggly motifs, massive shapes and vibrant colors now depict the collision of a giant thundercloud and a sinister cliffside. There is also a hint of male/female symbolism as a bullet-shaped rock penetrates a softly curling cloud.

In practical terms, puddle technique calls for paper to be laid out flat so that pools of color stand level as they dry. Bieser works quite simply on unstretched 300-lb. paper fastened lightly to a plywood board with masking tape. With a variety of brushes, she paints her standing puddles, as one shape leads to another, and the work tells her "where it is going." Natural rhythms guide the process, she says, but a degree of conscious control is also necessary. As it evaporates, each puddle is carefully watched and developed by adding new colors or perhaps tilting the board so that

NATALIE BIESER
Untitled, 1979
Watercolor, 22 × 30" (55.9 × 76.2 cm)

NATALIE BIESER
Untitled #66, 1980
Watercolor, 22³/4 × 30" (57.8 × 76.2 cm)

pigments run together interestingly. After drying, certain edges may need to be reinforced by overpainting. In *Tecata*, the cloud's interior formations are natural, while its outer contours have been strengthened by retouching.

As you can imagine, a major difficulty with this approach—and one reason why it isn't more widely used—is that you must wait endlessly for passages to dry before continuing. Fortunately, Bieser's studio opens onto the outdoors in a dry, 100-degree western climate that hastens evaporation, but Raffael says he often has to let his oversize watercolors dry overnight between layers. For the average person working on standard-size paper, however, using an electric hair dryer goes a long way toward minimizing the problem.

NATALIE BIESER
Tecata, 1982
Watercolor, 22 × 30"
(55.9 × 76.2 cm)
Courtesy Nancy
Hoffman Gallery,
New York

JOSEPH RAFFAEL
End of Summer, 1980
Watercolor with pastel, 34 × 72½" (86.4 × 184.2 cm)
Courtesy Nancy Hoffman Gallery, New York

Now living in the south of France, after many years on the California scene, Raffael is a marvelously inventive artist best known for lyrical images drawn from nature. He is particularly adept at conjuring up the iridescent light, foamy texture, and floating rhythms of watery subjects like the multicolored Asian carp (or koi) in *End of Summer*. Here the puddle process becomes not just a technical device but a visual metaphor for the watery subject itself. And though the picture is rather complicated and touched up with pastel, you can clearly make out several standing puddles on the upper left that have dried with crinkly rings around them.

It is easy to get exciting results with color puddles, if you use them abstractly. Unfortunately, combining them with subject matter is more difficult, since the puddles—which should be freely formed—become tighter and tighter as you try to make them look like something. Raffael does manage this successfully, but to make room for his flooded effects, he uses oversize paper cut from a roll and staple-stretched on a huge plywood board. As a photorealist—or perhaps one should say photoromanticist—he carries a camera the way other artists keep a sketch pad at hand. A painting like *End of Summer* starts with the selection of a particular image from hundreds of shots of random patterns in nature. The 35mm color slide is then projected onto the paper for a preliminary drawing. Later, Raffael projects it again while he paints, this time on the studio wall. He says he looks down at the watercolor spread out on a table, then ahead at the photographic image with the feeling of actually being in the presence of nature.

Like Bieser's paintings, Raffael's are animated by floating, amorphous shapes. Sometimes the themes are as simple as a blossom. At other times, his compositions are so complex that one wonders how he pulls them together. The way positive elements emerge as lights, rather than darks, is especially remarkable, since this is achieved without the aid of a masking device. Raffael's principle is simply to paint all the light areas first—putting in tiny bubbles and dewdrops, delicate flower petals, and darting fish before dealing with the background. Later he floods the spaces behind these positive images with swirling pools of color.

Finally, one notes that the principle of *imitation* is crucial to this idiom. Just as Bieser imitates accidental puddle formations in her overpainting, so Raffael works with constant awareness of similarities between the specific and the accidental. Look closely, and you will see that the rendering of a fishtail or fin is often made to resemble the contour of an accidental puddle formation nearby.

EXERCISES

Wet work appeals to some artists more than others, but it has applications even in basically wet-on-dry situations. Thus some experience with it is essential. Full-size 22 × 30-inch paper in a 300-lb. weight that need not be stretched is recommended. Four basic wet-into-wet exercises are outlined below. Complete three of them, with whatever personal variations are suggested by your reading of this chapter.

EXERCISE 1: PAINTING ON SATURATED PAPER
Arrange a still life with a mixed bouquet and two or three other colorful objects. After soaking the paper thoroughly, paint it in three stages: First, lay in basic colors that you expect to spread out and fade away. Second, heighten these colors with touches of darker pigment after they have dried out a bit but are still damp. Finally, add contours and definite edges with dark, neutral watercolors or India ink applied with the wooden end of a matchstick.

EXERCISE 2: PAINTING INTO PREMOISTENED AREAS
Arrange five or six small objects on strips of vividly colored as well as black and neutral brown paper. Random objects with natural rather than mechanical contours, like a doughnut, seashell, onion, or red pepper are suggested. The purpose of the exercise is to set rounded forms, modeled with overlaid glazes, against backgrounds of variable tonality. After making a drawing of the arrangement, paint the background strips with flat washes. Next paint each object, starting with clear water and then floating color into it. Build up the color and create roundness by repeating the process two or three times after the previous layer has dried.

EXERCISE 3: OVERPAINTING WET WORK
Tack several faded, rusty, or roughly textured found objects to the wall, along with strings, wires, straps, or other connecting devices. Paint a blurred impression of the set-up on soaked paper. Then, while it is damp, not fully dry, add bold cast shadows. Finally, after the paper is thoroughly dry, paint the main objects in wet-on-dry technique as realistically as you can.

EXERCISE 4: COMPOSING A "PROCESS" ABSTRACTION
Cover the page with free-form watercolor puddles, touching them with various other colors while still wet. When dry, overlay the first layer with two large shapes—one shadowy and dark, the other brilliant. Afterward, study the interlocking forms and repaint areas that interest you, perhaps adding new shapes, until a satisfying composition emerges.

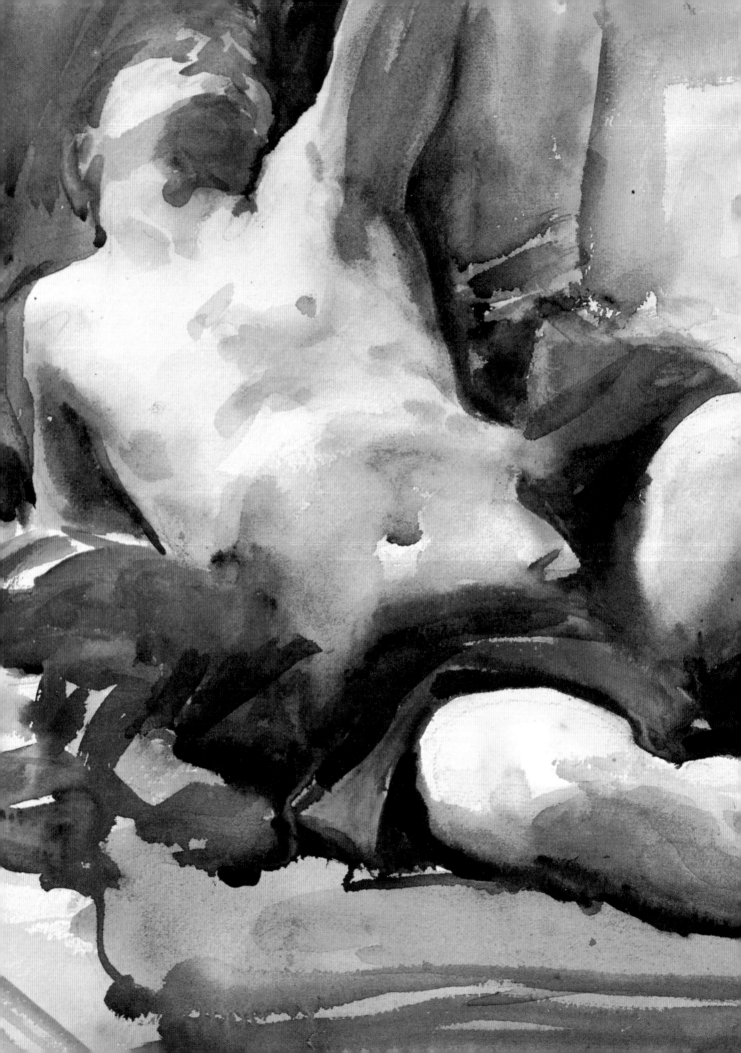

8 PAINTING THE FIGURE

The trick to painting the figure in watercolor is to paint it as you would anything else. If it is naked, think of a breast or arm as an apple or tree trunk; if clothed, study the folds of a dress over a thigh as you would a formation of boulders or driftwood.

Like pulling a rabbit out of a hat or making goldfish disappear, however, this is no easy trick. One difficulty is that the complexities of human anatomy get in the way of seeing shapes simply. Another is that we are apt to be more interested in the minor details of a portrait than those of a still life or landscape. It is all very well to observe that the model's head is egg-shaped, but what about the mole on the upper lip, and how do you put in eyelashes?

In oil or acrylic you can struggle with a likeness and still hope to get the general effect right, but this isn't feasible in watercolor. The medium is attuned to broad rather than miniature effects and to first impressions rather than corrections or adjustments. Thus you must have a clear idea in advance of the compositional approach and rendering technique you will use in defining the figure, and this chapter explores a number of basic strategies.

Although figure painting is interesting and enjoyable, it is not as essential for the watercolorist as the still life and landscape exercises described earlier. In general, working from the model calls for adapting basic techniques to a challenging subject rather than exploring new ground. Therefore, feel free to move on quickly to the next chapter if problems of anatomy are discouraging and you feel you lack sufficient practice in drawing.

FIGURE/GROUND RELATIONSHIPS

The best way to see a figure simply is to paint it as one of many forms in the picture space–like a single apple, for instance, in an abundant still life. You won't overwork one apple when there are other pieces of fruit and a bottle or basket to do; and your painting is likely to turn out well because of the interacting shapes and colors, even if the apple itself is unremarkable.

So it is with the figure. Philip Pearlstein's *Self-Portrait with Venetian Mirror* gives us a panorama of reflections rather than a standard head and shoulders. The artist's features are repeated on the mirror bevel and in myriad drop-like ornaments on the frame, while a view of Rome spreads out behind. In this kind of format, visual relationships abound. The texture of Pearlstein's knit sweater echoes that of the Italian pines, the furrows on his face relate to cloud forms, and the shape of a small easel fastener repeats that of a row of palazzo windows.

We commonly speak of this as placing the figure in a background. The more sophisticated phrase, however, is "working with figure/ground relationships," because the painter's concern for preserving the picture plane often requires things that are actually *back* to be brought compositionally *forward* by forceful colors or paint strokes. Accordingly, Pearlstein's pine trees are conceived as an aggressive pattern strengthening the painting's left corner rather than as a dim background.

Although it sounds illogical, the fact is that in figure work you will do better with more rather than less to look at. Creating visual excitement throughout a picture is often helpful from the standpoint of design, but the principle becomes imperative in watercolor for a practical reason. You see, concentrating on the figure alone, with the kind of plain background you might use in oils, forces your brushstrokes into a small space that quickly becomes saturated. Nothing is more discouraging than having to wait endlessly for an area to dry (unless it is seeing the eyes and mouth of your portrait run together as the result of impatience). Therefore, it is best to avoid the problem by surrounding the model with interesting things that will keep you busy while areas devoted to the head, hands, and other figurative details are drying. The set-up for Elizabeth Osborne's figure study *Nava with Green Cup,* with its fancy pillow, flowered dress, tubular chair back, and window view—is a case in point.

PHILIP PEARLSTEIN
Self-Portrait with Venetian Mirror, 1982
Watercolor, 29 × 41" (73.7 × 104.1 cm)
Collection of the National Academy of Design, New York

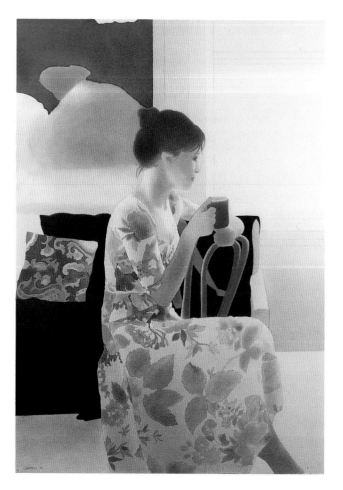

ELIZABETH OSBORNE
Nava with Green Cup, 1981
Watercolor, 42 × 29¹/₂" (106.7 × 74.9 cm)
Courtesy Locks Gallery, Philadelphia

I have opened this chapter with a Pearlstein self-portrait because looking into the mirror is the most natural way to begin working with the figure. The possibilities for varying the pose, lighting, and background are endless, and while it is difficult to persuade friends or family to pose, the model for a self-portrait is always Johnny on the spot. Ultimately, however, you may want to have access to a professional model and, fortunately, most art schools offer exploratory opportunities as well as full-time programs.

At this point, you will find that the naked body has a certain mystique for art students, both as a sign of professionalism and as a prime subject for the study of drawing and anatomy. Nor would I want be discouraging, if you are seriously interested in painting the nude figure, since motivation is half the battle in art. At the same time, you should understand that the unadorned figure presents difficulties that a watercolorist must overcome, whereas costuming provides entirely positive opportunities. Undressed, the subject's every finger, toe, and collarbone must be accounted for; clothed, such anatomical details are covered by loosely formed drapery. And whereas the nude figure—whether Caucasian, Black, or Asian—has a fixed tonality and set proportions, costuming opens up a world of colors, shapes, and patterns. Thus, though you may eventually want to tackle a nude subject, the costumed figure offers a better chance of initial success.

In any case, the key requirement here is to have a clearly perceived painting strategy. To put it another way, instead of merely setting out to paint, you must be able to say, "I am going to do this or that very specific thing with the person in front of me." Furthermore, this must be a *simplifying* approach, if you are not to be sidetracked by the problems of anatomy and portraiture that arise when your subject is alive and kicking rather than "still" life. There are, of course, innumerable ways of interpreting the figure, but let me outline four basic strategies—each illustrated by the work of a distinguished watercolorist—for your consideration:

1. EMPHASIZING PAINTERLY EFFECTS

We start with two of Sargent's watercolors, because his classic "broad style" of loose, sketchy brushmarks is a tried-and-true approach to the figure that is a natural for any life class. Working on an inexpensive sketch pad, you should be able to complete a preliminary pencil drawing in the first half of a one-hour pose and whip out a painting during the second sitting. I say "whip out," since speed and a plan that assigns only one or two touches to each area is the drill here. Later, you can select your best studies and perhaps develop them more solidly on good watercolor paper.

Sargent's *Arab Woman* is a particularly vivid illustration of what can be done with drapery, both as a vehicle for

uninhibited brushwork and as a means of suggesting underlying anatomical volumes like shoulders and arms without going into detail. Dazzling yellows and violets on the woman's white robe are also a reminder of the play of color one can develop when working with seemingly colorless drapes or costumes.

The artist's *Figure with Red Drapery*, on the other hand, is an object lesson in how to paint the nude—or at least almost-nude—model in a broad style. Here Sargent reduces light and shade to simple planes—broad shadows on an upraised arm, under the chin, and on the lower legs,

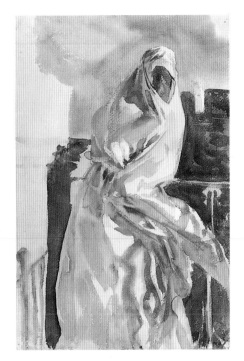

JOHN SINGER SARGENT
Arab Woman (Unfinished), ca. 1905
Watercolor, 17³/₈ × 12"
(44.1 × 30.5 cm)
Metropolitan Museum of Art, gift of Mrs. Francis Ormond, 1950

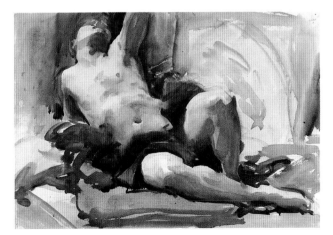

JOHN SINGER SARGENT (American, 1856–1925)
Figure with Red Drapery, n.d.
Watercolor and graphite on white wove paper,
24¹/₂ × 22³/₁₆" (62.2 × 56.4 cm)
Metropolitan Museum of Art, gift of Mrs. Francis Ormond, 1950

while chest and thighs are brightly illuminated. We also see how he establishes these planes with cool raw umber and then retouches them with a warm orangish tone that adds a fleshy glow. The image is then completed with a black brush drawing that clarifies the line of a knee or ankle.

Finally, we note that both watercolors have architectural settings which frame the figure in such a way that it can be rendered in "reverse" shading. That is to say, the male nude's shoulder appears as light against a dark wall, whereas his knee is dark against a light ground, and the Arab woman is similarly poised between dark buildings and a bright sky.

SIDNEY GOODMAN
Woman Taking off Shirt, 1979–80
Watercolor, 15 × 22³/₄" (38.1 × 57.8 cm)
Courtesy Terry Dintenfass, Inc., New York

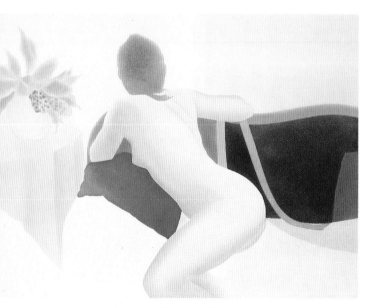

ELIZABETH OSBORNE
Woman on Black Sofa, 1989
Watercolor, 22¹/₂ × 30" (57.2 × 76.2 cm)
Courtesy Locks Gallery, Philadelphia

2. DEVELOPING SCULPTURAL VOLUMES

In *Woman Taking off Shirt,* Sidney Goodman's technique is the precise opposite of Sargent's. Where Sargent paints quickly with wet, broadly brushed planes, Goodman creates rounded volumes with slowly built-up layers of tiny fast-drying marks. Known primarily for powerful and often darkly symbolic drawings and canvases, he approaches watercolor with a lighter touch. It is a treatment, however, in which the artist's basic vision of the figure as a classically rounded columnar form—lighted from one side and shadowed on the other—is maintained. We are also reminded here that museums often classify watercolors as drawings, rather than as paintings, and Goodman's basic approach to works on paper—whether in charcoal, pastel, or watercolor—is that of a draftsman. Thus there is only one area of real color, a reddish shirt that fades into flesh tints, in an otherwise black, gray, and white scheme.

I recommend this approach for anyone interested in doing pencil or charcoal drawings in life class, and then developing watercolor studies from them at home. In essence, this is Goodman's method here, except that his source was a black-and-white Polaroid shot of an intimate pose with upraised arms that couldn't be held very long.

3. EXPLORING ABSTRACT SHAPES AND PATTERNS

Elizabeth Osborne's work is more abstract than Sargent's or Goodman's, and she sees the figure less as a center of interest than as part of an overall scheme. This strategy involves reworking sketchbook or life class drawings, rather than actually painting from the model. However, it is an approach with distinct advantages. Combining figure sketches with real or imaginary background shapes can be lots of fun. It is rather like putting together a collage, and you can even use clippings from home furnishings magazines as source material. In the process, you will learn how to build an environment for your subject with shapes that represent walls, floor, and furniture. And you will discover the importance of simplifying the figure itself, if it is to emerge as a vital presence in the final watercolor.

Osborne's studies of clothed and unclothed subjects suggest a range of possibilities. *Woman on Black Sofa*—with its softly painted female nude set against blocks of intense black, blue, and purple—is the more daring composition. But note that the boldness of her color areas is matched by an equally simplified treatment of the figure—a streamlined back view that eliminates hands, feet, and even a glimpse of the face. *Nava with Green Cup,* on the other hand, shows what can be done with ornamentation and richly nuanced passages. It is awash with intricate patterning that starts with the lady's Primavera-like flowered costume and moves upward to a Persian-print pillow and some abstract shapes above it that could be either a picture or a "picture window." And in contrast to the severe shapes in *Woman on Black Sofa,* this portrait of Nava is an exercise in modulations: The edge of an

electric-blue plane on the upper left edged by greenish ochre tones, an orange blob below it fading to gold, and the ink-black sofa softened by a velvety cast shadow.

4. FOCUSING ON COSTUMES AND PROPS

In a drawing one can concentrate on the figure alone. In a painting, however, the model must be presented in some sort of environment, and as Osborne's shows us, furnishings and architecture can add a great deal of visual interest. Yet there is one format which eliminates backgrounds altogether—the close-up view of a head or three-quarter figure. And here, instead of merely attempting a likeness, I suggest that you focus on lively costumes and props. For women there are saris and caftans, flowers, and feathers; for men, leather gear, designer T-shirts, bats, racquets, and baseball caps. The point is simply that your concept must fit the medium. While you can keep hammering away at an oil or pastel portrait, freshness rather than persistence is the key to a successful watercolor. And the subtle flesh tones that work so well in an opaque medium tend to seem merely pallid in transparent watercolor.

After his move to the French Riviera a few years ago, Joseph Raffael did a remarkable series of watercolors of his wife, Lannis, that ring every change on the theme of the costumed figure. Although I can show you only two examples, they are typical of the way Raffael uses costumes and props to surround his subject with colorful shapes and patterns. In *Awakening II*, the foreshortened image of a recumbent woman is so flooded with floral drapery that it might be a drowning Ophelia. In *Lannis with Parasol*, radiating spokes create a golden aura that is at once Oriental-looking and suggestive of a Byzantine saint's halo. Thus costumes and props can be used to invent striking images, while at the same time limiting the areas in which you must deal with anatomical problems.

Although Raffael is a super-technician, his strategy is quite feasible for the average painter. Using less ornate fabrics would be advisable, however—say stripes or diamonds instead of *mille fleurs*. And instead of painting from the model, you might work from a nude life drawing, adding a costume by observing the folds and patterns of fabrics hung over a chair. Above all, notice that Raffael's secret weapon is the way his colors flow through and beyond specific contours. A golden glow illuminates the upper half of the parasol portrait; and a similar radiance warms the right side of the reclining figure, while a cold white light shines on her from the left.

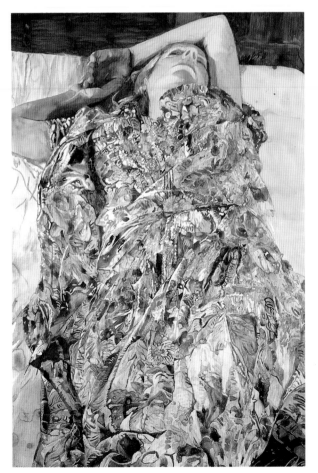

JOSEPH RAFFAEL
Awakening II, 1987
Watercolor, 55 × 37" (139.7 × 94 cm)
Courtesy Nancy Hoffman Gallery, New York

JOSEPH RAFFAEL
Lannis with Parasol, 1987
Watercolor, 60 × 44" (152.4 × 111.8 cm)
Courtesy Nancy Hoffman Gallery, New York

WORKING FROM A SKETCHBOOK

Life drawing is an essential discipline for the figure painter. Beyond working from set poses, however, there is an equally pressing need to do sketches that capture spontaneous gestures in everyday situations. So learn to carry a sketchbook in your pocket, and see how easy it is to jot down impressions on the bus, in the cafeteria, or in the park. "Recollected in tranquility," these notes may prove worth developing. Add a bit of watercolor to the sketchbook page. Then re-create it on good paper as a small wash drawing, rearranging or improving things as you go. Later, pin several such casual studies on the wall; perhaps one or two will be worth developing as full-scale paintings.

Artists from Rembrandt to Cézanne have developed ideas for major works from casual sketches, and you will find this a progressive process in which each step along the way has its value. I would love to own Demuth's tiny *Woman in Armchair,* for instance, even though it has none of the textural richness or formal structure of his "finished" watercolors. What it does have is the charm of immediacy—the cozy gesture of a woman settling into a chair, head thrown back, the curve of her arm matching that of the chair arm, her toes twitching contentedly.

Strictly speaking, this is a *wash drawing* rather than a fully realized watercolor painting—that is to say, a sketch with a light overlay of color in which the image is defined primarily by the initial drawing. Adding touches of color to your quick sketches, as Demuth does in this postcard-sized study, is the easiest and most natural way to slip into a figure-painting mode. And though Demuth's pencil marks are so fragile he has had to retouch them with hairline brushmarks, pencil can be a forceful medium when used with darker leads or with crosshatched shading. Wash drawings may also be done with traditional brown, sepia, or black India inks or with such contemporary materials as markers and water-resistant crayons.

While Winslow Homer's *Girl in Black Reading* is only an inch or two larger than Demuth's little sketch, it is a more fully realized painting. As such, it represents the next step you should take in exploring the figure. During an 1865 visit to Spain, the French artist Edouard Manet—a contemporary of Homer's—discovered Velázquez's principle of painting things in flat, minimally shaded colors. Composing with "flats" has been a standard technique ever since, and you will find it the most economical way to realize a figural image.

As Homer shows us, the trick is to think of the picture as if it were a woodblock print with three or four set colors—here, *brownish gold* for background and hair; *Payne's gray* for the figure's dress and cast shadow; untouched *white* for the penciled area of face, jabot, hands, and book; tiny touches of *red* on the girl's lips and a tasseled chair cushion; and, finally, a *black* brush drawing to outline her coiffure and stylish dress, the legs of a folding

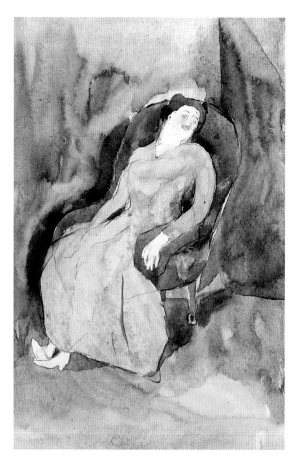

CHARLES DEMUTH (American, 1883–1935)
Woman in Armchair, ca. 1913
Watercolor on paper laid down on board,
8³/₄ × 5³/₄" (22.2 × 14.6 cm)
Courtesy Salander-O'Reilly Galleries, New York

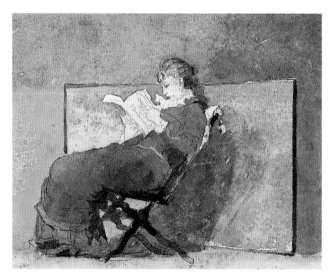

WINSLOW HOMER (American, 1836–1910)
Girl in Black Reading, ca. 1878–79
Watercolor, 7¹/₂ × 9¹/₄" (19.1 × 23.5 cm)
Private collection
Courtesy Hirschl & Adler Galleries, Inc., New York

chair, and the frame of a background screen. Homer's one-two-three process—drawing, followed by flat areas of local color, and a final bit of shading or brush drawing—will assure you of a fresh and crisply rendered figure study. There are also numerous ways of varying or enriching this bare-bones format. Here, Homer subtly embellishes the cloth-covered screen with a cretonne pattern of tiny gray marks and uses stippled brushstrokes to transform the burlap-colored background into a shimmering gilt surface.

After mastering this shorthand approach, you will be ready for more ambitious projects. Watercolors by two Philadelphia artists—Frank Hyder's *Arrival* and Frank Galuszka's *Nude in a Blue Bath*—suggest ways of moving from realistic figure studies to more creative picture-making. They also illustrate certain choices you must consider— working with a broad style or detailed technique, focusing on single-figure or group imagery, and, perhaps most important, composing with an architectural or open-air setting.

Where Demuth and Homer capture unstudied but rather quiet poses, Hyder is intrigued with dynamic situations in which figures interact with each other and the forces of nature. During summers at the New Jersey shore, he has transformed sketches of family and friends cavorting on the beach into innumerable drawings, oils, and watercolors— always, as in *Arrival*, with a sense of mystery and symbolism. Here a line of bathers, led by a naked horseman holding a child with arms upraised like an infant Christ, march toward the sea as if in a religious procession or primitive rite. To heighten the drama, his shadowy bathers are haloed by bright moonlight. And while Hyder's watercolor is as simply structured as one of Homer's, it is a riot of color, as rust-red figures edged in orange and yellow face a night sky smeared with blues, greens, and purples.

Although it has a similar radiance, Galuszka's watercolor is done with small strokes and delicate tints. In contrast to Hyder's *direct* painting style, this artist also uses an *indirect* Renaissance technique in which forms are drawn and shaded in a monochrome underpainting and then overpainted in full color. A seldom used technique, underpainting is, nevertheless, as effective in watercolor as in oil. And it has a special advantage for the figure painter, since it allows intricate hatching and dry-brush work underneath to be joined with a freely brushed overlayer. The underpainting can even be highlighted with white gouache or acrylic before being glazed with transparent watercolor.

You will find that indirect technique opens up exciting approaches to color. One of Galuszka's strategies is to put blocks of transparent color—red scarf, yellow shirt, green trousers—over specific areas of the underpainting. Another is to establish a dialogue between warm and cool hues by painting under- and overlayers in opposite tonalities.

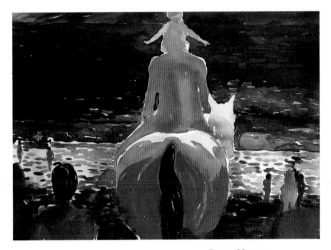

FRANK HYDER
Arrival, 1983
Watercolor, 22 × 30"
(55.9 × 76.2 cm)
Courtesy More Gallery,
Philadelphia

FRANK GALUSZKA
Nude in a Blue Bath, 1982
Watercolor, 22 1/2 × 30 1/2"
(57.2 × 77.5 cm)
Courtesy More Gallery,
Philadelphia

Nude in a Blue Bath, for example, features cool blue washes over a warm Venetian red underpainting. The point of such an approach is the shimmering mother-of-pearl vibration that ensues. Here each bathroom tile is a delicately shaded vignette of warm and cool see-through color relationships. Thus, with the addition of yellow glazes to suggest light from an outside window, the picture takes on a grotto-like radiance.

If Galuszka's painting technique is complicated, so is his drawing of the figure in an elaborate architectural setting whose furnishings include ceramic tiles, a shower curtain, a Venetian blind, and a still life on a windowsill. The artist works at home, sketching his family and friends in such everyday settings as the kitchen, study, or front porch. The finished paintings often have classical references, however, as in this image of a suntanned contemporary Venus emerging from her bath. And props like a kitchen stove or dressing room mirror sometimes take on symbolic overtones. Obviously, Galuszka's approach is the opposite of Homer's concept of watercolor as a spontaneous medium, and it isn't for everyone. Yet if you are a person who enjoys involved projects, you will find that painting the figure in a fully detailed interior setting can be a rewarding experience.

Meanwhile, a word of advice: The problems of such a project will be considerably lessened by developing it in stages—first as an informational drawing, and then as a more freely interpreted watercolor. To proceed with assurance, you will need pencil contours, which are difficult to set down directly without erasures and smudging. Therefore, it is advisable to work with tracing-paper overlays that permit you to redraw a head or knee and change proportions or gestures. In composing a figure like Galuszka's bather, for instance, the arms can actually be cut out of the tracing paper sketch, raised or lowered for best effect, and then redrawn in the preferred position. Another advantage is that anatomy and architecture can be studied on different sheets. A room's vanishing points, furniture placement, and wallpaper or tile patterns are detailed on one drawing. Later, an outline of the figure is laid over it and moved up, down, or sideways until a satisfactory adjustment is found.

Finally, the composite drawing is traced onto watercolor paper with a graphite transfer sheet. One always hopes the painting will turn out well. But if it doesn't, the preparatory drawing may be used again for a "new and improved" version.

Inventing Your Own Figures

Working from life is a valuable experience, but there is another world of figure painting to explore—the imagined or invented composition. I advise art students to start with still life or the model for two reasons: First, the vast majority of this planet's artists have drawn creative ideas from observed reality—and this includes such giants of modern art as Monet, Matisse, and Picasso. Second, observations made while working from life become part of your subconscious memory, to be drawn upon later in more imaginative work.

Nevertheless, inventing fanciful figures rather than looking at something is a way of life for many of today's artists. You should try it because, like Alice in Wonderland, you will find fascinating creatures on the other side of the looking glass. This is the land of Paul Klee, Joan Miró, Superman comics, and Disney animation. Although it is uncharted terrain, the place to start is with the germ of an idea and some scribbles that can be edited and enlarged into a full-scale pencil drawing. Once contours are in place, filling in shapes with witty colors is a piece of cake. And while the result may not be earthshaking, it is bound to be amusing, and in the hands of a free-wheeling satirist like Carmen Cicero or Gladys Nilsson, it can be truly exhilarating.

Cicero is a New York and Provincetown artist whose quirky paintings draw upon material from his second career as a world-class jazz musician. So, for me at least, the midnight skies, fedora-hatted gangsters, and pneumatic bimbos depicted in watercolors like *Hanky Panky* are

reminiscent of the St. Louis or Basin Street blues. I also find echoes of Cicero's tooting saxophone rhythms in the bouncy curves of his naked lady and the nervous dance of clouds around the moon.

The main thing to note here is that in invented figure studies there are two ways to go: You can opt for either elaboration or simplicity. The paintings of Dali, Bosch, and Magritte illustrate the first way, as do Gladys Nilsson's jam-packed contemporary watercolors. Cicero's work, in polar contrast, is characterized by innocent shapes and cartoon-like characters. One sees echoes of pop art in the lady's eyelashes, of Picasso in the gangster profiles, and of German Expressionism in the sinister yellows and greens of all three faces. Nevertheless, the great virtue of Cicero's art is its anti-establishment, devil-may-care tone. As such, it is the best kind of model for artists who want to loosen up and shed their inhibitions.

Nilsson's watercolors have quite opposite virtues. They are ambitious in scale, rather than intimate, and packed with detailed costumes and settings rather than generalized images. Thus, where Cicero can work from a quick sketch, Nilsson spends days or even weeks detailing the preparatory drawing for a typical work like *Studio Seen.* Originally a member of the Hairy Who, a wild group of Chicago imagists who startled the art world of the 1960s, she is essentially a social satirist with an eye for contemporary issues. She says her work is about confrontation—exchanges between men and women, or among women alone, in everyday

CARMEN CICERO
Hanky Panky, 1988
Watercolor, 22 × 30" (55.9 × 76.2 cm)
Courtesy June Kelly Gallery, New York

situations—and she usually starts with an idea based on an observed incident. After summarizing it in thumbnail sketches, she develops a full-scale drawing of one or two main characters and then embellishes the scene with tiny subordinate figures, furniture, costumes, and settings that will "poke windows, doorways, and floors into the space."

Studio Seen is a perfect example of Nilsson's multilevel imagery. The fun begins with a punning title like *Making Strides* (about women stepping into men's roles), *Léger Faire* (a takeoff on Fernand Léger's stovepipe figures), or, as in this instance, *Studio Seen* (a reference both to the artist as "seen" in her studio and the "scene" she is imagining, with characters literally leaping off her drawing board in a dizzy dance around the room). As usual, the picture was inspired by a simple event—the gift of a compact disc player that suddenly filled her studio with the sounds of rock and roll and country and western music. In this self-portrait, with paintbrush in mouth and apron around her waist, Nilsson gestures grandly toward visions called forth by the music—a cowboy atop her hairdo, a gaggle of hip-swinging male guitarists, and a Cher-like chanteuse roped in snakes and chains.

In turning these pages, you will find other artists who work with invented figures—Paul Klee, Mary Frank, Marilyn Holsing, and Robert Keyser, to name a few. Meanwhile, two main directions for the fantasist are suggested by Cicero's and Nilsson's watercolors: the impassioned little study sparked by personal symbolism, and a larger, more objective statement about issues in the external world. As it happens, both directions are on the cutting edge these days as our young artists turn, on the one hand, to autobiographical narratives, and on the other, to activist comment about such controversial issues as feminism, racism, environmental protection, and AIDS.

GLADYS NILSSON
Studio Seen, 1991
Watercolor, 40½ × 60" (102.9 × 152.4 cm)
Courtesy Phyllis Kind Galleries,
Chicago and New York

PRACTICAL GUIDELINES

Anyone seriously involved with the figure must, at some point, consider the nose, ear, shape of a foot, and action of a pelvis—in short, study every aspect of a complex organism. Fortunately, such visual experience is cumulative and not forgotten as easily as dates or historical facts. Each time you return to the figure, you will have a little more mastery of its forms.

Figure painting requires a certain amount of such patient study. Yet dogged perseverance is a trap to avoid. One way to do so is to vary your projects and the time allotted to them. Some watercolors should be conceived

as three- or four-day projects and others as quicker and more freely painted two-hour studies.

The kinds of directed exercises offered in earlier chapters are out of order here, since at this point you should be more on your own, dreaming up projects you want to try. Nevertheless, the strategies of artists illustrated in this chapter should give you numerous ideas, and you will do well to experiment with everything from portrait heads and full figures to group studies and poses in which the model is seen in an interesting costume or environment.

9 STILL LIFE STRATEGIES

The rise of still life painting is a curious development of modern art. This subject gets far more attention than in the past, and every other prominent watercolorist nowadays seems to be a still life painter. One reason is the positive image still life has enjoyed, since the days of Cézanne, as the most "abstract" of the representational idioms. After all, composing with apples and oranges is much like arranging colors in a collage. Another factor is that still life is highly suitable for the large "important" compositions now in vogue. Whereas a 19th-century artist might paint outdoors, contemporary watercolorists often prefer to work in the studio where objects and drapery will "hold still" for weeks at a time.

Still life is also a key proving ground for the watercolor student. Aside from the practical advantage of not having to worry about models or the weather, it offers a much less complicated experience than painting figures or landscapes—the opportunity, in short, to work with a few objects in a clearly defined space. A further advantage is your control over every aspect of the set-up—spacing, lighting, and deciding what to include or omit. Clearly, this is the visual equation to begin with, and after ventures afield, a subject to return to again and again.

A still life painting is conceived the moment you decide upon a specific subject. This is the germinal point, since your initial set-up will determine the possibilities and problems of the painting to follow, and it must have a visual excitement that will motivate you to go ahead with the project.

MARTHA MAYER ERLEBACHER
Detail, *Still Life Supreme*
(page 109)

THE SINGLE SUBJECT

When in doubt about what to paint, one foolproof strategy, as we saw in Chapter 4, is the "unarranged" still life of abundance. You simply pile everything in the house onto chairs and tables in a flea-market tableau and take it from there. With a paper viewfinder, you can easily pinpoint a section of this random set-up that composes well, and the beauty of this gambit is its spontaneity.

In a small apartment with not much to pull out of closets, however, you may prefer the opposite tack of focusing on a single intriguing subject. This can work out well, as Winslow Homer demonstrates in *Channel Bass*. An avid angler, the artist paints his catch in an arched silhouette like a mounted trophy in a sportsman's den—a rather curious image, actually, in which the fish seems to be in front of the water rather than *in* it. Thus, though *Channel Bass* is ostensibly a nature study, it is conceived in the manner of a Manet still life—a beautiful specimen laid out on a blue background that might just as well have been wrapping paper from the fish market. In any case, the subject is a traditional favorite among watercolorists, since fish are naturally associated with a watery milieu and their iridescence cries out for a transparent medium. Here Homer saves the white of the paper for the fish's glistening belly, while surrounding his central image with layer upon layer of lapis-blue washes.

The strategy of a single forceful image, whether a medieval Christ figure or an Andy Warhol soup can, has the virtue of capturing immediate attention. *It will only work, however, with the right subject.* The image must be complex enough to hold our interest, and this rules out most still life staples—commonplace things like plates, bottles, apples, potatoes. Homer's bass, on the other hand, fits the bill precisely. His great fish is visually stunning—decisive in outline, delicately modeled, gleaming. It also has human interest as we observe that the bass is freshly caught, with the hook

XAVIER GONZALEZ (American, 1898–1993)
Roses, 1966
Watercolor, 24 × 18" (61 × 45.7 cm)
Courtesy Left Bank Gallery, Wellfleet, Mass.

WINSLOW HOMER
(American, 1836–1910)
Channel Bass, 1904
Watercolor, 11 × 18⅞"
(27.9 × 47.9 cm)
Metropolitan Museum of Art,
George A. Hearn Fund Purchase, 1952

and a bold red fly still in its mouth, and vicariously share the artist's experience.

If you want to focus on one subject, there are plenty of options. Start with your closet. Hang a T-shirt or Japanese kimono on the door, throw a leather handbag with tangled flaps onto the floor, or paint a pair of old boots, as Van Gogh did. At the grocer's, look for things that come in "heads" or "bunches" like cauliflower, radishes, or beets. They make a strong unitary image even though composed of parts. And don't overlook the basement, attic, or local thrift shop. Anything from a stuffed pheasant to an antique doll may turn up.

Flowers are probably the most natural still life subject, because as Carolyn Brady demonstrates in *Dark Ground* (p. 42), a simple bouquet can provide both a striking singular image and an array of colors. With a conventional theme, however, one wants to add an element of newness. Joseph Raffael does this in *Summer Memory in Winter* (p. 25) by making a giant 4-foot image of a small flower.

In his watercolor *Roses*, the late Xavier Gonzalez (1898–1993) does it another way, with an offbeat situation. Instead of a prime bouquet, he shows us a single flower stalk stuck in a glass tumbler on the studio table—and it is quite dead.

After a season of working with lush bouquets from his Cape Cod garden, the artist saw beauty in this "last rose of summer," painting *dried* petals in matching *dry-brush* technique. And instead of charming the eye with a vivid palette, Gonzalez intrigues it with an almost monochrome scheme of Spanish blacks, grays, and browns washed with the merest hint of ochre and blue-green. What he sought was an impression, and this is captured by a virtual sampler of watercolor effects— smooth tones above, a standing puddle that has dried like a snowdrop behind the topmost white rose, roughly brushed textures on a lampshade on the upper right, and a stylish calligraphic outline of studio equipment in the lower left corner.

STILL LIFE AS ICON

Homer and Gonzalez paint their subjects casually in natural settings. In *La Famille Blanche,* Harry Soviak shows what can be done with a similar theme that is formalized, isolated from the environment, and made into a kind of icon. *Icon* is an ancient word for "image" with a historical connotation of holiness. In modern art, however, it simply refers to an image with an imposing, often stylized and frontal, presence. Symbolism may be suggested, but if so, it is apt to be personal rather than religious.

Monumentalizing an image has the paradoxical effect of emphasizing the picture's subject matter while, at the same time, heightening its abstractness. Soviak's stylized blossom is more insistently "floral" than Gonzalez's stalk of dried roses, and his vase decorations tell a more detailed story of butterflies, tropical birds, and honey gathering. Yet for all this thematic interest, *La Famille Blanche* is as elegantly abstract as an art nouveau poster.

Soviak (1935–1984) was a talented watercolorist who began to work as early as 1973 with the Redon-like theme of flowers in a classically shaped vase. From the outset, these paintings were designed symmetrically, and gradually their backgrounds began to disappear as Soviak's bouquets expanded to fill the frame. In later variations, even the flowers are gone, and we are left with only a vase, or part of a vase, like the fragment of an ornamented Greek amphora.

Don Nice is another painter who treats subject matter as an "icon" (my word) or as a "totem" or "heraldic emblem" (his words). An artist with roots in both New York and California, Nice explores more diverse subjects than Soviak. Characters like cowboys, Indians, soldiers,

HARRY SOVIAK (American, 1935–1984)
La Famille Blanche, 1980
Watercolor, 42 × 29¹/₂" (106.7 × 74.9 cm)
Courtesy Locks Gallery, Philadelphia

and New Guinea natives interest him, and he draws inspiration from a vast collection of antique toys, musical instruments, and illustrated books. One studio wall in his 18th-century mansion on the Hudson River is covered with miniature objects from dime stores and penny arcades—objects he blows up into full-scale pop-art images.

DON NICE
Alaska BK III PPXVII, 1982
Watercolor, 60 × 40" (152.4 × 101.6 cm)
Courtesy John Berggruen Gallery, San Francisco

Nice works with an arbitrary format, yet his subjects are painted quite factually. Indeed, since 1963, when he exhibited life-size canvases of horses and cows, he has been a "realist" in the sense of painting truthfully from direct observation. At the same time, he is obsessed by the idea of making an image look "modern." Thus, like Soviak, he has gradually come to disavow traditional figure/ground relationships, choosing instead to present his subjects without cast shadows or "referential space" on plain white paper. The intent is to make his watercolor into a "thing," with its own hand-painted presence, rather than a mirror of something else.

The effect is like a print made from several etching plates, and Nice sometimes heightens it by embossing his paper with dimensional "plate marks" before painting on it. He also numbers pictures according to stylized formats: *totems,* or vertically piled images; *predellas,* or horizontally banded images like those on a Renaissance alterpiece; and *book pages,* which are arrangements within a normal rectangle. As a further refinement, the paper sizes are indicated by Roman numerals. Thus the title *Alaska BK III PPXVII* translates as "The Alaska Image / Book Format 40 × 60-inch 300-lb. Arches Paper / #17 of a Series."

Although his work is rather specialized, Nice's approach to still life imagery, as exemplified by the Alaska watercolor, is of considerable general interest. The picture memorializes a trip to the 49th state, where, finding "eagles as common as robins," the artist decided to feature the bird in a heraldic profile against a medallion of native flowers. Below this public symbol, done in a Renaissance circle, or tondo, is a predella devoted to a private image—namely, the box lunch offered travelers on the Alaskan boat trip. On a field of aluminum foil we behold a sandwich and cookies in plastic wrap, a delicious apple, and a can of fruit juice with gaily-striped drinking straw. Like his ice-cream cones, tin horns, and all-day suckers, the Alaskan lunch interests Nice as both a symbol of personal adventure and an artifact of popular culture worth recording.

There is an important lesson here, since in addition to finding new ways of painting familiar things, we must also be on the lookout for entirely new subjects— things that Rembrandt or even Picasso couldn't have painted. Where smoky railroad trains were new for Monet, plastic foam coffee cups and egg crates are new for us. A few years ago, Janet Fish discovered the marvelous reflections on plastic-wrapped grocery produce. In the supermarket recently, I noted the beauty of iridescent grapes packaged in red string bags. Keep your eyes open!

MODULAR COMPOSITION

Normally, the subject you choose to paint—whether a single entity or a group of related objects—is sufficiently interesting to become the dominant element in your picture. An alternative principle, however, is composing with *modular units,* or small objects of relatively equal size and importance. In other words, painting an arrangement of eggs rather than a picture of the hen.

This is a strategy involving movements in space rather than solid volumes. To play the game, just think of your paper as a chessboard and your still life objects as pawns and rooks to be moved about on it. In *Still Life Supreme,* for instance, Martha Mayer Erlebacher uses a striped tablecloth as an almost literal game board on which she positions sixteen objects in crisscross diagonal rows. Since they are exquisitely painted—all are vegetables or fruits, including green, red, and yellow apples—they have considerable visual interest. Nevertheless, the point of the picture is the choreographed arrangement of jewel-bright modular forms against a red-toned chevron background. And despite its surface illusionism, there is an underlying sense of fantasy. Erlebacher likes anomalies, and there is often a subtext to her pictures. She says this one is a "take-off on modern art," doubtless because of the Bauhaus-like precision of its abstract scheme and the way she fits realistically painted everyday objects into it.

Erlebacher's watercolors are also notable for their unorthodox technique. As the detail of *Still Life Supreme* shows, she avoids standard washes entirely, building forms instead with the miniature crosshatched brushmarks usually associated with the egg-tempera paintings of Renaissance artists like Botticelli and Fra Angelico. Theoretically, an egg- or varnish-emulsion is needed to keep such strokes from dissolving as they are built up, but Erlebacher finds that plain watercolor works just as well. She likes to set bright objects against gray shadows that are either painted or rendered in graphite. With a palette of forty-seven colors (p. 17), the artist matches tones precisely. Here she is pleased to have gotten "just the right green for the dark lime and the special green of the pear as it began to turn color."

Bernard Chaet works in a more direct and improvisatory style that derives from the principles of Cézanne rather than Renaissance traditions. Typically, his paintings are based on modular arrangements of objects scattered seemingly at random on a piece of white paper (which then becomes the white background of the watercolor itself). Whereas Erlebacher paints disparate but neatly lined-up objects, Chaet pursues the opposite strategy. His subjects are uniform—pears in one picture, cherries or strawberries in another—but they are allowed to float irregularly over the page like leaves on a pond.

His painting technique is equally spontaneous, with every section of the paper seen as an opportunity for intensely observed note-taking. Thus the light and shade, coloration, and clustering of marks on every single berry (and there are sixty in all!) is as unique as a fingerprint.

MARTHA MAYER ERLEBACHER
Still Life Supreme, 1979
Watercolor, 16³/4 × 20" (42.5 × 50.8 cm)
Collection of Glenn Janss, Sun Valley, Idaho

BERNARD CHAET
Strawberries, 1983
Watercolor, 22 × 30" (55.9 × 76.2 cm)
Courtesy Marilyn Pearl Gallery, New York

CHARLES LE CLAIR
Mille Fleurs, 1988
Watercolor, 36½ × 51½" (92.7 × 130.8 cm)

This interplay between system and spontaneity is an important avant-garde principle today. A Yale professor and author of several art books, Chaet describes his goal as "the choreography of shape and interspace" or "making white of page equal partner to color strokes."[1] And in line with this principle, we see that he keeps the marks that shape each of his strawberries "open" so that bubbles of white sparkle in even the darkest passages.

You will find a similar, if somewhat less schematic, approach in some of my own watercolors. In *Mille Fleurs*, for example, a hundred or so tiny blossoms are conceived as modular units in the sense of being of equal size and importance; and like Chaet's strawberries, they are caught in a random "pepper and salt" arrangement of positive shapes and empty spaces. But where Chaet paints small studio set-ups, *Mille Fleurs* is a large, contrapuntal study of potted plants in a Cape Cod nursery with lots of things going on. Here, for instance, the pattern of red and yellow blossoms is echoed by a secondary pattern of blue cast shadows, while free-form plant rhythms are countered by the straight lines of plastic plant containers.

PATTERNING AND POSITIONING

For the painter interested in abstract qualities that go beyond mere illustration or portraiture, creating stylized icon-like images is one way to go, and working with modular arrangements is another. Far and away the most direct strategy, however, is to paint something that is already abstractly patterned. As we saw earlier, Philip Pearlstein is famous for studies of models dressed in ornamental kimonos or reclining on Navajo or Oriental rugs (p. 64). In still life set-ups, there are even greater possibilities for ornamentation because, instead of being limited to incidentals like rugs and cushions, patterning can be the dominant element in the picture.

The watercolors of New York artist Nancy Hagin are a case in point, and her titles—*Three Red Cloths, Dotted Quilt, Two Rugs*—tell the story. Where Pearlstein's paintings are about figures in a patterned environment, Hagin's are clearly about the patterns themselves—with a few jugs and pitchers thrown in to further complicate the design. Her watercolors also illustrate the importance of *positioning* in a patterned still life—with *Three Red Cloths* seen from above, *Dotted Quilt* shown head on, and *Two Rugs* composed in a more complex and purposely ambiguous perspective.

The earliest of the group, *Three Red Cloths*, is a breakthrough work painted during a fellowship summer at the MacDowell Colony. In her rather small studio, Hagin discovered a new way of working by arranging things on her small studio floor and looking down at them from on high. A collector of "junky, silly stuff" like this ornate yellow vase, fluted tureen, and thirties ashtray,

she set out these odd objects, added a white pitcher, and then threw down everything she could think of that was red—an Indian print, a floral cloth, a design of abstract birds, and a bunch of artificial lilies and poppies. The threefold shaving mirror was a smart added touch that reflects exterior light and creates geometric shapes.

This kind of boldly patterned still life is a must for your watercolor experience. The set-up is fun to arrange, and painting bright, flat designs is a cinch. What may prove tedious, depending on your temperament, is the preparatory drawing. Each flower, bird, and lozenge to be painted must be outlined in pencil first, and the spacing has to be in proportion. Once lines are in place, though, filling in colors is simplicity itself, and you will be pleased with the happy result.

Although fabrics can be draped or folded in various ways, Hagin usually simplifies matters by laying them out flat so that their ornamentation can be drawn without distortion. Sometimes she puts them on the floor, as here, and sometimes on a wall. In dealing with patterns, these formats are generally easier to work with than the usual tabletop arrangement. A view from above, like that in *Three Red Cloths,* offers an especially interesting diagonal perspective, but pinning things to the wall is often more practical. In a classroom everyone can see the arrangement, and at home a pet or child is less likely to disturb it.

Hagin's *Dotted Quilt* is a handsome example of the wall-relief format. Here the artist arranges things on a shelf at eye level in order to minimize depth perspective. With emphasis on flat design, she places a coffee pot and

cream pitcher in strict profile on top of boxes that repeat the rectangular shapes and red-and-black color chord of her patchwork quilt. Setting white objects against colorful patterns is a typical Hagin gambit, and we observe other interesting devices here—a red belt swag that echoes the curves of pot and pitcher handles; matchbox and cigarette logos that mirror triangular shapes in the quilt; and, as an especially clever touch, the placement of just one small object, the Diamond matchbox, in an overlapping and diagonal position that leads the eye across the narrow shelf and into the picture space.

The overall concept, then, is of inlaid shapes, each assigned a particular color and texture, and these squares, strips, and triangles are finished off one at a time. In general,

Hagin likes to paint patterned areas with flat washes, as in *Three Red Cloths* and *Two Rugs*, while saving fully rounded shading for a few solid objects. The puffiness of her quilt subject, however, calls for textural modeling, and you can see how patches like the blue triangles are developed with a flat local color followed by wrinkly shadows painted in a darker tone.

At first glance, such a project may strike you as overwhelming. Yet taken square by square, the technique isn't difficult, provided you have the requisite patience. A word of warning, though: by all means choose bold patterns rather than anything as tricky as Hagin's white polka dots, each of which has to be circled in pencil and then "saved" by a tediously filled in background.

NANCY HAGIN
Three Red Cloths, 1982
Watercolor, 29 1/2 × 42"
(74.9 × 106.7 cm)
Courtesy Fischbach Gallery, New York

NANCY HAGIN
Dotted Quilt, 1988
Watercolor, 27 × 39" (68.6 × 99.1 cm)
Courtesy Fischbach Gallery, New York

The third Hagin watercolor, *Two Rugs,* represents a more difficult tabletop format, where objects are shown from above, but in close-up perspective rather than from a distance as in a floor set-up. Drawing things below eye level is always difficult, but the vase, pitcher, and tureen in *Three Red Cloths* are at least seen from the same distant angle, with similarly shaped ellipses. Things are far more complicated in a tabletop study like *Two Rugs,* where the set-up is viewed at close range in a diagonal perspective. Here each object must be studied both separately and in overlapping relationships with its neighbors. In the foreground, for example, we look down into the mouth of a yellow pitcher and coffee cup; yet across the table, a white pitcher is already diminished in size and seen at a distant angle, even though it is only a foot or so away.

Nevertheless, if you are up to it, a complex perspective like this has its excitements. In contrast to the forthright design of her other watercolors, Hagin plays games with foreshortening and mirror reflections in *Two Rugs,* thus offering the viewer a visual puzzle. Stripes on the upper right belong to a rug on the floor beyond the table, but jazzy patterns on the left are purposely confusing. Ultimately, we discover they are reflections in a white-framed mirror—distant views of a chair leg and Oriental rug *behind* the artist plus close-up reflections of the white cream pitcher, brown jug, and embroidered tablecloth in front of her. Despite this representational logic, however, our dominant impression is of arbitrary shapes. Clearly, Hagin wants us to see her painting both ways—as realism and as abstraction.

Finally, I would emphasize that, like modular strategy, patterning is a way of thinking about design that can be applied to almost any subject matter. Choreographers make patterns with bodily movement; skaters cut patterns in the ice; and I have always been fascinated by the wonderfully clever patterns one finds in store window displays. This last was a theme I explored some years ago in a watercolor series that covered everything from fruit stands and supermarket produce to antique stores, toy shops, basketry shops, and florists. *Rue St. Honoré,* for instance, was inspired by an elegant shop window I came upon during a visit to Paris, and as you see, it is really a picture about rhythmic patterns rather than specific flowers. My interest lay not in the lilies and roses, but in the way they were displayed—the diagonal march of huge floral sprays and the repetition of small, distinctively shaped leaves or blooms within each cluster.

NANCY HAGIN
Two Rugs, 1986
Watercolor, 30 × 42" (76.2 × 106.7 cm)
Courtesy Fischbach Gallery, New York

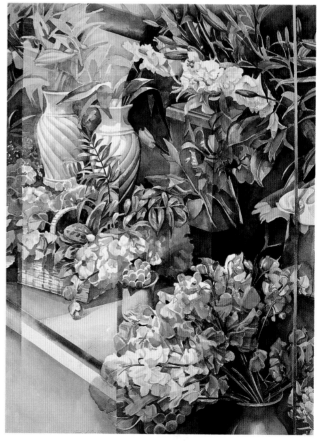

CHARLES LE CLAIR
Rue St. Honoré, 1987
Watercolor, 54 × 40" (137.2 × 101.6 cm)

THE MIRROR IMAGE

Reflections—whether on water, windows, polished metal, or glass—are basic to the watercolorist's vocabulary, since they reinforce the medium's essential quality of transparency. They are also widely used by painters, regardless of medium or subject, as a device for inventing shapes that are at once abstract and visually believable.

My own work often focuses on the creative possibilities of images reflected in mirrors. A continuing theme has been the idea of duality—a seamstress and her dressmaking dummy, a boy and his photograph, or, in a Roman series during the sixties, words and matching images. So when I turned to still life painting in the mid-seventies, after years of working with figural and architectural themes, using mirrors seemed a natural way to pursue my fascination with multiple images.

At that time I had a Cape Cod studio that was all white light, white floors, white furniture, and clean, bright objects gleaned from antique shops and yard sales. And it all started with the discovery of an old white three-way folding mirror. When I set this behind a plate of red tomatoes, presto change-o, three red spheres became thirteen bouncing balls in an abstract game of kaleidescopic perspectives. Later I did a number of similar paintings with modular units like cherry tomatoes, onions, and winter pears. This is a particularly good strategy for the beginner, incidentally, since you concentrate on just one object and get to practice it over and over again. It also provides experience with cast shadows and tinting white walls and tabletops so that they will seem solid rather than merely blank. Here I have used cool blues and violets for the shadows and a pale lemon/ochre/pink mixture for the white spaces.

Different mirrors create different effects. Pearlstein's *Self-Portrait* (p. 96), you will remember, features distorted facial reflections in the beveled edge of an ornate Venetian mirror. Nancy Hagin's threefold mirror in *Three Red Cloths* has flat glass panels that reflect seemingly abstract shapes (p. 111). And in her watercolor *Violets*, Sondra Freckelton uses a round mirror, the most difficult of shapes, very cleverly. You see, a perfect circle presents problems because it is totally at odds with both your rectangular paper and the verticals and horizontals of almost any subject you might want to paint. Yet Freckelton solves the problem easily by reducing round motifs to partial circles or arcs, and by substituting a diagonal tabletop for the usual frontal view. As you see, the top of her round gold frame is cut off, as are the curves of a reflected latticework flowerpot, while the circular lines of an embroidered cloth are modified by the straight edges of the table underneath. This table, meanwhile, is balanced precariously "on point"—its forward corner touching the bottom of the paper and its sides shown as upward-thrusting diagonals. A slanted wooden box,

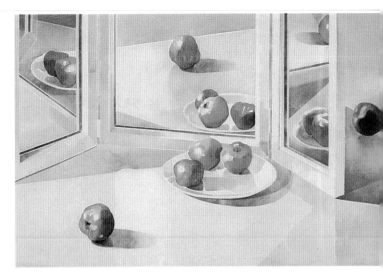

CHARLES LE CLAIR
Tomatoes, 1977
Watercolor, 25 × 40" (63.5 × 101.6 cm)
Collection of Dr. and Mrs. Paul J. Goldstein, Bradford, Mass.

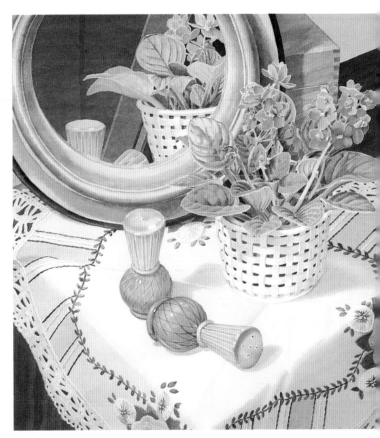

SONDRA FRECKELTON
Violets, 1989
Watercolor, 25 × 24" (63.5 × 61 cm)
Courtesy Maxwell Davidson Gallery, New York

a tipped-over salt shaker, and a glimpse of the artist's easel in the mirror complete this intricate arrangement of circular and triangular motifs.

While Freckelton's gold-framed mirror is intriguing, it is a one-time subject rather than something to use in various set-ups. And though my folding mirror was more flexible, I found that propping up bulky mirrors is a headache and, in the finished picture, their frames add an unnecessary note of heaviness. Thus if you are interested in reflective set-ups, I suggest starting with a lightweight dime-store looking glass. It comes with a thin frame and cardboard backing that can be stripped off for a clean-cut effect. Another option is a Plexiglas mirror, available in 4 × 8-foot sheets that can be cut into panels of any size. Just look in your Yellow Pages under "Plastics."

Sheet plastic also comes in colors, and after my initial work with mirrors I began to experiment with this semireflective material in red, green, blue, purple, and a gunmetal shade you see in *Orange Begonia*. In this floor set-up, a few small objects—one plant, three grapes, and a pear—are laid out on touching sheets of Plexiglas mirror and shiny smoke-gray plastic. Yet the "doubling" of each element in subtly varied, rather than exact, reflections creates a complex overall image. The potted plant's reflection on dark plastic, for instance, plunges downward

into deep space, whereas its bright green reflection in the true mirror pushes forward toward the viewer. Shadows cast by twin spotlights and the ambiguities of a reflected bookshelf and tile floor pattern at the top of the picture add further pictorial interest.

It is always exciting to work with innovative materials, and ultimately my experiments with plastics led to a distinctive still life vocabulary. The key element is a rectangular shape—like the purple reflective panel in *Oranges Against Violet*—that looks like a flat, crisply stamped imprint. Despite the representational subject matter, this sharply etched geometric figure sets an abstract tone that is reinforced by multiple-ray shadows (à la Pearlstein) and a masking-tape technique that leaves stylized white separation strips between painted shapes (see Chapter 11). A second principle is the placement of this bright rectangle on a field of white, with white objects like the milk bottle cutting into it as negative holes rather than positive volumes. And finally, the overall rationale for these still lifes is the idea of metamorphosis—the chameleon-like transformations that shapes and colors undergo in a reflective environment.

Painting Flowers is the most richly developed of this series. Here the background is still white, but motifs are more ornate and the set-up more elaborately structured.

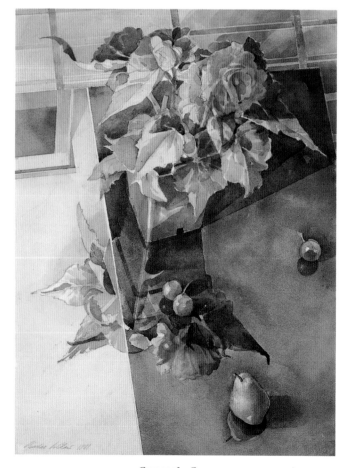

CHARLES LE CLAIR
Orange Begonia, 1982
Watercolor, 39 × 22" (99.1 × 55.9 cm)

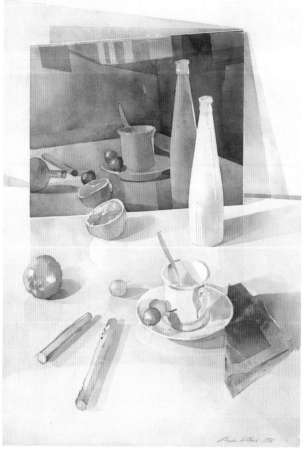

CHARLES LE CLAIR
Oranges Against Violet, 1978
Watercolor, 38 × 25" (96.5 × 63.5 cm)

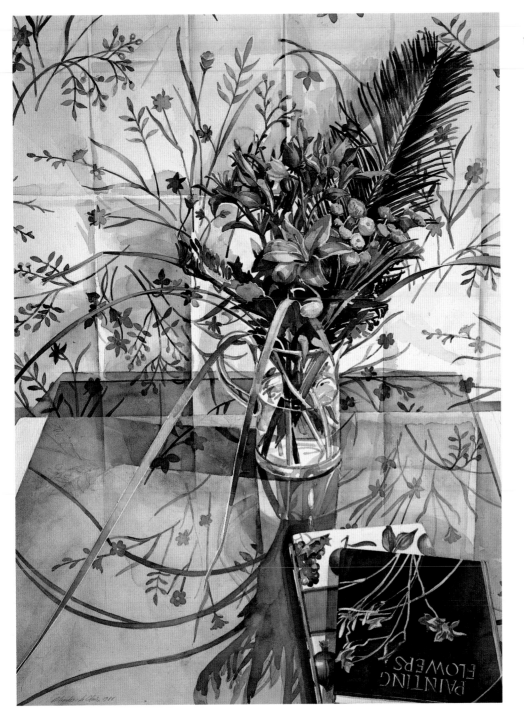

Charles Le Clair
Painting Flowers, 1988
Watercolor, 46 1/2 × 34 1/2"
(118.1 × 87.6 cm)

Basically, this is a contrapuntal study of whirling, linear patterns played out against another, quite different, system of architectural planes. The result is a richly layered effect, as flowers in a glazed chintz backdrop mingle with blossoms and fronds in a real bouquet and the set-up is then reflected in a luminous blue Plexiglas square laid over a see-through white tabletop. There is also a play on words and images, as the title of Elizabeth Leonard's book *Painting Flowers* appears on the lower right to announce what the artist is up to.

In conclusion, let me say that you will eventually want to choose between a deliberate style and a more casual one.

Right now, though, the important thing is to develop a vocabulary of shapes and color relationships, and this is encouraged by working with structured approaches to design. The strategies outlined in this chapter all have this end in view. When you experiment with positioning still life objects, visualize eggs or strawberries as modules, or look for patterns rather than subject matter, you discipline yourself to think like a painter—abstractly rather than literally.

1. Bernard Chaet, *Bernard Chaet and American Masters of Watercolor* (New York, Marilyn Pearl Gallery, October 19–November 13, 1982). Inside cover, notes on watercolor written in August 1977.

1924, 14?

10 FORMALISM AND EXPRESSIONISM

After working in the studio for a while, it is helpful to take time out for a look at watercolor from a more detached, theoretical point of view. There are things to be learned from museums, galleries, and the study of art history that will ultimately stimulate the development of your own work.

Earlier we reviewed the realist tradition of Homer, Sargent, and others. In this chapter we shall consider more abstract and experimental trends, starting with such father figures as Cézanne, Klee, Nolde, and Kandinsky, and concluding with representative contemporary watercolorists.

There is a considerable difference, however, between these two bodies of material. Historically, realism has been a dominant watercolor tradition, while interest in the medium's abstract possibilities has been sporadic. More often than not, avant-garde painters who work on paper have preferred gouache, collage, or mixed media. Nowadays, however, the situation is changing, as artists discover that it can be daring to use a "plain" medium instead of a fancy one. We see more and more abstract work in current watercolor shows, and some of the more experimental ideas are coming from our younger artists.

The American public was introduced to modern art by the famous Armory Show of 1913. This was a traveling exhibition of 1,600 art works attended by more than 250,000 people in New York, Chicago, and Boston in an atmosphere of brass bands and notoriety. Duchamp's futuristic *Nude Descending a Staircase* and the Cubism of Braque and Picasso created an instant public uproar. But for a generation of young American artists, the work of a quieter painter, Cézanne, had the most immediate and lasting interest.

PAUL KLEE
Detail, *Jörg*
(page 125)

117

CÉZANNE AND FORMALISM

Paul Cézanne (1839–1906) was one of five European artists accorded the most space at the Armory Show. Already, only a few years after his death, the French painter was an acknowledged giant of modern art, and in the history of watercolor there are few figures of his stature. He painted watercolors throughout his life, producing more than 400 catalogued works. This oeuvre is not only comparable in quality to the oils, but distinctive in revealing a more improvisatory side of the artist's personality.

In a museum, where Cézanne's canvases and paintings on paper hang side by side, one is struck by the fact that, whereas the oils come off as solid and weighty, the watercolors seem light as air. One reason is that the artist allows himself greater openness and fragmentation in the watercolors. A work like *Oranges on a Plate,* for instance, is literally half-painted—that is to say, Cézanne has put in the shadows and then stopped, leaving the centers of the fruit, china plate, and tabletop as blank paper. Unfortunately, he sometimes used inferior papers that have yellowed with time, as here, but one can imagine the brilliance of this watercolor with its original cool white background. In any case, this is a solidly shaped image, but Cézanne's late works are increasingly sketchy. Landscapes like his *Trees and Rocks, No. 2* (p. 79), for instance, are typically delicate in color and made with such scattered marks that the subject seems to hang in the air like a vague apparition.

Modern art is often charted as two streams of ideas—one emphasizing structure, the other emotion. In this scheme Cézanne is considered a *formalist* and the father of Cubism and nonobjective art, while Van Gogh and Munch are seen as ancestors of *expressionism* in its various manifestations. Like yin and yang in Chinese thought, these can be useful concepts provided they are understood as tendencies rather than absolutes.

Certainly Cézanne's main influence has been in the direction of formal structure. Even a modest little watercolor like *Oranges on a Plate* can be interpreted as an exercise in pure geometry—overlapping spheres set against a horizontal plane with vertical columns behind. At the same time, Cézanne was a transitional figure who never lost touch with nature. Despite their abstract look, his watercolors are always based on direct observation. On balance, then, his innovations should be seen as expanding the tradition of Homer and Sargent rather than opposing it.

The elements of classic watercolor style are brilliantly embodied in his work—immaculate, evenly stepped washes that are layered like waves lapping on sand and never retouched. Yet the artist breaks new ground by letting the paper speak for itself. In landscapes like *Trees and Rocks, No. 2,* he also avoids realistic local colors in favor of arbitrary warm and cool hues—orangish tones against blues and violets—that suggest space. And doubtless his major contribution is the shift from traditional broad washes to small, fragmented color planes. For Demuth, Marin, and many other modernists, composing with little "touches" became a form of personal handwriting and a way of translating three-dimensional reality into two-dimensional pictorial language.

PAUL CÉZANNE (French, 1839–1906) *Oranges on a Plate,* ca. 1900 Watercolor, 12³/₈ × 18³/₄" (31.4 × 47.6 cm) Philadelphia Museum of Art, Mr. and Mrs. Carroll S. Tyson Collection

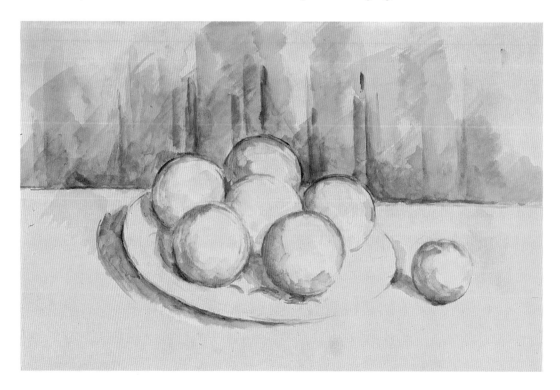

ABSTRACT MODES: KANDINSKY AND DELAUNAY

Shortly before the Armory Show burst on the American scene, the Blue Rider *(Blaue Reiter)* exhibitions of 1911 and 1912 created similar shock waves in Munich, Germany. This was a society that included many avant-garde artists of the day. And though the group soon broke up, two of its leaders—the Russian abstractionist Wassily Kandinsky and the Swiss painter Paul Klee—continued their commitment to radical ideas as teachers at the Bauhaus, the most influential cultural center in Germany after World War I.

Kandinsky (1866–1944) was forty-three when, after having found little success as a figurative painter, he discovered abstraction. In a series of "Compositions" and "Improvisations" he gradually eliminated all subject matter until, in 1910, he produced what is thought to be the first serious nonobjective painting. Interestingly enough, it was a watercolor. And though his later

architectural style is more familiar, the early abstractions are in a passionately lyrical vein. In *Watercolor No. 13*, for instance, the mood is rhapsodic, colors clash, and brushmarks have a kinetic energy that anticipates de Kooning and Pollock.

Meanwhile, other modernists were taking an opposite approach based on intellectual schemes rather than improvisation. The Dutch painter Mondrian reduced his shapes to horizontals, verticals, and primary colors. Malevich launched Russian Suprematism with the ultimate in nonobjective art—a plain black square on a white ground. In Paris, Braque and Picasso invented the first, analytical phase of Cubism—the concept of moving around the model or set-up and painting simultaneous views. It is an approach that "opens up" the subject, as if it were a fan or deck of cards, transforming a simple image into multiple facets.

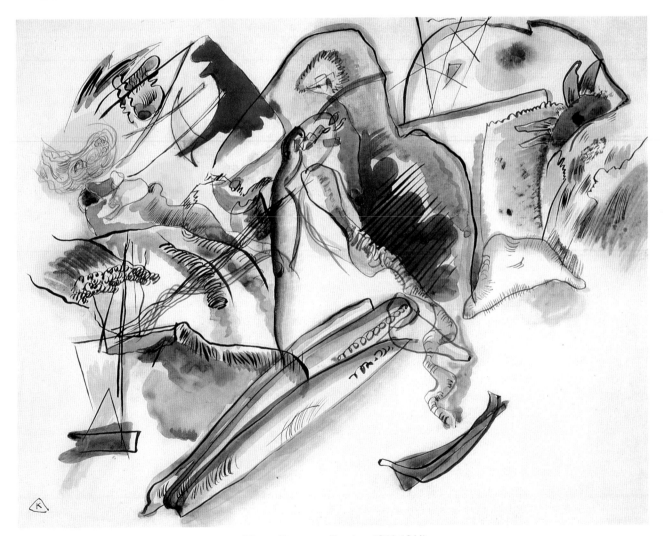

WASSILY KANDINSKY (Russian, 1866–1944)
Watercolor No. 13, 1913
Watercolor, 12⅝ × 16⅛" (32.1 × 41 cm)
Museum of Modern Art, New York, Katherine S. Drier Bequest

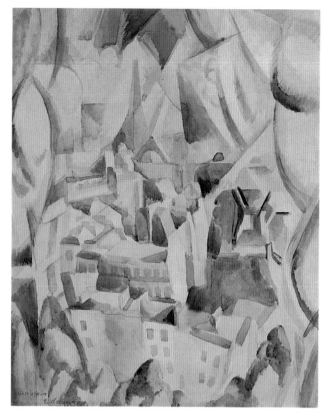

ROBERT DELAUNAY (French, 1885–1941)
The Eiffel Tower, 1910–11
Watercolor, 24¹/₂ × 19¹/₂" (62.2 × 49.5 cm)
Philadelphia Museum of Art, A. E. Gallatin Collection

Robert Delaunay (1853–1941)—though he called himself an orphist rather than a cubist—gives us a fascinating demonstration of the analytical principle in his watercolor *The Eiffel Tower*. The subject is typical of a period that equated advance-guard art with advances in science and technology. And whereas a conventional painter might have drawn the tower at the end of an avenue in vanishing-point perspective, Delaunay shows it, tinted orange near the top of the picture, as just one in a series of cube-like forms framed by a border of stylized trees.

In essence, Delaunay's concept is of a bas-relief with numerous depressions and bumps which, like ice cubes floating in water, rise to a surface level parallel to the drawing board or canvas. Artists call the principle "preserving the picture plane." This idea, implicit in Cézanne's work, was later systematized by the cubists, and it has been a key issue in contemporary painting ever since.

The free-form lyricism of Kandinsky and the geometric structure of Cubism are the two main paths to abstraction that artists have pursued, in various personal ways, throughout our century. By the same token, if you want to paint abstractly yourself, a clear choice of one or the other of these directions is needed. Whereas realism is based on what you "see," abstract art proceeds from what you have "in mind." This might be anything from an elaborate strategy to a dim feeling or mood, but it simply must be clear. And figuring out in advance whether to improvise or follow a plan and whether to paint with fluid or geometric shapes will get you off to an assured start.

AMERICAN MODERNISTS: MARIN AND DEMUTH

Among first-generation American modernists, John Marin (1870–1953) and Charles Demuth (1883–1935) are our most celebrated watercolorists. At the time of the 1913 Armory Show, Demuth hadn't yet returned from studying abroad, but Marin was already well established, with ten watercolors in the exhibition. With Homer gone and Sargent's career waning, Marin was recognized as their successor, carrying on the tradition of open-air landscapes in a new era. During the next four decades he painted the Maine coast, the mountains of New Mexico, and New York's skyline. And though he was a committed modernist, he also saw himself as a representational painter responding to nature. He said: "The sea I paint may not be *the* sea, but it is *a* sea, not an abstraction."[1]

Deer Isle, Maine—Boat and Sea typifies the subject matter and watercolor technique for which this artist is best known. Working at Small Point, Maine, then at Stonington, Deer Isle, and finally Cape Split, he was attracted by the experience of elemental winds and waves "pushing, pulling sideways, downwards, upwards." And Marin equated these forces of nature not with personal drama, as Homer had done, but with the dynamics of modernist picture-making. He replaced traditional smooth

washes with lunging brushstrokes and dry slashes on rough paper. And to achieve the "warring of masses"[2] he was after, he developed a format of symbolic images that play against each other in angular rhythms.

Thus *Deer Isle* is composed with separate elements that read like hieroglyphs: a circle for the sun, horizontal streaks for clouds, a cubistic schooner on a turbulent sea, waves rippling against the shore, and three tangles of fishing gear in the foreground. The horizon is also drawn at a slant, and this tilting of the overall image is reinforced by angled marks at the sides that have the effect of a frame within a frame. Marin often uses this device, making the inner frame off-kilter so that it leads the eye from the paper's placid outer rectangle into the melee of active shapes at the center.

Reputations change, and today Marin's stylized seascapes, much admired fifty years ago, come off as strong but a bit heavy-handed and dated. On the other hand, his contemporary, Demuth, is universally praised for work that is consistently subtle and interesting. In view of this judgment, it is fascinating to hear Demuth's own assessment: "John Marin and I draw our inspiration from the same source, French Modernism. He brought

his up in buckets and spilt much along the way. I dipped mine with a teaspoon, but I never spilled a drop."[3]

Demuth was born, did most of his work, and died in the small Pennsylvania-Dutch town of Lancaster, Pennsylvania. Yet he was also a man of the world who studied abroad, where he knew Gertrude Stein and Sherwood Anderson, and he was a regular visitor in New York art salons and night spots. Marcel Duchamp was a special friend, as was Eugene O'Neill, whom he saw during summers in Provincetown. The playwright based a character on him in *Strange Interlude,* and Demuth responded with a painted *Homage to Eugene O'Neill.* Unfortunately, a permanent limp colored Demuth's life, and after 1919 he worked in the shadow of a debilitating disease. Much of his best work was done during this last difficult period.

The artist did some interesting figure studies in an animated, fanciful style—studies of acrobats observed in local vaudeville houses; illustrations of scenes from the writings of Edgar Allan Poe, Henry James, and Emile Zola; and a score of watercolors of French sailors in homoerotic poses. Demuth is best known, however, as a formalist specializing in coolly detached still lifes like *Zinnias* (p. 50), and architectural studies like *A Red-Roofed House* (p. 27).

This last belongs to a watercolor series called Interpretive Landscapes, which he did in 1917 while wintering in Bermuda with the painter Marsden Hartley. With the encouragement of Hartley and Albert Gleizes, a French painter who also visited Bermuda that year, he began to paint in a more abstract style. *Bermuda No. 2 (The Schooner)* is an extreme example of this "cubist period," in which the subject is all but lost in overlapping planes. The schooner of the title is centered on the page like a flat paper cutout, with just one identifying insignia—a small

red square with a white cross that is echoed in the crossed bars of the ship's rigging. As in the work of the German modernist Lyonel Feininger, Demuth extends the lines of sails and masts, like cosmic rays, into the surrounding atmosphere. Delicate tones and open areas of untouched paper show the influence of Cézanne; and these fragile washes are enlivened by a distinctive blotting technique, which is particularly noticeable in the black center section of the ship's hull.

Like Marin, Demuth also worked in oils. But where Marin's canvases are cut from the same pattern as his watercolors, Demuth used oils and tempera for further inventions. Although he is best known as a watercolorist, Demuth's precisionist paintings of factories and silos, along with "poster-portraits" of friends like Eugene O'Neill, Gertrude Stein, and Arthur G. Dove would, in any case, put him in the top rank of American artists.

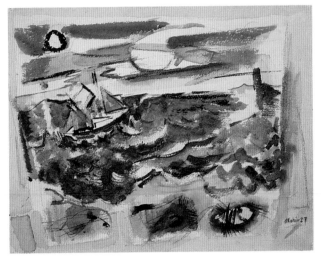

JOHN MARIN
(American, 1870–1953)
Deer Isle, Maine—Boat and Sea, 1927
Watercolor, 13 × 17"
(33 × 43 cm)
Philadelphia Museum of Art,
Samuel S. White III and
Vera White Collection

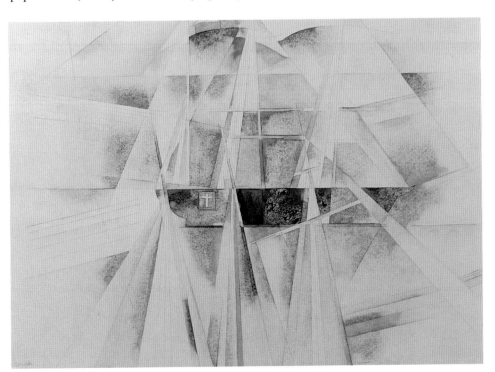

CHARLES DEMUTH
(American 1883–1935)
Bermuda No. 2 (The Schooner), 1927
Watercolor, 10 × 13⅞"
(25.3 × 35 cm)
Metropolitan Museum of Art,
Alfred Stieglitz Collection, 1949

Expressionism: Nolde, Grosz, and Burchfield

In discussing *expressionism* one must cut through various usages to a definition that is useful for the practicing artist. Historians speak generally of any style that distorts nature as expressionistic; the term is sometimes applied to the fervent Gothic impulse, as compared with Greco-Roman classicism; and in modern art it is used for specific movements like German Expressionism or Abstract Expressionism. In the studio, however, it is best thought of as just one of the basic approaches to representation. If you aren't into abstraction, there are essentially three ways to go: Making the picture look like the subject *(realism)*, creating a mood without fussing with details *(impressionism)*, or pouring out your feelings with hopped-up colors and exaggerated drawing *(expressionism)*. In this last mode, anything goes. Things can be upside down or out of scale, and faces can be purple or green. (Think of Van Gogh, Chagall, and Munch.)

Emil Hansen (1867–1956)—called Nolde after his hometown in remote northern Germany—is the leading watercolorist of the European expressionist movement. This started in Dresden in 1905 with the short-lived but seminal Bridge group *(Die Brücke),* which brought together artists like Pechstein, Kirchner, and Nolde, creators of a common style under the influence of the famous Norwegian painter of *angst,* Edvard Munch.

Nolde's *Papuan Head* was painted a few years later during an ethnological expedition to New Guinea, a trip motivated, like Gauguin's earlier visits to the South Seas, by the search for a "primitive" vision that might create a shocking effect. His watercolor seems innocuous enough

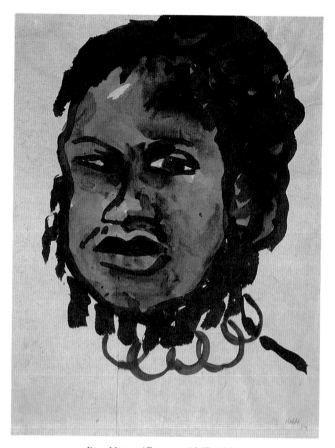

EMIL NOLDE (German, 1867–1956)
Papuan Head, 1924
Watercolor, 19⅞ × 14¾" (50.5 × 37.5 cm)
Museum of Modern Art, New York, Mr. and Mrs. Victor Thaw

EMIL NOLDE
Amaryllis and Anemone, ca. 1930
Watercolor, 13¾ × 18⅜"
(34.9 × 46.7 cm)
Museum of Modern Art, New York,
Gift of Philip L. Goodwin

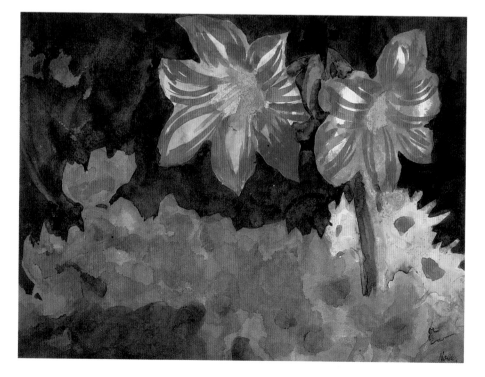

today, but it does illustrate the warm tropical colors and "primitive" black brush drawing he and other expressionists often used for figural subjects. Like the French artist Georges Rouault, who developed a similar heavily outlined "stained-glass" technique, he is known for somber studies of biblical scenes and mysterious, symbolic personages.

The expressionists were also influenced by Freudian psychology. They admired child art and cultivated a naive approach designed to convey deep-seated emotion. Accordingly, Nolde painted moody watercolor landscapes and flower studies with poster-bright colors, as children do, letting wet strokes run together and covering most of the paper with pigment. Like *Amaryllis and Anemone,* the flower studies are often composed of two or three blossoms in close-up against a sunlit or night sky. As images, Nolde's blossoms float like flowers in a dream garden. As watercolors, they are always exciting in color, with blots and spills that create a rich, earthy texture.

Nolde is much admired by today's art students who, without knowing it, are often of an expressionist temperament themselves—individuals intent on conveying their feelings without worrying about rules and regulations. However, painting with childlike directness isn't as easy as it sounds. Five-year-olds paint with poster colors that stay put, whereas wet watercolors run together in an instant.

So, if you want to work this way, note how Nolde adjusts his technique to the limitations of the medium. For one thing, he confines himself to themes that can be expressed with simple color masses and minimal drawing—subjects like sea and sky, or a blossom and two or three leaves. For another, he avoids standard papers in favor of absorbent stock that sucks up washes immediately, so that, when they bleed, it is only at the edges. Some of today's papers that have this effect are construction paper, Oriental papers, and soft-surface rag papers designed for printmaking.

After World War I, artists turned to symbolism as a means of conveying their social concerns. We see this in the plays of Brecht, the Mexican murals of Orozco and Siqueiros, and the late phase of German Expressionism dominated by the New Objectivity group *(Die Neue Sachlichkeit)* led by Max Beckman, Otto Dix, and George Grosz.[4]

Grosz (1893–1956) was essentially a graphic artist who, as we saw in Chapter 7, developed a wet-into-wet watercolor technique that could surround a brutal line drawing with sinister atmosphere. In *Eclipse* he portrays the corrupt middle class as headless automatons in empty starched collars, an image that calls to mind T.S. Eliot's poem *The Hollow Men*. These puppet figures sit in a room littered with skulls and bones of the war dead, while the sun (or perhaps the German state) goes into

GEORGE GROSZ (German, 1839–1956)
Eclipse, 1925
Watercolor, 20 × 16" (50.8 × 40.6 cm)
Philadelphia Museum of Art, Gift of Erich Cohn

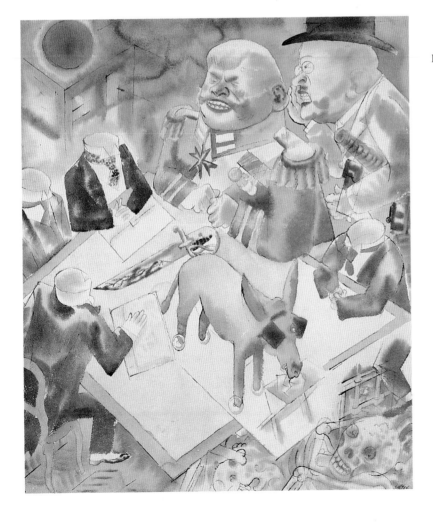

eclipse. The scene is presided over by a medal-bedecked general and a munitions maker with gun tucked under his arm at a conference table littered with briefcases, a bloody sword, and a toy ass wearing blinders.

This is expressionism with a vengeance—a reflection of the scathing social criticism that abounded in German art of the twenties. When the Nazis came to power, they banned such works as "degenerate." Nolde was put under surveillance and forbidden to paint, while Grosz, like many other modernists, fled to America.

In this country, expressionism didn't take hold as it did in Europe and Mexico. Between the two World Wars, artists like Jacob Lawrence and Ben Shahn did paintings of social protest, but there was little sense of a "movement" here. Hence, most Americans whom one might compare with Nolde or Grosz were loners, like Charles Burchfield (1893–1967). A native of Buffalo, Burchfield first worked as a commercial wallpaper designer and then as a camouflage artist in World War I. By the age of twenty-three, however, he had emerged as a serious painter with a vocabulary of symbolic shapes he called "conventions for abstract thought." These were based on facial expressions applied to houses and trees in the way that Disney animators invest nature with human gestures. *Dandelion Seed Balls and Trees,* for instance, is brought to life by distinctive animated motifs: dandelions with happy circle faces tilt to the right like dancers in a chorus

line; the bark of the center tree stands up in points like bristling porcupine quills; and the tree on the right has black snake-like branches that writhe and wriggle. Thus the painting is composed like music, with each element—foreground grasses, distant fields, and various trees—assigned a linear motif (or "melody") as if it were an instrument in an orchestra. Nor is this comparison a mere figure of speech, for Burchfield liked to sprinkle his landscapes, as here, with tiny zigzag lines and peppery dots designed to evoke the murmur of crickets and cicadas.

The painter had a curious career. He started as an expressionist, had considerable fame during the 1930s as an Edward Hopper kind of realist, and after 1940 returned to his original style. These late watercolors take up where the early work left off, except that they are more arbitrary and less tied to an observed situation. They also have historical importance as the first major works in the medium to be done on a monumental scale. Since oversize papers weren't available during his lifetime, Burchfield achieved his ambitious 40 × 56-inch pictures by glueing several sheets to a backing. When dissatisfied with certain areas, he cut them out and pasted in new sections, working doggedly at compositions that sometimes took years to complete. Sometimes the resultant paint quality is more earnest than fresh, but Burchfield's watercolors have weight, conviction, and the stamp of a unique talent.

CHARLES BURCHFIELD (American, 1893–1967)
Dandelion Seed Balls and Trees, 1927
Watercolor on off-white wove paper, 22¼ × 18¼"
(56.5 × 46.3 cm)
Metropolitan Museum of Art, Arthur Hoppock
Hearn Fund, 1940

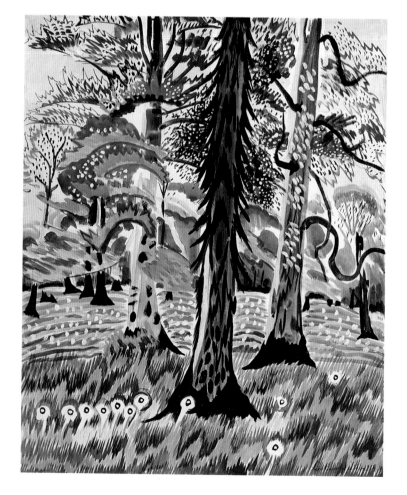

EXPERIMENTAL MODES: KLEE AND SOME CONTEMPORARIES

In a watercolor class, I keep two books at hand to illustrate this or that point—monographs on Sargent and Klee. You can find almost any representational technique in Sargent's work, because he painted in such varied ways. In an abstract frame of reference, the same can be said for Klee. He approached each subject as a new experience, and there are innumerable experimental ideas to be noted in his paintings.

Paul Klee (1879–1940) was a Swiss artist who spent most of his life in Germany, where he taught at the Bauhaus and then in Düsseldorf until the Nazis dismissed him in 1933. If he were living today, Klee would doubtless be called a "conceptualist." For this is a musician who finds painting analogous to composing melodies; a poet who writes imagist titles like *The Twittering Machine* and *The Equilibrist Above the Swamp;* and a student of dance, opera, and theater who paints his friends as though on a stage complete with props, masks, and puppet strings. Above all, Klee is a painter whose ideas center on systematic use of the basic elements of line, value, and color. In this sense his work is closely linked with the formalist impulse in modern art, but his interest in primitive, childlike, and Freudian imagery also has overtones of expressionism.

To illustrate, let's look at a watercolor portrait of Klee's friend *Jörg.* The gentleman's frontal position and gesture suggest a pantomimist; he is costumed like William Tell with a feather in his cap; and his face is like a paper-bag mask. Doubtless Klee was influenced by Bauhaus theater productions which featured marionettes, circus, and vaudeville acts, and student performers with masks or painted faces. At the same time we see how Klee builds a picture with linear motifs repeated like musical themes—*circles* for eyes, locket, armpits; *parallel marks* for costume shading, feather, and Abe Lincoln beard; a *V shape* for the nose and breastbone. The shape of the tail-stroke of the letter *G* in "Jörg" is even repeated by the tip of a curling feather.

Just as Cézanne influenced 20th-century abstract art, Klee is a key figure in contemporary "experimental" painting. This is a view of the artist less as creator of esthetic order than as inventor of novel visual games. And here one of Klee's most influential discoveries is the principle of *diagrammatic space.* Instead of giving us a picture of the subject, a watercolor like his *Dying Plants* charts what is happening to it the way technical illustrations or video games might do. The story starts with a top blossom that is alive and well. Then horizontal bands create a time frame for the descending drama of the plant's last hours. We follow light shapes down the page—first, a round flower; then one with peeling petals; next, a crumpled blossom that begins to look humanoid; and, finally, a flower lady lying dead on the ground.

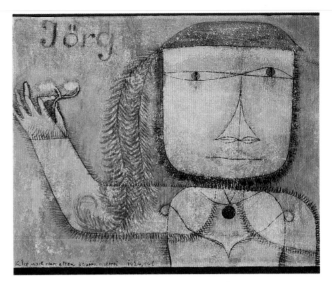

PAUL KLEE (Swiss, 1879–1940)
Jörg, 1924,
Watercolor, 9³/₁₆ × 11³/₈" (23.3 × 28.9 cm)
Philadelphia Museum of Art,
Louise and Walter Arensberg Collection

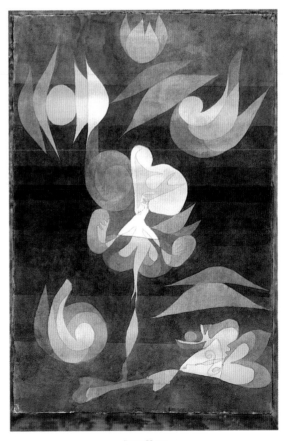

PAUL KLEE
Dying Plants, 1922
Watercolor and ink, 19¹/₈ × 12⁵/₈" (48.6 × 32.1 cm)
Museum of Modern Art, Philip L. Goodwin Collection

Traditionally, small-scale watercolors had been associated with open-air sketching. Klee's great contribution was the notebook-oriented, quirky little painting on paper. This has remained a vital contemporary idiom, as we see in the work of artists like Robert Keyser and William T. Wiley.

Keyser is a Philadelphian whose small-scale watercolors and oils are imbued with Klee-like wit and a methodology that mixes logic and improvisation. As in Klee's work, his enigmatic subjects are accompanied by provocative and often sexy titles—*Dream of the Sugardaddy, Secret Agent as Voyeur, How to Cure the Hecups,* and *Centerfold,* to name a few. And he likes to discover his themes through games of free association in accidental situations. One such game is to play with a deck of prepared "magic cards"—fifty-two notecards covered with writing, signs, and color notes that can be juxtaposed in various combinations. He also works with cardboard stencils of recurrent personal symbols, like the man and bird in *Centerfold,* that can be moved about, positioned, and then outlined with a Rapidograph pen.

This last watercolor is an especially intriguing mix of private and public imagery. As always in Keyser's work, one senses layers of meaning, some to be uncovered by further study, others that may lie buried. The artist explains: "More often than not, my works just happen, with the titling following the act. However, the iconography of *Centerfold* fairly well supports the title. Two figures are represented: on the left a runner (perhaps a jogger) momentarily arrested in space, and on the right a bird supporting itself on its tail feathers. They confront each other blankly—each from a different world. We have no idea of what is going on in the brain of the fully fledged but unruffled bird. But the jogger's head contains the image of recognition, a similar bird; and it also contains an image of its own head—perhaps a symbol of memory."[5]

Where Keyser focuses on a few intriguing motifs, the California artist William T. Wiley likes to pile up complex, intricately layered images. A painter, draftsman, watercolorist, and sculptor, Wiley says he simply "allows" words, numbers, and objects to appear by free association. However, what distinguishes his work is that nothing in this stream-of-consciousness process is obscured. He explains: "It's all still there, almost right down to the first mark. . . . It's not opaqued out; all the layers are transparent. And I find that idea really interesting—the notion that one thing doesn't have to preclude the next."[6]

The full impact of this approach is to be found in huge paintings that combine colorful acrylics and oils with areas of black-and-white pencil drawing. However, the canvases can be overpowering, and Wiley's watercolors deal with similar material in a more relaxed, accessible way. The setting for *The Good and the Grubby,* for instance, is the artist's studio, and its central image is the wooden sculpture of an abstract but functional musical instrument he is working on. This is noted in an inscription on the lower right, "Banjo for 6. D.," and the picture's title is also written in tiny letters along a dotted line at the bottom of the page. Presumably, the wooden box with its green gift ribbon is the banjo case; behind it on the left a sprouting avocado seed, wine bottle, and horse's skull symbolize life and death; abstract circles, triangles, squares recur throughout the space; and on the upper right there is a flurry of baroque shapes based on the templates architects use for drawing curved lines. At first these things may strike you as unrelated, but there is an epiphany or summation of Wiley's themes in the

ROBERT KEYSER
Centerfold, 1983
Watercolor,
12³/₈ × 20⁷/₈"
(31.4 × 53 cm)
Courtesy
Dolan/Maxwell
Galleries,
Philadelphia and
New York

WILLIAM T. WILEY
The Good and the Grubby, 1985
Watercolor, 30¼ × 22½"
(76.8 × 57.2 cm)
Courtesy Frumkin/Adams
Gallery, New York
Collection of Mr. and
Mrs. Graham Bund,
Cambridge, Mass.

central image. Here an architect's curve and the S-hole of an instrument's sounding box confront each other on the face of the banjo, thus signifying the oneness of music and visual art.

The wedding of personal imagery and abstract design was a key principle in Klee's art, and it remains so for contemporary painters like Keyser and Wiley. If you want to work with fanciful themes yourself, it is well to remember this duality. While Keyser and Wiley, for instance, draw inspiration from "free association," one sees at once that their images are set down in an orderly way. And just as there are conventions for realistic art, there

are stylized conventions here that you might find helpful. Both artists work with *borders* that flatten the space and give it the look of a stage set. Both introduce *dotted lines* that suggest a chart or plan, rather than a tangible subject. (Wiley's are black-and-white strips that look like perforations; Keyser's are dotted to show that the left leg of his cardboard running man is an underlayer attached at the hips with two small screws.) And finally, there is an overall emphasis on *transparency* rather than solidity. This is particularly noticeable in the upper-right section of Wiley's watercolor, and in the undersea look of the coral-like encrustations along the border of Keyser's painting.

Nonobjective Work

Over the years, watercolorists have been quick to respond to almost every modernist movement except one—nonobjective painting. Cézanne's semi-abstract approach, Nolde's expressionism, and Klee's quirky style have all had their followers. But few have turned to the kind of rhapsodic nonobjective painting Kandinsky initiated, and it is a rare watercolorist who has explored the geometric idiom of a Mondrian or Malevich. Nor is the reason for this avoidance hard to understand, for the medium simply doesn't have the weight, scale, or tangibility that abstract painters generally look for.

Not that it is impossible to reconcile transparent washes with a geometric scheme. But it *is* unusual and, in 1991, the veteran abstractionist Al Held made news with a series of Italian watercolors precisely because his shift from oils to transparent washes was so unexpected. The *New York Times* commented that this artist's personal touch became apparent for the first time in the watercolor medium, noting that the resultant "variety of strokes, colors, and textures soften and breathe a kind of life into Mr. Held's airless universe."[7] Nevertheless, this is solid, unglamorous work as watercolors go. Though washes in

a painting like *Victoria XIV* are applied rather roughly, there is no shading, and the general effect is of poster-flat shapes. This is reinforced by Held's technique of stretching the paper over and around the edges of a rigid board, thus permitting the picture to be shown as a dimensional panel instead of as an opening in a mat or frame.

Held's postmodernist approach to design is also noteworthy. As you see, he works with a vocabulary of squares, circles, triangles, and other geometric shapes. But in contrast to the ideal of a flattened picture plane held by early 20th-century modernists, Held has a contemporary concern for spatial dynamics. Accordingly, his squares become cubes, his circles are funneled into cylinders, and a red triangle in the center of *Victoria XIV* has a house-like shape topped by a green roof. We also find a brown box on the left with a rotary motif at the center that throws off golden particles like wood chips. And as a further complication Held gives us separate little pictures in the four corners. Presumably these were suggested by the predellas of altarpieces he studied in Italy. In a larger social context, however, I see this postmodernist imagery of geometric progressions sliding through cosmic space as

AL HELD
Victoria XIV, 1991
Watercolor on paper stretched over board, 49½ × 57½" (125.7 × 146 cm)
Courtesy André Emmerich Gallery, New York

JEAN K. HAMBURG
Ramifications, 1991
Watercolor, 18 × 13" (45.7 × 33 cm)

This is no easy trick. But if you would like to bring it off, Hamburg's guidelines will be helpful. She begins with a fine pen-line abstract drawing. Next, the white areas are blocked off with masking tape, bent, or cut into various intricate shapes. This is a key step, since in addition to preserving snappy whites, the edges of the tape serve as dams into which puddles of liquid color can be poured without overflowing. From this point on, the picture is built up in wet-into-wet layers. Foundation washes are done on areas that have been premoistened with a small, very wet sponge. After this first layer is dry, sections are again masked off, the surrounding area is then moistened with an atomizer and painted in another somewhat darker color. (A tree-branch shape on the right shows this batik-like process quite clearly, as taped white lines are painted over with a bright cerulean layer, and masked-out cerulean branches are then overlaid with gray and ultramarine.) Hamburg says: "At the outset, I have no fixed idea of the painting's horizontal-vertical orientation, and I continually turn the paper in order to achieve balance and cohesiveness. The success of my work depends on a combination of clean color happenings, interesting white spaces, and watercolor washes applied wet into wet."[8]

This chapter has been devoted to the work of modernists who, rejecting conventional realism, have sought an art of greater intensity. Some, following Cézanne's lead, have moved toward formal design while others, inspired by Nolde and Klee, have worked in expressionistic or experimental styles. In the course of our discussion, any number of strategies have been suggested that you might want to explore in your own work. Whatever your interests, however, remember that abstraction is as dependent on orderly thought and sound technique as realism is, even though there isn't the same point of reference—a tangible subject to look at. Abstract art focuses on ideas rather than things and, above all, on the ideal of creativity. Thus the concepts you work with and the motivation to pursue them must be your own. So, though it would be easy to provide a homework "assignment" here, it will be best for you to name your own game and then, by looking at what is going on in the art world today, figure out how to play it.

parallel to the abstract, insistently mobile logos that identify today's television networks. In the same vein, Held's separate corner pictures are like the simultaneous shots of London, Paris, and New York one encounters on certain news programs.

Thus, despite its limited acceptance by contemporary abstract painters, watercolor can be effective in nonobjective work, particularly if the design is intricate and there aren't large open spaces. For most watercolorists, however, Jean Hamburg's brand of "lyrical abstraction" is more accessible, because it draws strength from the watery, translucent quality of the medium itself, rather than a predetermined design. This is an approach sparked by improvisation, and I can think of no one who manages swirling, liquid effects better than Hamburg. The lower half of her *Ramifications,* for instance, intermingles streams of emerald, chartreuse, cerulean, cobalt, and ultramarine that fuse like stained glass yet retain their separate brilliance.

1. Donelson F. Hoopes, *American Watercolor Painting* (New York: Watson-Guptill Publications, 1977), 148.
2. John Marin, "Notes on 291," *Camera Work,* 42 (April–July, 1913), 18.
3. Hoopes, *American Watercolor Painting,* 148.
4. Strictly speaking, *Die Neue Sachlichkeit* arose in opposition to what other expressionists were doing. In a broad context, however, it may be seen less as a reversal than as an extension of the movement, with a new focus on social issues.
5. Robert Keyser, memorandum to the author, July 25, 1992.
6. Katherine Gregor, "Zen and the Art of William T. Wiley," *Art News* (April 1989), 184.
7. Michael Kimmelman, "Al Held: The Italian Watercolors," *New York Times,* September 13, 1991, 33.
8. Jean Hamburg, memorandum to the author, May 27, 1992.

11 SPECIAL EFFECTS

Nowadays science-fiction movies are made in two stages. First the script is shot, and later the special effects are added. Sometimes camera wizardry and drama are convincingly wedded, but at other times technical marvels are the main reason for seeing the show.

The trouble with watercolor is that it lends itself all too easily to special effects—indeed, to the point where it is viewed in some quarters as a lightweight medium lacking the importance of oil, acrylic, or even pastel. Nothing could be further from the truth, however, and my own position is clear. In watercolor, as in moviemaking, you should master fundamentals before specialized techniques. Yet these, too, have their place, and this last chapter is an important one. It may even be the place where you get "turned on," because we shall be discussing exciting processes and ways to enrich your work with subtle textures.

Texture is the most seductive of art elements. In fashion, it spells the difference between a couture gown in brocade and the muslin sketch. In painting, texture can be either a positive or negative factor, depending on how it is used. Contemporary watercolorists sometimes bend over backward to avoid tricky effects in the belief that texture should be the natural result of a simple, direct style, as it was for Homer and Cézanne. On the other hand, inventing bizarre textures was as important for Klee as coming up with new shapes. And the unique quality of a Demuth watercolor derives in large measure from an elaboration of surfaces.

Both do's and don'ts are important here. The main thing to keep in mind is that texture in painting is not, like icing on a cake, something added at the end. Instead, it must be "baked in," as it were, as part of the total creative process.

SAM FRANCIS
Detail, *Untitled*
(page 136)

DRY-BRUSH WORK

Dry-brush painting is a classic example of a special effect. Everyone has heard of it, and after a week or so in any watercolor class, someone will eagerly inquire: "What about dry-brush?" Yet once explained, the technique has limited appeal, and few major watercolorists use it extensively.

John Marin is a notable exception. In much of his work, he overlays even the wettest passages with gritty dry-brush strokes. This gives an effect of juiciness combined with weight that is akin to oil painting. Turn to his *Deer Isle, Maine—Boat and Sea* in the previous chapter (p. 121), and you will see how he combines broad strokes that have a bubbly texture with certain thin, dry lines. Technically, all that is involved is a brushmark executed so swiftly that it hits the bumps on textured paper without filling in the hollows. For this purpose, a *rough* surface, rather than the usual moderately toothed *cold-press* paper, is most suitable.

When a modernist like Marin creates dry-brush effects, he doesn't identify them with "dry" objects like grasses or tree bark, but uses the technique as a unifying texture—even when the subject is a watery seascape. Andrew Wyeth, on the other hand, has a more traditional approach in which delicate dry-brush work on smooth paper is used to imitate the textures of things like wheatfields, driftwood, or weathered surfaces. This is a much-admired technique,

but a difficult one to bring off. If you would like to try it, remember that the trick is to create richly toned washes and then to weave your overlaid dry-brush work rhythmically *throughout* the painting, rather than in a few "finicky" places.

In this respect, modernists and realists have much the same goal. In Wyeth's *Island Beacon,* for instance, storm-tossed grass is textured with white-line scratches and dark dry-brush strokes—all slanted to suggest a high wind. But note that the dry-brush work also extends into the sky, with its roughly textured storm clouds, and to the curious central image. This last is an improvised marker for homecoming sailboats composed of sticks, wires, and cloth topped by a rotating wind-catcher and flag. It is an intriguing subject that demonstrates Wyeth's quicksilver ability to move from fluid to dry passages as well as from the coarse marks of a wooden armature to thread-thin guy wires. A muted grayish tonality helps to integrate the mixture of wet and dry-brush effects by inviting us to see this as a watercolor *drawing* rather than as a *painting.* The somber atmosphere is enlivened by a wafer-thin bit of color on the lower left—a sliver of purple sea set against a mossy, greenish-black land mass. As usual with Wyeth, this is color at its subtlest!

ANDREW WYETH
Island Beacon,
1945
Watercolor and pencil on paper,
22¹/₂ × 29³/₄"
(57.2 × 75.6 cm)
Metropolitan Museum of Art,
George A. Hearn Fund, 1946

SALTING

Since any watercolorist's brush will sometimes run out of fluid, dry-brush work is considered a natural and hence thoroughly respectable technique. For purists, on the other hand, sprinkling salt to achieve a bubbly champagne sparkle comes under the heading of unnatural additives. Since my own feeling is that anything goes, if done well, I was delighted to learn that our most admired American watercolorist, Charles Demuth, had the habit of salting his paintings. As noted in earlier chapters, Demuth was a past master of indirect effects who liked to put down a wash and then tamper with it—blotting it with tissue, marking it with the edge of an absorbent card, or creating a porous texture with salt sprinkles. These effects are particularly striking in geometrically faceted watercolors of architectural subjects like *A Red-Roofed House* (p. 27). If you want to try this technique, use coarse kosher salt rather than the common variety, which produces too fine a texture to bother with. In principle, when salt is sprinkled onto a wet wash, it sucks up the color and turns dark. Later, when the paper is dry, the grains are brushed off and leave light spots. On white paper, these will be white; but interesting effects are also achieved by salting the top layer in a series of washes, in which case the undercolor will show through.

For a successful result, certain cautions should be heeded: Your washes must be intense rather than pale. They must also be wet, yet not too wet. Therefore, it is advisable to wait for colors to "set" and become a little viscous before applying the salt. Finally, *since sodium chloride attracts moisture, all traces must be removed* lest your framed watercolor become moldy under the glass. After brushing the finished paper, scrape it down gently with the edge of a flat table knife.

LIFTING, SCRAPING, AND SCRATCHING

Lifting, scraping, and scratching are three ways of removing paint, either partially or entirely, after color has been applied. *Lifting* is simply the technical term for blotting a wet wash with the intent of lightening it or removing specific shapes. For many artists this is standard procedure, since it is easier to lighten a wash that is too strong than to start with a pallid one. Also, by pressing down on one edge with a paper towel, you can create dramatic shading. A genuine blotter gives even sharper definition, and it can be cut into specific shapes for an impression of a city skyline or sails in a harbor. Lifting is also an efficient way for the realist to suggest the shine on glass or plastic wrap. Don Nice, for instance, uses the technique for wrapped cookies and sandwiches in *Alaska BK III PP XVII* (p. 108). To portray something like this, use a crumpled facial tissue or paper napkin to lift out shapes that look like folds. As with salting, it is also important to wait until the wash has settled before removing highlights. If you act too soon, color will seep back into them.

Scratching and *scraping* are techniques for cutting into the paper to reveal its whiteness or at least to pare off some of the paint. The distinction between the terms isn't precise, but scratching *out* is usually done with a sharp or pointed metal instrument such as a penknife, razor blade, needle, or compass point on *dry* paper. Scraping *off,* on the other hand, works best when the paint is wet, and though a dull table knife may be used, wooden or plastic instruments like a spatula or expired credit card are preferable.

Winslow Homer used scratch-out technique to suggest sunlight on water or leaves, and he sometimes shaded objects with finely scratched, parallel white lines, as in an engraving. Scratching became a cliché of the watercolor academies, though, and modernists have generally avoided it. But turn again to Wyeth's *Island Beacon,* and you will see how a more traditional painter uses the technique to provide a convincingly earthy texture. Here clumps of turf are re-created by richly shaded washes overlaid first by a dry-brush rendering of dark grasses and then by light-line grasses executed in scratch-out technique. The plowed-up surface is most clearly evident at the horizon on the far left, where scratches cut into the white paper. However, some of the center grasses, as well as the legs of the beacon, are scraped down to a layer of greenish gold underpainting, rather than being scratched into the paper itself.

Scratching is difficult, since it takes a lot of assurance to cut into a painting at the last minute. Scraping, on the other hand, is a simple and enjoyable process that will produce any number of effects, depending on your tool and how you use it. Watercolor is surprisingly malleable, particularly in wet-into-wet technique. You must apply a heavily pigmented wash, let the paint reach the almost-dry stage, and then think of it as fudge or dough to be scraped off. Transparency is created by these swipes of a straightedge, which pare off excess pigment and also indent the damp paper a little, giving it a sculptural quality.

You can also make a light-line graffito drawing by marking the pigment with a point rather than a blade. The effect is like an incised Greek vase design made by cutting through black and red clay layers. In watercolor, your stylus must be an instrument that will scrape off paint without cutting into the paper. The tip of a letter opener or the pointed shaft of a paintbrush is the sort of thing to experiment with, but your best bet is the wooden end of an old-fashioned kitchen match.

MASKING DEVICES

Masking is the principle of covering an area so that you can paint over it rather than around it. To show a sailboat mast against the sky, for example, press down a strip of masking tape cut to fit, paint the sunset with a broad brush, and later just peel off the tape. A trick? Yes, in some situations. But masking *can* be done with integrity, and the alternative—having to "save" the slender white mast by painting around it—won't achieve quite the same smooth result.

There are three types of masks: *stencils* made of paper, plastic, or tape that are ultimately removed; *frisket,* or *maskoid,* a liquid rubber cement that you brush on and later rub off; and *crayons* or chalks, which are water-repellent and remain as a textural enrichment.

For a quick introduction to masking, experiment with children's wax crayons and work either abstractly or with a subject that lends itself to light, fanciful treatment. Be sure to buy a large assortment that contains the white and light-hued crayons you will need. Start with a little white-line drawing. Invisible at first, it will stand out boldly when watercolors are added. Then try hatching or stippling with pink, yellow, violet, and aqua crayons. Dark washes over this kind of bright but pale drawing have a startling stained-glass brilliance. When you are ready to move from Crayolas to adult pastels, other options include white conté crayon, china markers, colored pencils, and oil pastels.

The most direct way to protect white areas is to cover them with masking tape. This comes in various widths that you can cut to almost any crisp shape. In discussing Jean Hamburg's *Ramifications* (p. 129), we saw how curved and irregular abstract shapes can be carved out with this technique. In *Skenikos,* shown here, she demonstrates an interesting but quite different approach—the creation of architectural spaces with straight-line, uncut strips of tape laid out in a vanishing-point perspective. Hamburg's title,

incidentally, is a Greek word for "scene," and though her work is essentially abstract, it does have "scenic" overtones—in the foreground, green fields, white roadways, a picket fence; on the upper right, foliage and blue sky; and on the upper left, heavenly clouds or factory smoke.

Frisket, or maskoid, has an irresistible appeal for the beginner, who should learn to use it with integrity rather than as a gimmick. The late Philadelphia artist Lillian Lent (1921–1993) shows us how. Instead of seeing maskoid as a shortcut for saving a few highlights, she conceives of it as an energizing principle for the whole picture. Her *Day Dream* is done like a Javanese batik in which designs painted in wax resist the dye. Here the resisting material is rubber cement applied as a white-line guide for the painting that is to come.

Lent's frisket marks are reconstructed in the accompanying diagram. Imagine them as originally gray against white paper, then painted over, and finally, rubbed off to reveal clean-cut white marks as shown. For Lent, however, this is only the start of a complex process. Compare diagram and finished watercolor and you will see that most of the masked-off whites were later tinted in various tones and colors. The borders at top and bottom glitter like sequins, and no two circles are alike.

The secret of success with any such specialized technique is to use it *intensively*. But the process must also be compatible with the artist's imagery, and Lent drew inspiration from a fantasy world reminiscent of Redon where "special effects" can be magical. She was intrigued by what she called "transformations"—changes that occur as an idea is interpreted in different materials and mediums. Here her subject, suggested by Alexander Pushkin's poem *Eugene Onegin,* is a young girl's waking dream of terrible animals. In typical fashion, she has explored this theme in

JEAN K. HAMBURG
Skenikos, 1992
Watercolor, 29 × 41" (73.7 × 104.1 cm)

LILLIAN LENT (American, 1921–1993)
Day Dream, 1976
Watercolor, 9 × 8" (22.9 × 20.3 cm)

A diagram of Lent's Day Dream. *The initial maskoid marks are shown in white. Blocked-out areas were later tinted with vivid colors.*

a Dream Series that includes other watercolors, etchings, inkless relief prints, serigraphs, and even embroidery.

Aside from esthetic considerations, certain practical realities should be kept in mind when using liquid mask:

1. Rubber cement ruins brushes, so use an inexpensive one for this sole purpose.
2. Maskoid is fully effective only on smooth (or hot-press) paper. On a cold-press or rough surface, it leaves vague or irregular marks.
3. As in batik, you may save whites, "dye" the paper with a wash, save parts of this layer with more maskoid, then brush on a second color, apply still more maskoid, and repeat the process several times.
4. The paper must be thoroughly dry before applying or removing maskoid.
5. Neutral gray maskoid is preferable to the pink or orange variety, which may leave a stain.
6. Maskoid should be rubbed off very gently with a soft cloth or tissue, since it acts as an eraser that can remove some of the watercolor pigment.
7. Washes change color when laid over previously masked paper. Therefore, in masking a shape to be tinted later, always cover the whole area rather than merely the edges.

SPATTERING

Spattering involves applying paint in little irregular droplets. I have done it on occasion by holding a loaded watercolor brush horizontally over the paper and tapping the shaft with my forefinger. Most serious spatterers, however, prefer an oil painting brush or toothbrush—something with stiff bristles that can be stroked with a fingernail or matchstick until droplets fly off. For more control, another option is to tap a loaded brush on the back of a second brush or stick held in the other hand; and for a perfectly even spray, rub a toothbrush dipped in paint on the top side of a piece of window screening held over the paper. The area to be spattered can also be controlled by surrounding a given shape with newspapers that will catch unwanted droplets. Thus the effect can be either impressionistic or precise, depending on your technique.

Serious painters sometimes think of spattering as disreputable because it is superficial in the literal sense of that word—laid on the surface, like rouge on a lady's face. There are two situations, however, in which drips and spatters play an integral role—the Jackson Pollock brand of gestural abstraction, where paint is actually thrown at the picture, and the Andrew Wyeth tradition of detailed realism, which deals with scarred, pitted, and weathered surfaces.

Sam Francis's *Untitled* illustrates the first of these idioms. A follower of Pollock, Francis carries forward the idea of an art of "controlled abandon" based on a technique of dripping, flicking, and splattering paint with the athletic movements of a dancer. Thus he begins a painting like

this with bold blue brushmarks in the four corners plus thick blue drops that look like heavenly constellations. Later he adds thick smears of yellow, red, and black, but in between these massive strokes, he divides the space with dozens of fine-line spattered trajectories.

As we saw earlier, this is a process I used in *Zoom* (p. 87) and other watercolors of the early 1970s. The act of literally throwing the paint produces a quite different kind of spatter than the usual generalized texture. Each throw has a curved trajectory, often with a hook on the end, in response to your arm movement. Although there is an element of chance, directional thrusts are controllable to a degree, and when a gesture is right, it can be repeated for emphasis. Thus a structured composition is developed from an improvised start through a process of layering. Just make a network of spattered lines, stare at it until you visualize interesting shapes, and then paint them with a brush as Francis does. Later, repeat the process with alternate layers of thrown lines and smaller painted shapes. The beauty of this approach is that it stretches the picture space both outward by the force of thrown paint and backward toward infinity by the layering, which has a cosmic effect, rather like the celestial view in a planetarium.

Aside from these virtues, throwing paint is great fun. You simply load the brush, hold it by the handle tip, and hurl the paint with a snap of the wrist. The paper should be on a slanted drawing table, since pinning it to the wall encourages runny drips and the floor is too distant for the stand-up gestures you need. Naturally, every stroke splashes

SAM FRANCIS
Untitled, 1962–65
Watercolor 19 × 25"
(48.2 × 63.5 cm)
Philadelphia Museum of Art,
given by Vivian Springford

far and wide, so you must work outdoors, in a studio where anything goes, or with a drop cloth. The inexpensive clear plastic kind works well. Tack it to the wall, let it fall over the drafting table and onto the floor. Then lay your paper or drawing board on top of the plastic, and go to work.

Charles Schmidt's technique is the opposite of Francis's—textural rather than gestural, realistic rather than abstract. Yet the possibilities for using spattering in a trompe l'oeil watercolor like *Spirit Level* are equally exciting. As noted in Chapter 7, Schmidt is a master of under- and overpainting techniques, and here he has come up with an unusually rich and involved process.

The artist began *Spirit Level* by spattering over tightly stretched strings. After their removal, this produced the light-line squared-off grid (visible on the upper left) against which objects and bent wires are superimposed in visual counterpoint. The spatter-work also provides a textured underpainting, suggestive of decaying surfaces, that flickers in and out of subsequent washes. The next step was to loosen the strings, make wet-into-wet puddles, and allow these to dry with the strings lying in them. Schmidt says: "This is what created the wires running through the painting. The objects were then worked up out of the 'mess,' as it were, with carefully detailed overpainting."[1]

In a close-up of the upper section, you can see how objects are built up largely by local color and dramatic shading. A rectangular wood block is set off by a brownish background wash and then pushed forward by a blue cast shadow. The numeral 5 (shown backward in a block of wooden type) and a large begonia leaf are shaded in much the same way, but with the addition of a specific red hue. The Oriental design on a square of fabric is rendered in flat blue, pink, and brown washes, always with the

spattered undertexture showing through. And to unify this arrangement of disparate objects—which includes an antique clock face, Mexican ex-voto with Holy Ghost wings, and bits of an old horse harness—the picture is crisscrossed with wires whose shadows move up and down and in and out of various grooves and projections.

This is ambitious work, but a beginner with some drawing experience shouldn't be discouraged from trying something like it. Remember that Schmidt's watercolor is very large, while yours, on standard paper, will be half the size and include fewer objects. In any case, working against a spattered grid (masked with string, as here, or with paper shapes) is an intriguing concept. Letting foreign objects dry in wet puddles is another good idea. You can create exciting effects with anything from old coins to birdseed, and the technique may be used either abstractly or as the underpainting for a representational image.

CHARLES SCHMIDT
Detail of *Spirit Level*

CHARLES SCHMIDT
Spirit Level, 1979
Watercolor, 30 × 40"
(76.2 × 101.6 cm)
Collection of Dr. Michael
Greenberg, Wayne, Penn.

TAPING EDGES

If masking tape can be used to "save" white areas, it can also be used to achieve crisp edges. Yet while this is accepted procedure in acrylic painting on canvas, very few watercolorists make use of it. Two reasons suggest themselves: On one hand, the medium's fluidity isn't usually associated with hard-edged style; on the other, those who *do* experiment with taping on paper are too often discouraged by technical problems such as paint leaks or torn surfaces. So let me say straight off that *taping isn't at all difficult.* By following the procedures outlined here, you should have no mishaps.

In my own work, taping has been a key technique for achieving a unified style in both canvases and watercolors. Recent still lifes, in particular, have featured Plexiglas surfaces and track-light shadows which call for the kind of crisp rendering only a material like masking tape can give. The objects in *Christmas Cactus,* for example, are set on a faintly reflective sheet of clear plastic laid over white foamcore. In back, a square of sheer smoke-colored plastic leans against an opaque black panel in a transparent, overlapping effect, while a mirror in the foreground features a double-image reflection and a beveled edge.

Frankly, with geometric subjects like this, I would be lost without masking tape—not only for the assurance of sharp edges, but because of the freedom it provides within the walled-off shape. You see, once taped boundaries are in place, you can flood an area and splash away, as in a swimming pool, without fear of overflow. In *Christmas Cactus,* for instance, velvety blacks are achieved by layer upon layer of richly pigmented brown-black, blue-black, and purple-black washes—painted always with the taped edging in place. Beyond establishing straight edges, masking tape is

helpful in smoothing out curves. In floral studies, I often use it on both sides of a plant stem in order to create rounded shading within a carefully defined but narrow channel. Since tape bends with a certain evenness, and is easily pulled off and readjusted, I also use it to perfect arcs and ellipses that are difficult to get right in the pencil drawing. Before painting a circular plate, for instance, the edge is perfected with a series of short, overlapping pieces of tape that follow the pencil line and improve on it where needed.

There is nothing more disastrous than finding, upon removing a tape, that a blob of color has run under it or—even worse!—that the paper has been ripped up. It took me a long time to figure out how to avoid such mistakes, but once learned, the secret is simple. Just remember that masking tape cannot be applied anywhere and everywhere as on canvas, but only on paper that is either untouched or very lightly pigmented. Therefore, I have come up with a technique of white-line separations between color areas, which you can see in *Christmas Cactus* where the bottom edge of the black Plexiglas panel meets the bluish white tabletop. At first these were bold 1/8-inch separations, but I have learned to make them almost invisible. The trick is to use narrow half-inch tape, pressed down on only *one* side against the penciled contour. Later, when you want to paint on the other side of the line, simply leave a 1/16-inch space of blank paper, to which the tape will safely attach itself.

Ultimately, success with masking tape depends on avoiding certain pitfalls. Like the Deadly Sins, there are seven temptations to beware of:

1. *Using the wrong paper.* Masking tape is effective only on good rag stock with a firm cold-press finish.

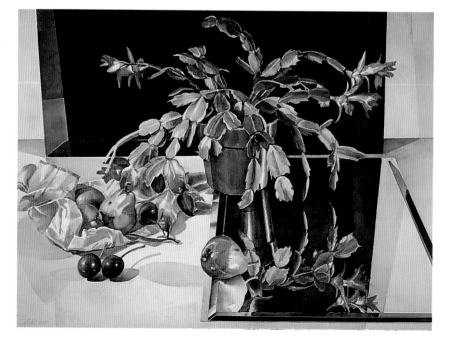

CHARLES LE CLAIR
Christmas Cactus, 1987
Watercolor, 19 1/2 × 41 1/2" (49.5 × 105.4 cm)

It will tear cheap paper or a too-smooth hot-press surface, and it can't fully seal heavily textured rough paper.

2. *Using the wrong tape.* It is imperative that you use half-inch tape rather than the usual 3/4-inch width.

3. *Pressing down too firmly.* The trick is to press on only *one* side with the thumbnail and to leave the end unattached for easy removal.

4. *Removing the tape too quickly.* Band-Aids are best ripped off smartly, but masking tape must be pulled up with the speed of a snail, lest bits of pigment and/or paper tear off. Burn this important principle into your memory!

5. *Pulling tape in the wrong direction.* Tape extending off the picture onto the drawing board must be removed by lifting an inside end and pulling outward. A reverse action may tear the paper's outer edge.

6. *Taping on too-solidly painted areas.* Tape will hold and be safely removable only on lightly tinted washes. Therefore, learn to limit your taping to the early stages of a painting before there are heavily built-up areas.

7. *Letting masked edges touch.* This is not feasible in a taped watercolor as it would be in a painting on canvas. A 1/16-inch separation strip between edges is recommended, although this may be tinted with a subsequent untaped wash.

ALTERNATIVE WAYS OF APPLYING PAINT

Most of today's leading watercolorists are "straight" painters who apply the paint with good-quality but quite ordinary brushes. And when they use special effects, it is usually to make the texture of their brushed-on washes more interesting. Salting, lifting, and spattering add flutter; taping, a sharper look.

For an artist of experimental bent, however, the challenge often is to avoid standard brushes altogether and find an alternative way of putting on paint. In his 1928 abstraction *Geometric Forms*, for instance, the Russian modernist Kandinsky uses three contrasting nonbrush textures: a fine watercolor mist done with an airbrush or sprayer, splatters of paint dropped from on high to create moon-crater blobs, and crisp ink lines drawn with ruling pen and compass.

The *ruling pen* might seem an unlikely suggestion for a watercolorist, but in a group of art students there is usually someone who enjoys working with mechanical devices. And people are often unaware that a ruling pen can be used, not only with ink as in Kandinsky's work, but with watercolor in a heavily pigmented solution, and even with maskoid. The pen should be filled with the tip of a fine brush, so that fluid is held between the blades rather than outside, and the pen must be held vertically. White-line effects, done with bright washes over maskoid patterns drawn with a ruling pen, are particularly handsome. To try this, use smooth hot-press paper and dilute the maskoid slightly with a few drops of soapy water.

Split-brush technique is another alternative to straight washes. In her handsome *Woman with Fishes*, Mary Frank uses a flat, square-cut brush 2 or 3 inches wide. The bristles of such a brush can be made to separate when wet, so that a single stroke divides into irregularly spaced parallel lines. While Frank's medium is colored inks, her technique is equally effective with watercolors. You will recall that I used it in paintings like *Zoom* (p. 87). Here, the best bet is an inexpensive housepainter's brush that will take rough treatment, and rather than dipping it into a wasteful container of premixed fluid, I work on a sheet of glass. This accommodates a generous paint puddle that

Wassily Kandinsky (Russian, 1866–1944)
Geometric Forms, 1928
Watercolor and ink on paper, 19 × 11" (48.2 × 27.9 cm)
Philadelphia Museum of Art,
Louise and Walter Arensberg Collection

is used up as the brush is pressed into it with a scrubbing action which loads and separates the bristles.

The function of a split-brush stroke is to carve out space, as Frank does in *Woman with Fishes* with a giant wave-like stroke below and a vehement thrust above. As you can see, these split-brush washes in muted magenta are vaporized by salt or lifting, and parts of the figure have also been blotted or sponged. Observe, too, how the woman's left leg has been masked so that the split-brush stroke springs from a clean contour. (This is done with a cut-paper stencil laid over the positive shape before the background tone is put in). Finally, note how Frank clarifies this rather blurred image with a few cleverly drawn fine-line additions. The wing-like upper arms or fins of her sea creature are outlined with crisp pen lines, as are the legs

and a flying fish that cuts across them. Thigh muscles are also shaded with tiny diagonal hatchings. Clearly this is an approach that requires advance planning and practice on trial sheets, since every mark must count in the final painting. *Sponge painting,* incidentally, is an alternative to split-brush technique that produces a similar effect, and I have used them interchangeably. You just moisten a square-cut synthetic sponge, dip one edge in paint, and make a few well-calculated swipes across the page.

Imprinting is the logical complement to these processes. After establishing generalized background tones with sponging and split-brush work, you can stamp on more specific shapes or images. Just cut the silhouette of your subject out of heavy paper or light card stock, brush it with paint, and press firmly onto your dampened watercolor.

To illustrate these techniques, I have dug up an old watercolor which is a vivid sampler of textural possibilities. Titled *Domani,* the Italian word for "tomorrow," it depicts a medieval wall in banded light-and-dark stones that has been plastered over with modern advertisements. On the top right you can see the first broad sweeps of a 3-inch split brush, plus a bit of *spattering*. Slightly above center on the left, there is a long gray smear with white lines that have been *scratched out* with a comb. And throughout the painting, the blocky stonework is created by rectangular imprints that reflect the dampness or dryness of the paper and the variable pressure of my fingers and palms.

Imprinting can be even more exciting when done with found objects. At home, at school, or in a walk through the woods, you will discover countless small objects that can be dipped in paint and stamped onto damp paper with intriguing results. Imprints of leaves and ferns will suggest a jungle, while things like corrugated cardboard, matchbook flaps, buttons, and alphabet blocks provide fascinating material for surrealist imagery or geometric abstractions.

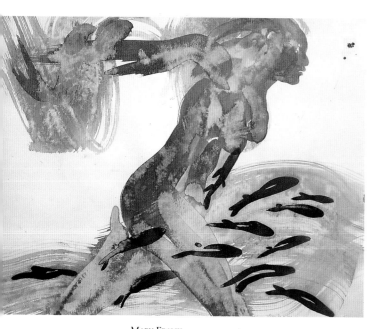

MARY FRANK
Woman with Fishes, 1979
Colored inks, 20 × 26" (50.8 × 66 cm)
Courtesy Zabriskie Gallery, New York

CHARLES LE CLAIR
Domani, 1972
Watercolor, 26¹/₂ × 34" (67.3 × 86.4 cm)

TISSUE-TEXTURES, FOLDING, COLLAGE, AND OTHER OPTIONS

Our discussion of special effects can hardly be all-inclusive, since the possibilities for combining processes and materials are truly endless. Indeed, for many painters, experimentation itself, rather than subject matter or design, is the starting point and ultimate inspiration for their work. Elizabeth Pratt is just such a person—a Cape Cod artist and teacher who reverses the usual approach to watercolor. Instead of working over a predetermined drawing, she starts with "controlled accidents" which are then gradually shaped into a coherent image. Pratt says: "Any set plan would impede the spontaneous effects that occur. I cannot forecast much of what happens. The paintings evolve as I decide which accidental effects to save and which to correct or eliminate."[2]

Painting through tissue paper is one of this artist's most innovative techniques. To create a network of tiny lines, she crunches up white gift-wrap tissue and lays it on smooth hot-press paper that has been dampened with an atomizer. When paint is brushed over the tissue, watercolor collects in the wrinkles and is transferred to the paper in a spider web of uneven lines. After the tissue has been lifted, these lines can be developed into the branches of a tree or the veins of a leaf. To achieve the more massive dark patches in her *Alpine Peaks*, Pratt laid crumpled tissue over dry rather than damp paper. She says: "I loaded a thick, firm brush and painted over the tissue with strokes that resembled the shape and direction of the ravines. The water channeled into the wrinkles and settled in jagged patterns that look like land poking through snow." This time, she removed the tissue only after it was thoroughly dry, so that the edges of areas that had seeped through and become attached to the paper would be sharply defined. These original jagged shapes are evident in the mid-section of Pratt's painting, and you can see how she has added an atmospheric sky with direct painting and created a sense of alpine vastness with clusters of nearby and distant trees.

We haven't talked about another kind of experiment—the idea of getting away from regulation watercolor paper and exploring alternative surfaces. The reason is that an introductory handbook like this serves the reader best by focusing on the essential medium (watercolor, rather than dyes or acrylics) and on the standard painting surface (a rectangle of good-quality white rag paper). Now that you have mastered first principles, however, you may be ready to set aside your Arches pad and see what happens when watercolor is applied to colored stock, such as toned charcoal paper, or to Oriental rice paper. Although these surfaces pose problems of fragility and permanence, artists often solve them by minimal application of paint—perhaps a few calligraphic marks or sprayed-on tones. Distinctive papers also lend themselves to *folding* and *shaping*, techniques that are of lively current interest.

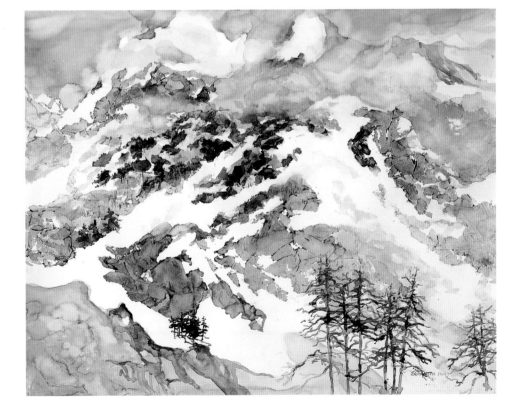

ELIZABETH PRATT
Alpine Peaks, 1989
Watercolor, 23 × 29"
(58.4 × 73.7 cm)
Collection of Mr. and
Mrs. William S. Howard,
Chatham, Mass.

Dorothea Rockburne, for instance, has revived transparent vellum—the material used for medieval manuscripts—which she paints on both sides and then folds in geometric patterns. And the avant-garde artist Alan Shields weaves, staples, and sews rough strands of handmade paper into openwork shapes that are colored with anything from an eyedropper to a water pistol.

Watercolor is also sometimes combined with *collage.* This can be done in the manner of a cubist drawing by adding small paste-ons, such as theater-ticket stubs or newspaper cuttings, to the painted page. I was deeply into this sort of thing during the early seventies while working in Rome. In *Lo Sport,* for instance, the poster for a modern sports event featuring an outspread hand is surrounded by the fragmented body parts of heroic classical sculptures. The theme is developed, not as straight watercolor, but as a "watercolor drawing with collage" in which black-line pencil drawing, brushed on color, and paper cutouts play equally important and interactive roles. Crosshatched shadows in the drawing are reinforced by overlaid washes; a mood of antiquity is established by penciled cracks and fissures, paint spatters, and a palette of Roman reds and umbers; and the machine-age crispness of the sports poster is emphasized by small but crucial bits of collage—on the left, a vertical band of cyanine blue, and in the center below, a strip of printed letters and numbers. The drawing for the poster was of course traced from the original so that the paste-ons would fit, down to the tip of one finger.

While collage is used selectively in this instance, it can also be employed more comprehensively, as in *Untitled,* a fascinating painting by Marilyn Holsing. Here, within a brickwork proscenium, an entire stage picture—a woman reading in an interior with overstuffed chair, table, lamp, wall-to-wall carpeting, and ornamental screens—is assembled out of flat, intricately patterned pieces of paper. The effect is not unlike a collage of assorted wallpapers, but the pieces are, in fact, all hand-painted in watercolor and then put together.

Thus, watercolor collage has interesting possibilities, and you will find that it is quite simple technically. There is one caution, however: to avoid puckering, all painting must be done in advance, and a full day's drying time should be allowed before pasting. For best results, use a nonacid wheat library paste or acrylic medium as the adhesive.

1. Charles Schmidt, memorandum to the author, Dec. 9, 1982.
2. For a detailed description of Pratt's innovative techniques, see: Elizabeth Pratt, "Experiments with Watercolors," *The Artist's Magazine,* vol. 6, no. 7 (July 1989), 49–52.

AFTERWORD

These pages have been written on the assumption that readers will be interested not only in technical know-how but also in mastering the "art" of watercolor. Hence, the book's title and emphasis on the relationship between materials and processes and the esthetic concepts they serve.

It is significant that painters often speak of what they do as "making art." Like making love, this is primarily a matter of expressing deep feelings, but for the student of art there is a problem. The painter's vocabulary doesn't come naturally, as the lover's is supposed to do. It has to be learned, and this takes time. Often you can spend a year in a drawing class or two years painting from the model, without really finding yourself.

The beauty of watercolor painting is that it allows you to move ahead so quickly. In a few weeks' time you can explore a full range of techniques, thus discovering the medium's possibilities and preparing yourself for the more important task of developing a personal idiom.

For this reason, teaching watercolor has always appealed to me. This is a subject that permits students to *analyze* separate elements and *synthesize* their experience by the end of the course. If this book were the syllabus of one of my actual classes, Chapter 11 would read "Week 11," with four weeks left in the semester. This last month is devoted to an independent project in which each student explores an area of personal interest. Afterward, there is talk, on a one-to-one basis, about the direction of the individual's work and how it might develop in future.

Thus, it is what you will be motivated to do with watercolor after exploring the projects in this book that is of greatest concern to me. Unfortunately, we can't sit down together for a personal discussion of your paintings, but perhaps some general advice will be helpful.

First, keep in mind that one of the main problems in developing a personal watercolor style is finding a subject and technique that are compatible. It doesn't matter whether chicken or egg comes first. If you love landscapes, for instance, a loosely brushed style may be in order; on the other hand, if you like to work with precision, you will need to find a subject that lends itself to clean-cut shapes. This is not an issue to be resolved in an instant,

nor one requiring you to adopt one set style, forsaking all others. After mastering basic techniques, however, it should be the next item on your agenda. The way to get at it is to look for painting ideas that can be developed in a series of studies, with variations and comparisons along the way. Someday you may want to have a one-person show with a dozen or more paintings that "go together" stylistically; but right now, why not start with a group of four or five related watercolors? These might represent either different treatments of a single subject or various themes done in a particular technique that interests you.

The second thing you will need, if you are to work independently, is a way of keeping your spirits up. Friends or family can help you stay motivated, but the surest way is to have some of your best watercolors framed under glass. There is a world of difference between a rumpled pile of good, bad, and indifferent studies and a few selected watercolors proudly displayed for everyone to admire. Framing won't make you an instant professional, but it does give your work a proper setting, and it will go a long way toward strengthening your image of yourself as an artist.

Finally, I urge you to consider exhibiting your watercolors whenever an occasion presents itself. You may not be ready to take this step for a while, but it is something to aim for, because showing your work, in a sense, completes the creative experience. At home, you see a painting from a personal viewpoint. Coming upon the same picture in an art gallery, on the other hand, enables you to judge it objectively, and often your assessment of its strengths and weaknesses will change as you see it beside other entries in the same show.

Painting is also a way of expressing yourself, and it is encouraging to find an audience and sense its reaction to what you have to say. Fortunately, opportunities to exhibit abound nowadays at every professional level—in local clothesline shows, community art centers, commercial galleries, regional competitions, and national exhibitions.

I hope you will avail yourself of these opportunities, and that the advice and information conveyed by this book will contribute in some small measure to your success as an artist.

INDEX